Museums and Galleries
A teachers' handbook

Gene Adams

Hutchinson
London Sydney Auckland Johannesburg

Hutchinson Education
An imprint of Century Hutchinson Ltd
62–65 Chandos Place
London WC2N 4NW

Century Hutchinson Australia Pty Ltd
89–91 Albion Street, Surry Hills,
New South Wales 2010, Australia

Century Hutchinson New Zealand Limited
PO Box 40–086, Glenfield, Auckland 10,
New Zealand

Century Hutchinson South Africa (Pty) Ltd
PO Box 337, Bergvlei, 2012 South Africa

First published 1989

Set in 10/11pt Sabon
by Input Typesetting Ltd, London
Printed and bound in Great Britain
by Mackays of Chatham PLC, Kent

British Library Cataloguing in Publication Data
Adams, Gene
 Museums and galleries
 1. Visits by British school students.
 organisation for teaching
 I. Title
 371.3′8

 ISBN 0–09–182358–7

Contents

Acknowledgements

I would like to thank all my friends and colleagues from ILEA, and from the Museum or Gallery Education Departments in London, whose help, valuable contributions and support made this book possible.

In particular I should like to thank the following:
Lloyd Trott and Dot Bigwood (ILEA members);
Norman Binch, Michael Hussey and Fred Nind (ILEA Inspectors);
William Stubbs (Former Education Officer ILEA, now DES officer);
Marion Taylor (ILEA Education Library) and David Allen (Horniman Library);

Colin Bagnall (former Head of English, Croydon);
Phyllis Hallett (former Education Officer at the National Maritime Museum);
John Jacob and Anne French (Curator and Dept Curator of the Iveagh Bequest, Kenwood, and Ranger's House);
Ivy Davis, Gwen Stephens and Josie Smith (secretarial and typing assistance at the ILEA Centre for Learning Resources).

Last, and most importantly, I would like to thank all the children, their parents and teachers, whose work in museums and galleries has provided the inspiration for these ideas and the illustrations in this book.

The Publishers' thanks are due to the following for permission to use material: Museums Journal, vol 85, no 4, *page 7*; Air Gallery *pages 13 and 14*; Royal Academy *page 22*; The Tower of London *page 24*; National Army Museum *page 31*; Shaun Holland, Beth Saundry, Pamela Dawson and Harjit Kaur Dhillon *pages 38 and 39*; Gene Adams *pages 45, 46, 48, 49, 50, 51, 52, 55, 64 and 65*; Joan Denvir for the artwork on *page 52*; Science Museum *page 53*.

Foreword

The wide range of galleries and museums is well known to visitors to the capital city. Increasingly in recent years, considerable efforts have been made to make these museums more interesting and attractive for young people. Consequently many schools have responded by arranging visits for their pupils.

As any adult who has taken a young person to a museum will know, much interest and curiosity can result from a successful visit. However, success is not assured. The visit needs to be properly planned if the experience is to prove rewarding for a child. This applies even more in the case of school visits, when children cannot expect to have as much attention from an adult as when visiting museums with their family.

If the children know in advance what they are going to see and have had an opportunity to read and talk about the visit beforehand, their interest on the day is much more likely to be sustained. This involves the teacher in thinking carefully about how the visit is intended to relate to the school curriculum and what follow-up work may need to take place afterwards. Of course, attention also needs to be given to the detailed arrangements for the time spent out of school.

This handbook by Gene Adams gives much useful information about how to make these arrangements. It derives from her own extensive experience in working with school parties visiting museums in London. The book includes a mixture of sensible advice about how to gain most from school visits and timely warnings about pitfalls to be avoided. Any teacher planning a visit to a museum or gallery would benefit from spending a little time beforehand reflecting on Gene Adam's advice. The outcome on the day for both teacher and pupils is likely to be much improved as a consequence.

William H. Stubbs
Education Officer, 1982–8
Inner London Education Authority

ix

Introduction

In London there is a long-established but largely unrecognised tradition of education in museums and galleries. It is also an under-valued tradition – visits to museums are often seen in the same light as those which combine a little serious education with an 'outing'. But those who know the true value of extending children's learning beyond the classroom recognise the immense resources which are available in both national and local collections. During recent years many changes have taken place in such institutions making them more accessible and welcoming. Education departments have provided a service for schools and colleges, developed ingenious ways of engaging children's interest and readily supported teachers who themselves often feel inadequate when faced with major exhibitions.

In the best examples of collaboration between museums staff and teachers, children learn to use all resources in the same way and work in a museum or gallery is simply an extension of studies in school. Attitudes to learning of this kind are not easily achieved and many successful but different strategies are employed. Sometimes a visit is the main stimulus to subsequent studies carried out in school. At other times, several visits may be necessary; in the most advanced examples, older children arrange their own visits and develop the ability to use museums and other external resources independently.

The ability to sustain independent studies is a characteristic of good primary school education and it is a main objective in good further education practice. In secondary schools it has perhaps been restricted by the dominance of passive learning systems and subject specialisation reflected in traditional examinations. The introduction of the GCSE, with all its attendant problems, has made a substantial impact on teaching and learning methods. Active learning is strongly encouraged and coursework is a major component of assessment. In some subjects, previously locked into insular patterns of school-based study, these requirements have

created demand for resources which is difficult to meet. In art and design, for example, the introduction of critical and contextual study into approved syllabuses has caused a dramatic increase in the volume of students visiting art exhibitions and national collections. Education staff are reporting impossible demands on their time and resources, particularly when they are being forced to make cuts to comply with financial constraints.

There is, therefore, an urgent need to ensure that all visits and work out of school is thoroughly planned. Museums education staff should know well in advance of an intended visit and whenever possible they should be involved in, or consulted about, the planning. Unfortunately there is little published guidance readily available to teachers and this book is a most timely addition to existing material. Written from an extensive background of experience of work in schools and museums it provides sensible advice and information in every important aspect of museum education. Teachers and education staff alike should find it an invaluable professional reference.

Norman Binch
Staff Inspector for Art
Inner London Education Authority

Maybe this is what permits thinking about museums in general: that, despite their immense variety, what they all have in common are contents that can make us marvel and wonder. They can arouse a curiosity that is not easily satisfied but which can induce a lifelong veneration for the wonders of the world.

Bruno Bettelheim (1980) 'Children, Curiosities and Museums'. *Children Today.*

Terminology

As the work of running museums becomes more complicated so the phrases and words describing it are changing. In London there is a mixture of national, local and 'private' collections, each using slightly different traditional terms. Broadly speaking, the following descriptions are in use in museums and galleries throughout the country:

Museum Formal collection of original material
Art gallery Collection of paintings and sculpture
Gallery Display gallery in any type of museum

Staff in Museums	Title	Responsibility
Professional	Director (or Curator)	Head of the Institution
	Curator (one of the terms with changing usage)	Head of Department
	Keeper (especially in the national collections)	Head of Department

The post of Keeper (or Curator) in a museum is analogous to that of a Professor in a University. But, in addition to management, administration and research, a Curator has the crucial responsibilities of adding to and conserving the collection of rare objects in his or her care. The conservation of an historic building or site may also be included in this responsibility.

Staff in Museums	Title	Responsibility
Professional	Research Assistant	
	Assistant Curator and Assistant Keepers	Responsible to individual departments
	Museum Assistant	
	Education Officer	Education services for schools and public
	Seconded teachers from the Local Education Authority (LEA) work with schools visiting museums or galleries	
Technical	Conservators Technical Officers Scientific Officers	Preserving, restoring, cleaning objects; research and data collection
	Photographic Officers	Photographic records
	Exhibition Officers	Creating displays and exhibitions
	Cleaning staff	Cleaning the building
Public Relations and *Administration*	Secretarial Staff	Administration and personal assistants to curators
	Museum Shop Staff	Manage shop
	Publications Officer	Publicity and printed material
Security	Warders or Attendants	Safeguarding the collection

NB: Secretaries working for Heads of Departments would be the best people for teachers to contact (after consultation with the Museum Education Officer) when enquiring of departments other than education in a museum, e.g. Prints and Drawings, Textiles, etc.

_____ **Guidelines**

What is a museum?

Children talking

Conversation between two children, overheard on a bus passing the National Gallery in Trafalgar Square.

A (aged about 7): What's that place?

B (aged about 12): You know what a museum is? Well, that's what that place is. . . . The National Art Gallery.

A: What?

B: Like a MUSEUM. You know – they got things – like bones . . .

A: BONES! Like a dog eats?

B: No! No! . . . Silly . . .

A: I'm not listening any more!

B: Well you're mad. You won't learn things.

A: All right . . . I'm listening now. Tell me.

B: Well, you know how a museum is? It's got bones and things . . . like . . . dinosaurs . . .

A: No, I *don't* know! I don't know what dinosaurs is!

B: Well, all right then, statues!

A: Yes?

B: Well, a gallery is like a museum, only it's got famous pictures inside . . . and statues. (*Profound silence, impressed at last.*) Lots and lots of famous pictures . . . all up the walls!

A: What! (*Recovering normal irreverance.*) Like Michael Jackson?

1

What is a museum?

'Cabinets of curiosities': the first museum

> ... a goodly, huge cabinet ... wherein whatsoever the hand of man exquisite art or engine has made rare in stuff, form or motion; whatsoever singularity, chance, and the shuffle of things hath produced; whatsoever Nature has wrought in things that want life and may be sorted and included ...
>
> Francis Bacon, *Gesta Grayorum* (1594)

Origins

European museums and art galleries originated during the late sixteenth century as part of the renaissance of classical learning. They embodied older ideas such as the veneration of holy relics, the superstitions of magic and alchemy, as well as the new interest in Natural Philosophy (Science) and Classical Art. Elegantly designed 'Cabinets of Curiosity' or 'Closets of Rarities' housed these early collections.

By the seventeenth century the fashion for collecting had reached England and was popular among the educated middle class as well as the wealthier aristocrats. John Evelyn the diarist possessed a 'cabinet of curiosities' which still exists and can now be seen at the Geffrye Museum, Shoreditch.

As the collections grew, so the cabinets multiplied and 'repositaries' were needed to hold the collections. The word 'Museum' was not used in the modern sense until the eighteenth century.

Tradescant's Ark – London's first public museum: 1628

The earliest public museum in London was in a house in Lambeth owned by the famous gardener, John Tradescant, who collected 'rarities' on his travels round the world. Founded in 1628, it was known affectionately as 'Tradescant's Ark'.

Ark to Ashmolean – 1679

When Tradescant died the collection was inherited by Elias Ashmole, a lawyer, who transferred it to Oxford. In 1679, as part of the University, it was housed in the first purpose-designed museum building. This still stands and is now the Museum of the History of Science.

Museum education in London – 1660

It cannot have been long after the establishment of the Ark that schoolmasters saw the potential of such collections for what we would call 'educational resources'. A London schoolmaster, Charles Hoole, 'having thrice seven years experience in this despicable, but comfortable employment of teaching school', wrote a book called *A New Discovery of the Old Art of Teaching School* (1660). Amidst Latin and Greek grammar, the Catechism and other 'core curricula' of the day, he observed:

> But in London, (which of all places I know in England) is best for the full improvement of children in their education because of the variety of objects which daily present themselves to them, or may easily be seen once a year, by walking to Mr John Tradescant, or the like houses or gardens, where rarities are kept. . . .

Visiting 'The Ark'

Reading this, one visualises a troop of happy seventeenth-century schoolboys skipping along the dusty roads and fields of Lambeth till they reach the mysterious arched whale bones which form the entrance to the famous garden of the Ark. Following a path between clumps of rare plants from the new colonies of Virginia, or 'apricocks' from Barbary, one imagines the eager children disappearing into a large house to look for 'divers curious and beautiful coloured feathers', or 'a lion's head and teeth', or a 'piece of stone of St John Baptiste Tombe', or even 'Anne Bullen's Night Vayle embroidered with silver'.*

As the art of drawing was also introduced in the curriculum at that time, it would be nice to think that each scholar had with him a 'little paper book' – one of Mr Hoole's recommendations – in which with goose or raven quill he might later 'gather to himself all parts of the imagination' and painstakingly record what he had seen.

The Ark is no longer there, but today's searchers or explorers will

* *Museum Tradescantium*: catalogue of 'The Ark' (1656).

find Tradescant's extraordinary tomb, sculpted with antiquities, crocodile and seven-headed hydra, in St Mary's Church, Lambeth, now the Museum of Garden History (see page 136).

Twentieth-century definition of a museum

The International Council of Museums (ICOM) defines a museum as: *'a non-profit making, permanent institution, in the service of society and of its development, and open to the public, which acquires, conserves, researches, communicates and exhibits, for the purposes of study, education and enjoyment, material evidence of man and his environment'.*

That definition includes any collection of original *material,* two or three-dimensional, live or dead. In this book, therefore, the phrase 'museum education' means educational work in art galleries, temporary exhibitions, zoos, as well as in conventional 'glass case museums'.

Free access

Free access to authentic museum collections and heritage sites is as important to the primary school child as it is to the university scholar. For both the sight of authentic material is the ultimate proof of many statements which must otherwise be taken on faith from books, teachers, or researchers. Often it is the sole remaining evidence on which all further discoveries are based. By several definitions, 'museum education' provides an irreplaceable and unique experience which is a central part of the universal right to education.

Enjoyment

Before the experience of 'education and enjoyment' can be conveyed, the museum is concerned with collecting, conserving, research and display. Because three of these activities take place out of public view they are often misunderstood and under-valued. It should be part of our general education to understand how a museum functions and to be able to separate these functions from the public displays or exhibitions which we can all see but which are, in a sense, the least important and most superficial aspect of a museum.

Cross-curricular resource

For teachers, museums and galleries are, above all, vast unlimited resources of verification, information and inspiration on every

3

academic subject. The same collection can and should be used at different times by different teachers to enlighten and amplify all or several clusters of traditional subjects. Paintings are not 'only for artists', and natural history or science is not 'only about science' – museum collections are an unlimited potential resource right across the school curriculum.

2

Museum education – the methodology

Seeing the collection

It might be stating the obvious, but the purpose of visiting a museum is to observe the collection, and at an historic site this extends to studying the building as well. The way the visit is organised will determine whether the experience is *seeing and understanding*, or merely *looking at* the collection with thoughts unrelated to visual experience. Seeing might also be extended by touching, hearing or even smelling. The primary experience, then, is 'sensory' education, but the intellectual experience is of equal importance.

Clearly the visits will vary enormously, depending on the nature of the collection and institution, and the service provided by the museum's education department, if there is one. One thing the museum education experience should *not* be is a lesson which could as easily have been delivered at school, and almost all schools will benefit from using the special expertise offered by museum education departments during (and sometimes after) the visit.

Reference – the 'Three-dimensional Library'

Museums have a vital role as reference collections. A well-kept collection will be classified and catalogued by experts who dedicate their lives to this highly skilled specialism. Such a collection provides a standard of comparison to which all can refer. One fine specimen might be an interesting rarity – almost a kind of freak – but five examples of it, all with slight variations imperceptible except to the trained eye, will begin to define the 'type'.

Young children may not at first appreciate this function of a museum. This does not mean to say that they will not benefit from

using it as such in limited practical exercises, in much the same way that they will also be using written references in a library.

Are 'things' important in education?

'Things' – objects, artefacts – as examples of, or revelations of, reality are infinitely important. Each object in its context is a unique 'statement', rather as every human being has unique finger-prints. Each object tells a different story and, one might almost say, uses a different 'language'. The secret of the museum educator is to learn to listen to the message, and to hand on the art of listening to the pupils.

Treasures

It is unfortunate for educationalists that some museum articles have a monetary as well as a cultural value and are therefore seen as 'treasures' rather than 'messages'. What museum educationalists try to do is to tap into the 'real' value of an object and sidestep the concept of museums as vast treasure stores, or immensely superior 'department stores' where one gazes enviously at things one cannot purchase. In fact, we already 'own' the objects in museums by virtue of the fact that we share the knowledge, nation-ally and internationally, which they generate.

A teaching model from the Science of Archaeology

In the eighteenth century, archaeology was seen merely as a form of treasure-hunting; our contemporaries with metal-detectors still see it that way. Archaeology, however, has evolved from these primitive beginnings to its present use of careful scientific discovery, measuring every object, dating every level of earth and relating every find to its physical context, and then to its intellectual or cultural context. This is the true value of archaeological discovery, and these scientific and intellectual processes provide educators with a useful model: a museum case with its careful arrangement of related objects and information could be seen as a site for discovery from which the pupil draws deductions and conclusions about an object in relation to a wider academic study, much as they are drawn in a real 'dig'.

Investigative learning

Watching children work in a museum or art gallery, it becomes apparent that the common experience in both places is the adoption by the pupils of similar patterns of learning, in spite of the

differences in the collections from which they take their starting point, and differences in age and ability of the pupils.

Each person, when confronted with an object, be it bone, or machine, or painting, adopts a similar investigative strategy: first through enquiry, then through independent research and study. The teacher (and museum teacher) provide the essential context of the project, but once the student has reached the point of confrontation with the object on display it is his or her personal learning experience which no other person can undertake on his or her behalf.

Arts or Sciences?

Whether the collection is related to the Arts or to the Sciences makes little difference to the *means* that the pupils will need to adopt, and the *method* the teacher needs to understand, in order to facilitate that learning process.

Objects do not 'know' what subject category they are supposed to belong to. Art, science, history or maths are academic subjects; they are divisions within the academic mind which allow us to think in orderly fashion. But an object is not a mental category, it is an object.

For example, a chair can be thought of:

as an invention to support a human being,
as an art object,
as a sculpture,
as a piece of historical evidence,
as a medical machine,

and in many other ways.

It could be found in an art gallery, a science museum, or a local history museum. This 'inside out' way of thinking is a major value of museum resources – you may go into a museum for 'confirmation' of an idea, but you may come out with totally different conclusions.

Balancing the programme: contemplation

When you take children to a museum, your study project should be programmed so that most (two-thirds) of the visit time is spent by the pupils studying, drawing, thinking, hunting for information, and making records. These activities are normally a solitary 'one to one' experience for each pupil and are beneficial in a variety of ways: they allow individuals to work at their own pace, to think their own thoughts, to make their own intellectual links, and

Diagram 1 Proposed model for artefact studies
(*Museums Journal*, vol. 85, no. 4)

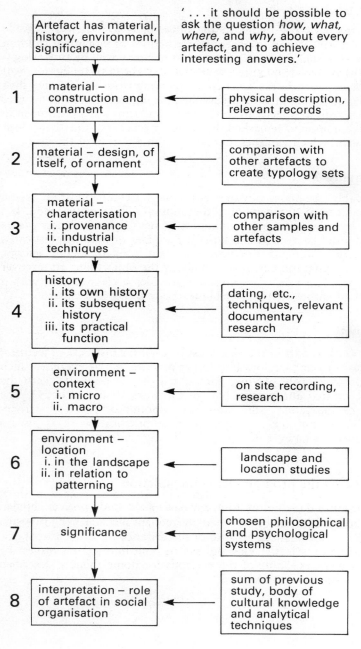

Museum Education Methodology

Artefact has material, history, environment, significance

'... it should be possible to ask the question *how, what, where*, and *why*, about every artefact, and to achieve interesting answers.'

1 | material – construction and ornament ← physical description, relevant records

2 | material – design, of itself, of ornament ← comparison with other artefacts to create typology sets

3 | material – characterisation i. provenance ii. industrial techniques ← comparison with other samples and artefacts

4 | history i. its own history ii. its subsequent history iii. its practical function ← dating, etc., techniques, relevant documentary research

5 | environment – context i. micro ii. macro ← on site recording, research

6 | environment – location i. in the landscape ii. in relation to patterning ← landscape and location studies

7 | significance ← chosen philosophical and psychological systems

8 | interpretation – role of artefact in social organisation ← sum of previous study, body of cultural knowledge and analytical techniques

generally to control their own learning experience. This process is described in detail on pages 25–59.

The teacher's role

The teacher's role while in the museum is to watch and guide unobstrusively, and to observe the reactions of individual children in this unusual situation. These reactions may well be surprising – the slow child who expresses unusual delight in the enlightenment of the experience; the quiet child emerging from a protective shell of silence to join in with discussions; the impatient or hasty worker who reveals a capacity to concentrate; and (this last a phenomenon very commonly remarked by visiting teachers) the 'behaviour problem' which vanishes, at least for the duration of the visit.

Stimulus

Probably the most obvious value of museum education is the experience of 'the new' and 'the unusual'. To a young child, but also to slow learners, the stimulus of new sights and new places can hardly be over-stated. Equally for older or more sophisticated learners, a museum can inspire a great burst of mental energy, activating natural curiosity and giving the opportunity to discover so many 'answers'. The museum provides a class teacher with a wave of enthusiasm impossible to create solely in a classroom.

Activity

Obviously a part of the visit must be used for instruction, lectures, discussions and exploration. Other practical active exercises, such as drawing, role playing, games, will be necessary to vary the concentrated and passive part of the work described above. The age of the group will dictate the amount of practical activity necessary, but for a long visit some practical work is always beneficial, whatever the age-group of the students.

Repetition

'Little and often' is the golden rule. The ideal visit is a short concentrated session in a limited part of the collection, which can be repeated (varied or extended) in frequent subsequent short visits. If this is not possible because of the distance from the school, the principle of 'selective viewing' can be built into a day's project by the organisers. Some of the methods for doing this are described in this book on pages 25–59.

Follow-up work

The purpose of work at school or college after the museum or gallery visit is, firstly, to reinforce the information gained, and secondly, to expand from this knowledge new ideas and new links with other areas of the curriculum. This should happen in such a way that the museum visit is self-evidently a part of the total experience, and is never thought of as a pleasant but inessential 'extra'.

Various practical suggestions for follow-up work are given in Sections 7 and 8.

3

Art galleries – are they relevant?

The short answer to this question is 'Yes!' By referring to the ICOM definition (page 3) it is clear that art galleries are also museums. Paintings, drawings and sculpture offer as much education as the traditional 'glass case museum'. It just depends on the scope of the collection, the needs of the class and the knowledge of the teacher.

Paintings and drawings can be thought of:

as historical documents,
as aesthetic statements,
as decorations,
as technical exercises,
as technological experiments,
as records,
as personal expression of emotional or intellectual ideas,

and in many other ways.

Cross reference

Perhaps the main difference between modern Western art collections and others is the tremendous emphasis given today to individual artistic expression, and the value attached to signed works of art. We rightly attach great importance to individual credit being given to original and creative people. But this has almost come to mean that signed and identifiable works of art are somehow seen as being more important than those which are unsigned

or anonymous. This is not really so, except to the dealer whose interest is primarily commercial, or to the specialist collector who is involved in the fields of identification and scholarly comparisons.

To the educator, an unsigned portrait from a primitive English period, perhaps from the Middle Ages, or a foreign artefact from an Ethnographic Department, might be just as important because of their aesthetic or historic 'statement' as a famous and well-authenticated Old Master painting. It is a question of what message the teacher sees in the painting or object, and where it fits into the context of his or her lesson or project.

Copying famous paintings

Once copying was almost all that art students were expected to do. The big national collections had days set aside for students to copy 'the masters'. Then copying fell from fashion and for many years was considered too 'academic' as well as too dull. Nowadays it might occasionally be considered a useful practical exercise for older students, not in order to produce a 'replica' but as a teaching device to enable the student to analyse and concentrate on the original in a way that he or she would not otherwise do.

Getting permission to use paint in a gallery is obviously not possible except for special students, or in special situations. But, as always, it is worth asking – you might be lucky.

Photographing the paintings

This is strictly forbidden in the National Gallery. Other galleries might allow it but only after written permission. The use of flash photography is not allowed in any galleries because of the damage done by exposing paintings to the brilliant light of the 'flash', which though not immediate will accumulate over years and years of photographing by thousands (perhaps millions) of visitors. (Paintings, textiles and drawings are all vulnerable to light.)

If permission is given to photograph, these problems can be solved by the use of a fast film, e.g. ASA 400.

Activity sheets in an art gallery

From the teacher's point of view, activity sheets are as useful when visiting an art gallery as in any other museum, especially because they slow down the viewer and most of us are conditioned (perhaps unconsciously) to think we can take in a painting by a mere side-ways glance. (Further ideas will be found on pages 40–47.) When composing your questions for activity sheets based on two-dimensional material (paintings, drawings, maps), it is wise to limit the

area of the painting which you wish the pupils to study by the way in which you phrase your question. Direct their attention to a *part* of the painting to help them to learn to concentrate. (More detailed advice will be found on pages 40–47).

Open questions

Use 'open questions' where possible. In the gallery it is important to concentrate on enlarging the pupil's aesthetic perceptions. Try to use questions, both on activity sheets and in your teaching, which can have several alternative answers. 'Closed questions', to which the answer is 'yes' or 'no', tend to shrink the perceptions and close down the doors of the imagination. They are often too easy to answer, being 'ticked off' from museum labels, or the result of superficial observation. They produce no new concepts, no original perceptions, and no enlargement of the mind.

Certainly facts must be learnt in relation to the museum objects, but your criteria must always be: 'Can this fact be learnt more easily and appropriately at school as preparation for or follow-up to the visit?' Ideally the questions asked in the museum should be those which can only be answered by looking at the objects, by thinking about them and reading part – not all – of some labels. (This is why it is often not helpful to send museum worksheets in advance to a school.) Personal attitudes, opinions and judgements should be drawn out of the pupil, as well as logical deductions and intellectual correlations.

Art projects in galleries

If colour is important in the theme of your study (for example, if you wish to investigate the use of colour by different artists), you might also want students to use colour during their practical work. Before giving instructions to the class, check with the Education Staff at the gallery whether art materials, apart from pens or pencils, are allowed in the public galleries. Coloured pencils are usually acceptable, but some galleries will not allow wax or pastel crayons, or 'magic markers', or any other wet media. This is because of possible danger to the collection and, more mundanely, to the walls or the carpets.

These rules vary from place to place. In the big national collections, where supervision of the public is a problem and school classes might get merged into crowds of tourists, rules tend to be stricter. In quieter places, where attendants are less harassed, the attitude might be more lenient. If the work is being supervised by gallery education staff as well as school staff, attitudes of attendants might be different. If you have clarified the situation in advance,

11

you might find that rules can sometimes be waived if good reasons are given.

Art workshops in small galleries: a 'way in' to Contemporary Art

Galleries, such as the Serpentine, the Air Gallery and others, sometimes run practical art workshops in conjunction with a particular exhibition. These might even be conducted with the help of the artist. They are a valuable way of learning to understand, or at least to enjoy, an area of art which might still be thought of as 'difficult'. Properly thought out, these projects also demonstrate that in fact there is a continuity in all visual arts whether representational or not; the different approaches are complementary and not, as some think, in opposition.

Talking about paintings

Note-taking will be an important part of the older student's method, but sometimes descriptive and creative writing can be brought into use. In this case the student is being asked to translate from one 'language' (painting) to another (words). Paintings can be the starting point for poems or plays and, if that objective is built into the final plan of the project, the written work in the gallery will later be transformed and elaborated in the class room.

Some galleries, such as the Tate Gallery, occasionally employ a 'Writer in Residence' who works with visiting school classes in this way.

Utilising temporary exhibitions

All major museums and galleries have temporary exhibitions. These are often of value to both the specialist and the general viewer, because they bring together material which is not normally on view in one place. This might include foreign material, and the work of an artist during his earliest as well as latest years. For that reason such exhibitions are expensive to produce and usually costly to view.

There are also numerous galleries and at least one museum (the Livesey) in London which only have temporary exhibitions because they do not hold a permanent collection. Examples are the Hayward, the Barbican, the Serpentine, the South London Art Gallery, the Whitechapel, the Air Gallery and others.

The conditions which all temporary exhibitions share – short duration and expense – make problems for schools. But there are

PARADISE LOST

A 3½ day workshop taken by Marty St James and Anne Wilson with Islington Green School

Friday 3rd April – afternoon
Eighteen 4th Year pupils visit AIR Gallery to see an Installation, 'Paradise Lost', by Marty St. James and Anne Wilson.
Marty and Anne talk to the pupils about their work and show them a Video Art-work.
The pupils are then presented with the project:
To make an Installation and a video based on one of four themes:
1 Our City – London
2 Our Home
3 A Memory (e.g. Holiday)
4 Paradise
The pupils are given notebooks to fill over the weekend with ideas, drawings, research material etc., based upon their group's title piece.

Monday 6th April – all day
In the school artroom, within their groups, the pupils discuss and decide how to present their Installation and Video Art-Work. They start work on their Installations.

Tuesday 7th April – morning
Group 1 makes video with Marty; Groups 2, 3 & 4 continue work on Installation and take photographs.
– afternoon –
Group 2 makes video with Anne; Groups 1, 3 & 4 continue with Installation and photographs.

Wednesday 8th April
The two remaining groups make their videos – one in the morning and one in the afternoon. By 4.30pm, all Installation and Video Art-work is complete. Pupils who are using photographs, continue to work on these in their spare time.

Monday 13th April
Pupils put up their Installations at AIR Gallery.

Very special thanks are due to Marty St James and Anne Wilson. Many thanks also to Alex Brewood, Head of Art at Islington Green School and to David Shepherd of 'The Arts in Schools Project'.
 AIR Gallery would like to thank BP and GLA for their very generous support for this project and for AIR's education programme in general.

Jenny Lockwood
Jenny Dale

13

EXTRACT FROM ISLINGTON GREEN SCHOOL'S NEWSPAPER

The AIR Gallery project ran from 3rd–8th April at AIR Gallery and Islington Green School. The finished work was exhibited at AIR between 15th–18th April.

The idea behind the project was to bring two practising artists into the school to work with our Art option pupils. The artists, Marty St James and Anne Wilson introduced four themes: 'The City', 'The Home', 'A Memory' and 'Paradise'. The pupils had just 3½ days to produce installations and videos based on these themes. An installation is a piece of art work you can walk into and around. The pupils could use any materials they could find – newspaper, wood, cardboard, photos, bags of rubbish, sand, paint and objects brought from home.

To illustrate 'The Home' one group of pupils built parts of a house. They designed the wallpaper, built a fireplace and window, constructed a set of stairs and even made a clock to sit on the mantelpiece.

'The City' looked like the opening credits to "EastEnders"! The Thames twisted its way through a collage of newspapers. Over this collage the group designed a series of silhouettes showing a city gent, a factory worker, a child, an old lady and a policeman. On the ground beneath them lay a drunk in the gutter.

If you found this too depressing you could leap on the tandem in the next installation. This took you to places remembered by the pupils which were painted in red on a big map of the world.

'Paradise' was a tropical island with tall palm trees and real golden sand. These last two installations were linked by a huge Air Canada jumbo jet, flying across the wall.

As well as the installation the pupils made videos to illustrate their ideas. Unfortunately the installations were too large to keep on permanent display in school. However we are making copies of the videos which will be available for you to borrow.

The Art department would like to thank everyone who helped make this project such a success. We would especially like to thank: Jenny Lockwood from the AIR Gallery, David Sheppard and Ken Taylor from the Arts in Schools Project and the Office Staff for all their help with the administration.

Finally, most thanks must go to Marty St James, Anne Wilson and the 4th Year pupils who all worked so hard to produce an excellent exhibition. As a result of this exhibition further projects are being planned, *SO WATCH THIS SPACE!!!*

Alex Brewood
Head of Art

strategies which teachers can use to overcome the problems and capitalise on the advantages offered by these exhibitions.

Advance information is the first necessity. If schools form a positive, even personal, relationship with the education staff they can gain not only advance information but many other kinds of special treatment, sometimes even cheap entry.

The second necessity is for the school to build in some kind of special flexibility to their timetable which allows staff to make and carry out quick arrangements to visit a gallery, without upsetting regular curriculum work. This applies especially to secondary schools.

Artists in residence

Galleries who support practising artists (and poets, musicians, actors, or dancers) are keen that these experiences should gain maximum support from the young. Schools who wish to extend this experience may well find that the artist in question is happy to visit the school or college for follow-up work. If necessary the school could negotiate an independent fee to cover the artist's expenses.

Art history for sixth forms

With the availability of slides, students no longer need to study art history merely through library books and biographical anecdotes, but, art history students need above all to learn how to visit a gallery or museum on their own, frequently and independently. Because seeing and comprehending, absorbing and comparing, depend on subtler, intellectual and emotional sensitivities, a short concentrated visit which does not tire eye or brain is essential. It is equally important that this experience can be repeated frequently. Students in London and the major provincial cities who enjoy 'free' admission to matchless collections are superbly placed to build up these skills of observation.

Close observation

At the sixth form stage, the use of activity sheets as a device for concentration is no longer available to the teacher, so the student will not have this mental 'support' or 'brake' to regulate natural enthusiasm. For the older student there is no substitute for self-discipline. Concentrated viewing means constant scanning of the same object from different viewpoints in order to extract the last piece of information from it. To impress such observation on the memory, the best practical activity is then to draw it.

15

Drawing as a learning technique

Older students should make use of drawing as a 'learning technique'. There is a rather sad idea that drawing is something we grow out of when we leave primary school. However, students of all subjects who continue the early habit of drawing as a recording technique will be in a much better position to benefit from museums as learning resources than others. (See also Section 10, page 47.)

4
Heritage education – what is it?

This is a new way of describing the educational use of historic houses, monuments, or sites. The basic method of education is the same as that which has been evolved for use in 'glass case museums': that is, seeing and understanding the physical object (or objects, or building) forms the basis of the learning experience. In the case of an historic building or site, a ready-made stage or background for numerous activities and all kinds of imaginative or dramatic work is provided. For obvious reasons heritage education focuses on history which is 'brought alive' by the use of various related arts such as music, dance, drama and visual art.

Role playing and drama

Heritage education often uses a total immersion experience, with role-playing, led perhaps by one of the Theatre in Education groups. National Trust properties form superb sites for this kind of event, but such events tend to be expensive to put on. This means that they cannot be relied on as a regular programme, happening at the same time and place each year. This irregularity might create problems for a school wishing to plan its courses and visits in advance. Other negative aspects can include superficial historicism rather than an understanding of history or art. At a practical level, role-playing can be a risk to valuable collections. But if well operated, and if children are well prepared, these events can be immensely rewarding, almost a magical experience.

It is easier, and quite often educationally more sound, to construct a project or day visit which uses some of the elements of the great public events which took place at a particular historic

16

property. For example, on a day visit limited use can be made of drama, dancing, or music, and this can be tailored to the needs of a specific class at school. Thus, instead of the entire school, or several schools, visiting the museum or historic property to take part in role-play and a reconstruction of some historic event, such as a Royal Progress and visit by Queen Elizabeth I, led by a team of professional actors, it might be educationally more profitable to arrange several visits for one class at a time, led by only one or two actor-teachers. During each visit the class would see the place and its collection, have a lesson from the Education Officer about Queen Elizabeth's visit, and could spend an hour learning sixteenth century dances, or music, under the guidance of specialists. This day would cost the organisers a fraction of the money and time of the larger event, and might well teach the children far more and in just as enjoyable a manner.

What the smaller event would not do is advertise the property to tourists, or to the wider public, but that should not be the priority of the educators, either from school or from museum education services.

Quality

Above all it is the quality of heritage or museum education which counts, not the quantity of people who attend a particular event or place. This is a hard point for education administrators or museum publicity officers, but it is for that reason all the more important that teachers and educators should keep it firmly in mind. It is the quality of the experience that provides a unique kind of education for every single visitor; the quantity of visitors should be an irrelevance to the educator.

Heritage or privilege?

The concept of 'heritage' with its overtones of the inherited wealth and privilege inevitably associated with 'stately homes' can be a dangerous trap. Among Inner City teachers, for example, it is sometimes said regretfully that 'our children' will not get much out of this or that stately home or castle. However, a place represents the way certain people live or lived and whether it is 'good' or 'bad' cannot be judged until it has been seen and studied in its proper context. Students should be allowed to make their own decisions by studying evidence and being encouraged by the school to visit the widest possible variety of places during their formal education. The imagination of the individual child plays a larger part in his or her responses than social background. Such value

17

judgements are best deduced by children themselves when they have gone through the process of sifting the evidence.

The heritage industry

In recent years, interest in heritage education has been shown by the tourist industry, now an exceedingly important part of the national income. From the point of view of the educationist there is a danger that profit and entertainment will come before information and enlightenment. There might even be a temptation to invent history and dress it up in Disneyland style. Since this trend seems inevitable, it is again up to the teacher to make a critical evaluation of the site or exhibition before assuming it would make a contribution to the curriculum. Some reconstructed historic houses or factories, or exhibitions, are of a very high standard, and it would be a mistake to rule them all out, but equally some are both expensive and spurious.

Field studies ('off site' studies)

This form of education is related to heritage education, although it is a somewhat older and more familiar term and therefore perhaps less controversial. Field studies are considered more 'serious' because usually constructed around science, geography, or mathematical projects, which may literally take place in a field, or certainly out of doors. Using a wider, modern definition of the term it is possible that a visit to a palace or stately home could also include 'field studies' rather than 'heritage education', but this is really a matter of aim and choice on the part of those organising the visit.

Multi-ethnic education in museums

In the context of multi-ethnic education, heritage and field studies alike should lead to an investigation of different ethnic heritages as an aspect of heritage education. Museums such as the British Museum, the Museum of Mankind and the Horniman Museum are the natural sources of information in London about different heritages for our pluralistic multicultural society. It is a matter of not only perceiving the ethnic diversity but also setting in an historical context the relevant social and political relationships. We all benefit from studying the diversity of ethnic heritages because each particular heritage expresses a part of the total human heritage.

'Folk Studies or 'Ethnography'?

Museum education officers and curators are conscious these days of the delicate human area in which ethnographical and anthropological collections operate. They realise that there are many hidden forms of prejudice, some of which surface in displays and give offence. For example, there is almost an unconscious code by which the same activity might be given one label when applied to white Western society and another for other races: 'folklife' seems to signal something in Britain, while 'ethnography' probably suggests Africa, or West Indian cultures. An object in a museum might be classified under 'technology' if its origins are Western, but gets labelled as 'art' or, worse, 'primitive art' if it comes from another culture. The word 'primitive' is in itself dubious, and should only be used as a description of an early stage within a recognised tradition.

Museum curators and educationists are patiently working to eradicate these bad habits, and together they share the aim of presenting the continuity of human experience in an objective, scientific manner, allowing visitors to view this information from whatever 'angle' they themselves wish.

This is the ideal, but like many ideals it is a long way from actuality. In the mean time, teachers and museum staff need to communicate each other's problems for the sake of the development of human knowledge about humanity, as well as the sensitivities of visiting students.

Problems for schools

Because museums represent historical reality in terms of *surviving* objects, they cannot display objects which have not survived. They reflect reality as it was (or is) and not as it ought to have been, and so there are sometimes objects on view of which people disapprove.

Should a museum display a racist stereotype such as a golliwog?

An example of a problem might be a nineteenth-century golliwog in a toy museum. To a teacher sensitive to the negative stereotype of black people that the Golliwog presents, prior discussion with the pupils would be essential and could be carried out in the classroom in the context of the school's policy on combating racism. In such a discussion the teacher could discuss the offensive caricature of black people presented by a golliwog, and could compare it with the caricature of a girl's face in a traditional rag doll. The belittling of women through dolls which represent

19

stereotypes of 'prettiness' and 'empty-headedness' is a parallel and much older tradition in children's toys. In this way the children or students would arrive at the museum already alerted to the hidden message which might lie behind a display.

The museum could help by modifying or changing its display: for example, by having a label that explicitly puts the case against such a toy as a golliwog as seen in our day while explaining how it would have been seen by a child of the 1880s.

Following the visit, the teacher could ensure that pupils have access to a range of positive images and artefacts reflecting black culture (for example, a visit could be arranged to the Commonwealth Institute, or the Horniman Museum).

In the case of older children, the golliwog in the toy museum could be the focus for a far-reaching, frank debate on the roots of racism in white Western society. Paintings of black slave children in eighteenth-century portraits of English aristocrats, of which there are many examples and some by very great painters, could be used in the same way to initiate a study of the evils of slavery and the campaign to eradicate it.

All these ways of using museum resources (and many more) are possible; they depend only on imagination and co-operation between museum and school staff. What we cannot do is falsify history, or take over the direction of museums from the professional staff who have the responsibility for the care and display of the collections. And, rather unfortunately, it is a fact that very few museum education officers have enough power within their museums radically to alter exhibitions. One hopes that this is gradually changing and that curators too will consult with those responsible for handling the public before final plans are made for a major display or exhibition.

5
Researching your subject

Reference libraries in museums or galleries

Obviously you will want to make a preparatory visit or visits to the museum (or art gallery) which you intend visiting with your class. You will also need a good reference library. Many museums have their own specialist reference libraries which are open to the public, or to serious students. It is advisable to phone or write in

advance to ask if they have the kind of book you require and perhaps to secure any extra help you might need from the librarian. (See Index of reference libraries page 205.)

Closer look

In addition to reference libraries and reading rooms, some museum departments will show objects which are not currently on display. This service is for serious enquirers and mature students, and not to be confused with a school 'handling collection' which is a facility that occasionally is offered to children from the museum education department.

If you wish to take advantage of this service in a big multi-subject museum such as the British Museum, write to the Keeper (or Head of the Department) of the relevant section in the museum. Ask to see specific objects and give the correct reference number from the museum's catalogue, which can either be bought from their shop, or (sometimes) borrowed from a local library.

The fact that you will not be able to secure this 'close look' service for a class of children (in the big national museums) does not mean that you should not take advantage of it yourself in your preparatory work. The depth and thoroughness of the teacher's research will have a tremendous spin-off value in subsequent work with the class.

Public lectures

All the major museums and galleries run regular public programmes of talks by curators and guest lecturers. These may fit in with your time and theme, and if so will be an enjoyable way of either brushing up on your subject or finding out about new material. The programmes will be obtainable from the publications department, and possibly from the Education Officer also. Investigate your local adult education provision as well.

Teacher in-service courses

These might prove an ideal opportunity to plan and research your proposed project (see Section 6).

Private views/lecture for teachers/sixth forms at the Royal Academy

The Royal Academy and The Times present

OLD MASTER PAINTINGS
FROM THE THYSSEN-BORNEMISZA COLLECTION

PRIVATE VIEW OF THE EXHIBITION FOR TEACHERS AND LECTURERS

FRIDAY 25 MARCH 1988

6.30 – 9.00pm
Doors open 6.30pm

Entrance: £2.50

CEZANNE: THE EARLY YEARS 1859-1872
Sponsored by The Chase Manhattan Bank

PRIVATE VIEW OF THE EXHIBITION FOR TEACHERS AND LECTURERS

FRIDAY 20 MAY 1988

6.30 – 9.00pm
Doors open 6.30pm

Entrance: £2.50

TO RESERVE A PLACE FOR THE PRIVATE VIEWS PLEASE CONTACT THE EDUCATION DEPARTMENT

CEZANNE: THE EARLY YEARS 1859-1872
Sponsored by The Chase Manhattan Bank

SIXTH FORM LECTURE

THURSDAY 26 MAY 1988

INTRODUCTION TO CEZANNE:
THE EARLY YEARS 1859-1872

2.00pm Introduction to the exhibition
3.00pm Discussion period
3.15pm Unaccompanied visit to the exhibition

Cost: £1.40 (cost of entry to exhibition)

BOOKING MUST BE MADE. BY TELEPHONE ONLY. THROUGH THE EDUCATION DEPARTMENT. 01-734 9052, ext 251/2/3

6

Teacher in-service courses in museums and galleries

Aim of museum courses for teachers

The basic aim of these courses is to train teachers to use the museum in the way most appropriate to their class or school. Courses for serving teachers are now thought of as essential provision by a good museum education service. Regretfully they are not yet regarded as equally important by LEAs, although there are many honourable exceptions. One hopes that the time will soon come when regular attendance at museum courses during term time is regarded as part of a teacher's normal commitment.

Museum courses have enormous potential, especially in London with its wealth of collections of national status. Not only can teachers obtain the direct learning experience described earlier in relation to children studying in museums, but these courses also offer contact with nationally renowned experts in their fields. In addition, there is the refreshing and revitalising experience of being surrounded by beautiful or interesting objects and perhaps a striking building and garden as well.

Programmes

The courses usually offer a programme of lectures, activities and discussions, together with time to muse and time to socialise and make valuable contacts with the museum's education staff. Lectures will probably be given by Keepers (or Curators) who in London may well be international experts in a particular field. Sometimes there is a chance not normally offered to visitors to see behind the scenes. These courses may take place after school hours, but the best are those which happen during normal working time. These provide all the experiences described in a situation free from normal pressures of work.

Audience

Some courses are offered especially to school heads, but so far, none have been run exclusively for local education officers. Perhaps

23

HISTORY
at the
TOWER OF LONDON
Autumn 1988

A NEW OPPORTUNITY FOR TEACHERS AT THE TOWER

Teachers who wish to bring junior or lower secondary pupils to the Tower as part of a study of the Normans, Castles and the Tudors, are invited to use the resources of the Education Centre to prepare their groups for work on site.

One-day workshops take place regularly through the Autumn Term to introduce teachers to the resources at the Centre, as well as the Tower, for these topics.

The Normans and the Tower
19, 26 September; 4, 20 October; 7 December

The Tower as a Castle
20, 30 September; 17 October; 1 November; 8 December

The Tower and the Tudors
21, 28 September; 13, 24 October; 9 December

P.T.O. for a note of explanation.

TEACHERS' COURSE	Whole day course for junior and secondary teachers explores life at the Tudor Court, with demonstrations of music, dance and costume. 11 October.
PRE GCSE	Armour in Evidence, as developed for younger secondary pupils, uses the Education Centre's handling collection, which includes arthentic armour as well as two complete replica suits of mail and plate, to introduce pupils to GCSE skills and concepts.
HISTORY THROUGH DRAMA	'Richard III on Trial' Designed for pre-GCSE pupils, this programme uses drama to explore the forms and reliability of historical evidence. 21 - 25 November 10.45 am
GCSE AND A LEVEL	The Tower and the Royal Armouries offer a wide range of learning resources and experiences suited to GCSE and A level history. The Education Centre is always ready to work with teachers to develop tailor-made programmes, pieces of course work, site investigation exercises and materials for use at the Tower or in school. Recent evidence-based programmes of this kind include Exploring a Castle, Artefacts as Evidence, Medieval Women, The Norman Conquest, Chaucer's England, Tudor Propaganda, Henry VIII and Sir Thomas More, Elizabethan Catholics and Early Firearms.
SPECIAL A LEVEL PROGRAMMES	Day courses for A level history sixth formers combining students from several schools or colleges in studying primary evidence, and in debate and role play: The Wars of the Roses and Henry VII. 30 November, 1, 6 December.
PUBLIC LECTURE COURSES	Forthcoming Saturday courses feature The Glorious Revolution (5 November) Richard III and the Early Tudors (12 November, for the Historical Association), Chivalry in the Renaissance (3 December).

For further details of these programmes or to discuss particular requirements, please contact the Education Centre, Waterloo Barracks, H.M. Tower of London EC3N 4AB
(01-480 6358 ext. 332).

some should be, because in this way museums would underline and make the point to the upper hierarchy that museums are essentially working tools for the educator and not just places for an outing.

Finding out about museum in-service courses

Because these courses vary in time and conditions, the best way to be informed is to ask to be put on an individual museum's mailing list. Write to enquire about this possibility from the museum education officer.

> This, then, I believe to be the museum's greatest value to the child, irrespective of what a museum's content may be: to stimulate his imagination, to arouse his curiosity so that he wishes to penetrate ever more deeply the meaning of what he is exposed to in the museum, to give him a chance to admire in his own good time things which are beyond his ken, and, most important of all, to give him a feeling of awe for the wonders of the world. Because a world that is not full of wonders is one hardly worth the effort of growing up in.
>
> Bruno Bettelheim (1980) 'Children, Curiosities and Museums'. *Children Today.*

7

Planning a school's museum project

'Project' in this context means the entire exercise:

1 Preparatory work at school/college.
2 The visit to the museum/gallery and work done by the students there.
3 Follow-up work at school/college.

The project can be varied and extended depending on circumstances, but its essence is that the visit to the museum should be integrated into normal school work as the filling of a kind of

sandwich. This certainly does not mean that the pleasure of an outing should be denied, but rather that its wider significance should be made clear to all participants. The museum staff too would like to have a full understanding of your total plan.

Preparatory work

Time for preparation (lessons and reading) is essential. If students are insufficiently prepared, the museum time is misused because the museum teacher will have to use it to give basic information which could have been learnt in advance. For example, a senior group studying the Italian collection at the National Gallery should be clear in their minds about the importance of the Renaissance, or how it related to, or is different from, the Reformation. Members of a class must understand why they are visiting a museum or gallery; what they will see which is not available elsewhere; and the position of the gallery work in their current class work.

Having said that, it is also important not to over-prepare — surprise and discovery are essential ingredients for the museum visit, no matter what the age of the students. Your preparation needs to point them in the right direction, but not to do their work for them.

Discussion about future follow-up work

As students will be expected to use their discoveries from the museum visit in their follow-up work, it is important to discuss these plans in advance of the visit. What they are aiming to produce? Who will do the research and who will execute the plans? If the idea is to produce, say, a tape recording, who will do that? Should there be a practice session? Each role does not have to be determined beforehand, but ideas need to be raised, and expectations, *especially those of the teacher*, need to be understood and accepted. This is particularly important when the project is to prepare work that will be assessed for the General Certificate of Secondary Education (GCSE); for example, English (oral or written), drama, or history.

Practical instructions: dates, times, venue and so on

For older students, these can be dealt with by a circular letter. For younger ones, a thorough discussion will also be needed to clarify problems, and to reassure any anxieties.

Diagram 2 Planning a school museum project

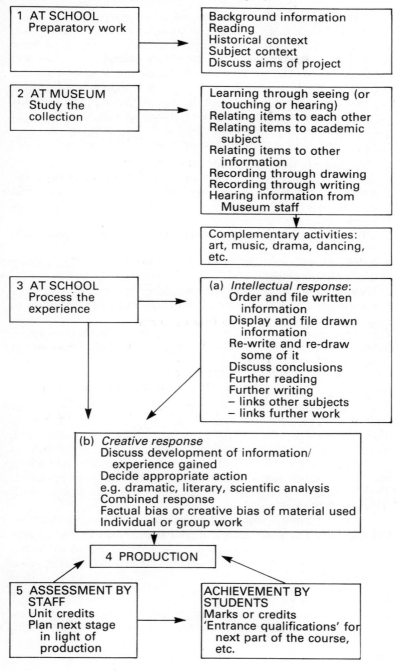

1 AT SCHOOL
Preparatory work

→

Background information
Reading
Historical context
Subject context
Discuss aims of project

2 AT MUSEUM
Study the
collection

→

Learning through seeing (or
 touching or hearing)
Relating items to each other
Relating items to academic
 subject
Relating items to other
 information
Recording through drawing
Recording through writing
Hearing information from
 Museum staff

Complementary activities:
art, music, drama, dancing,
etc.

3 AT SCHOOL
Process the
experience

→

(a) *Intellectual response*:
 Order and file written
 information
 Display and file drawn
 information
 Re-write and re-draw
 some of it
 Discuss conclusions
 Further reading
 Further writing
 – links other subjects
 – links further work

(b) *Creative response*
 Discuss development of information/
 experience gained
 Decide appropriate action
 e.g. dramatic, literary, scientific analysis
 Combined response
 Factual bias or creative bias of material used
 Individual or group work

4 PRODUCTION

5 ASSESSMENT BY
STAFF
Unit credits
Plan next stage
 in light of
 production

ACHIEVEMENT BY
STUDENTS
Marks or credits
'Entrance qualifications' for
 next part of the course,
 etc.

Museum projects for

(a) Infants (children between five and seven years)

Young children can gain enormous stimulus from a museum visit, provided that it is short and simple and that the visit is planned to be the star of the event. At five or six everything is new and exciting – a first trip on a bus or tube train might make a greater impression on the infant mind than the first sight of an Egyptian Mummy! So make sure that both the travelling and the work inside the museum are integrated to ensure maximum educational benefit from your museum project for impressionable young minds.

There should be a ratio of five (or fewer) children to one adult.

Basic guidelines for infants are:
1 Check that children of that age will be welcomed at the museum.
2 Arrange a short (5 minutes) personal welcome from education staff if possible. Personal contacts make all the difference for young children.
3 Ensure that there is only a short distance to travel, preferably on foot.
4 Emphasise direct visual experience; limit teaching and talking to 5 minutes or so.
5 Provide plenty of plain paper, pencils, or crayons.
6 Encourage a liberal amount of drawings and other responses to take back to school.
7 End the visit after one hour, or less, depending on their response.
8 Start the follow-up work at school the same day, or as soon as possible after the visit.

(b) Juniors (seven–11 years)

This is the best age for museum projects, particularly for upper juniors of 9–10. Not only is it a highly receptive stage, but many of the practical problems of the extremely young have disappeared. Nevertheless do not over-tax juniors because they are so enthusiastic. They are still juniors and there are many museum visits which they would appreciate and understand more when they are older. These should be saved up for the more complicated or difficult stages of their development.

Part of the trouble with teaching secondary children is that they feel they have seen everything and done it all before. In the museum education context, this is often because they have had too many superficial encounters with museum collections during their primary years.

Basic guidelines for juniors are:
1 Plan the entire project with them, but do not over-prepare them.
2 Keep a ratio of 20 children (or fewer if possible) to each adult,

supervisor, or teacher. Involve as many parents and other adults as you can; small groups with an adult can spread through the gallery and still be supervised.

3 Talking to children at the museum should be limited to 20 or 30 minutes.

4 Give clear instructions about worksheets just before they are due to be used.

5 Make sure that groups are small and well spread out through the gallery.

6 Provide varied activities (such as art or music) depending on circumstances, if it is a day visit.

7 Allow a full hour for the lunch break and give a chance to run about outside.

8 Allow time to buy postcards and take a *little* look at things which catch their attention but are not included in the project.

9 Start follow-up work at school within the same week, or, better still, on the same day.

(c) The early secondary years (12–14 years)

The same method of educational work applies to lower secondary as for junior children, except that the intellectual content and level needs to be appropriately up-graded. The big problem however is that the secondary school timetable militates against this type of work and can make the organisation of such projects extremely difficult. Young adolescents still need this integrated subject approach, familiar to them from their primary school. It can be a valuable way of providing them with stability at a time when they are having to cope with so many other changes in their new secondary school environment.

(d) The GCSE Years

Integrated Timetable: initiated by Head and Heads of Department
It is well worth the effort to organise such co-ordinated projects, involving (perhaps) the whole year intake, and all the relevant subject teachers. The museum project should be planned and integrated into the main timetable so that all staff have time to work out their individual contributions, and so that the problems created by one (or some) staff wishing to be away from school, or borrow someone else's class, who then miss geography or maths will be obviated. The project might be the aim of a term's studies, with appropriate marks and credits attached. If possible it should be initiated by the Head, or Heads of Departments working together, and not left to individual enthusiasts lower in the hierarchy, who then have the burden of persuading less enthusiastic colleagues to

29

do them a favour. Advance timetabling allows essential bookings to be made for transport and also for lessons or specially arranged programmes at the museums to be visited.

Improving Secondary Schools by Using Museum Resources
A cross-curricular approach, with short 'modules' (parts of courses) and complete courses, providing short-term aims and goals within the larger school year, is very much in tune with current initiatives to improve the quality and standard of education especially in Inner City secondary schools. The new GCSE curriculum will need this kind of approach to learning resources in museums and galleries.

General Certificate of Secondary Education
GCSE, which includes academic and 'project work', is now compulsory for all children. Methods must be evolved to enable these intentions to be fulfilled. From 20%–100% of the final marks are allocated to the coursework, which makes these projects extremely important. Autonomous methods described in this book will be essential to every candidate and in many subjects, not just those thought of as 'practical'. Not every GCSE course will make use of a museum or gallery, but surely many will do so, for example, as part of courses in art, technology, English, drama, science and history.

Autonomous Learning for Secondary Pupils
Assuming students take the public exam between ages 14 and 16, it is crucial that independent methods of study are developed in the years from 11 to 14, as well. Mini-museum or gallery courses could be devised and fitted into the normal curriculum from the first year onwards. They should be simple and short, and should gain marks, so that the principle of being marked for coursework is well understood by the time of the public examination at ages 15 or 16.

Local Museum or Gallery
To begin with the purpose will be to train the students in such basic skills as: finding their own way; using public transport; reporting in to the museum or gallery; reporting back to the school at times requested; working alone or with a small group; self-assessment. Hence it is best to start by using the closest museum.

Safety
Naturally, the safety of pupils working out of school, with only partial supervision, will create a special problem. There can be no universal rule except that the safety of each child must be paramount, and schools are, of course, *in loco parentis*.

30

NATIONAL ARMY MUSEUM

EDUCATION DEPARTMENT

GCSE STUDY SESSIONS

During the Spring and Summer terms we plan to launch GCSE study sessions relating to soldiers in the SECOND WORLD WAR, along the lines of the existing sessions for the First World War.

Material which may be examined will include uniform, weapons, and original documents and artefacts concerned with the lives of British soldiers.

If you would like to be kept informed about the development of GCSE study sessions, please tear off the slip and return to the:

> Education Department
> National Army Museum
> Royal Hospital Road
> London
> SW3 4HT

--

Please send me further information when available about GCSE study sessions on the Second World War.

I would also be interested to know if the National Army Museum could arrange GCSE study sessions on ..

Name ..

School ..

School Address ...

...

...

Mobility and Self-Reliance for Secondary Pupils
Having weighed the risks and solved them according to each school's decision, in co-operation with parents, there is no other way in which investigative learning can be carried out. GCSE implies a quiet revolution in the secondary sector and has to be effected without further imposition on teachers. They, in turn, will need to avoid the 'spoon feeding' that so quickly kills off enthusiasm, or creates defiance and, worse, truancy. (Thinking of truancy, it might be useful to remember that Inner City truants have been using public libraries and museums, unprompted, for years!)

*Starting a Project: The Library**
A detailed plan should be made and factual research done by the students in the school library, preferably with assistance from the school librarian; and then in the public library if necessary. Only after that, and after some time spent in background reading, should the museum or gallery be considered by the students.

Letter to a Museum or Gallery Education Officer
The students will need help with this letter. It should give details (from the museum's published catalogue, if there is one) of the objects they hope to see; the reasons why they wish to see these; some information about their course; practical details about time and date of their proposed visit; a little information about their level of work; and, finally, a request for advice or help from the museum. It should be written in time to allow at least two or more weeks for a reply.

Unfortunately it has to be said that it is a universal experience for all museum or gallery education officers to receive letters from eager pupils which break all of those rules. The type of letter which starts, 'I am doing a project on . . . Please can you send me all information on the subject', is no exaggeration. These letters are sadly self-defeating and can only receive a dampening reply.

Perhaps it would be possible, before launching children on to their 'project', to devote a lesson to writing the project letter? It would help to eliminate these false starts before exposing the pupil to the unsympathetic reaction of an outsider.

Small Art Galleries (See Section 3)
Many of these run practical workshops linked to an exhibition. These, if close at hand, will be good places to use for 12- to 14-year-olds. In them it is possible to alternate between small group work or whole class participation which will be partly or entirely

* For more detailed advice, see Linda Cheetham, *The Innocent Researcher and the Museum*, Museum Ethnographers' Group, Occasional Paper No. 3.

supervised and will have the advantages of learning how to work with strangers, but within reach of school. Although these places are obviously useful for those doing art and design courses, other subjects (history, languages, environmental studies) and so on might also make use of them.

Self-assessment
Self-assessment and self-recording techniques need to be built into these projects by the teacher. These will train the student to be aware, among other things, of the value of his or her own time.

(e) Museum projects for Sixth Forms (see also Section 3)

Non-academic Sixth Forms (16–18 years)
Provided that these students have been trained in the methods of museum education and can use a visit to a museum properly, museum resources provide an ideal way of allowing students to work at their own pace, individually or in small groups. At the same time they learn to assess their work, and do so in an adult situation which helps them to behave maturely and to relate to the world outside.

Many museum Education Officers will be willing to provide special demonstration sessions, or illustrated talks for these groups, which could be additional to students' own work in the galleries. Stools are often available for sketching if the education service has been contacted in advance.

Academic Sixth Forms
These students are usually well provided for in museums by Sixth Form Study Days, related if possible to A-level Studies. Individual museum departments send out information about these study days and welcome requests by individual teachers to be added to the mailing list.

Other smaller museums would be willing and able to provide such courses. There will be public lectures and other programmes put on by the education department, such as film shows, which might fit into the A-level syllabus in question, and to which individuals or groups of sixth-form students could be directed.

Advance Discussion with Museum Education Officer
As with all school-museum projects, it is worth going to see the museum Education Officer well before you start any action, to discuss your needs, to find out if they are already being catered for, and if not to ask if the museum will arrange something special for you. Nine times out of ten museum staff are only too delighted to be asked to arrange some special educational event, and this is

33

especially the case if it is likely to supply similar needs for a large number of schools, or if it related to other educational work being run by, for example, the BBC, or is related to an A-level, or other published examination syllabus.

(f) Museum projects for classes with Special Needs

Range of Special Needs
These might be slow learning, hearing or vision deficiencies, physical handicaps, emotional problems, or serious illness as in the case of children attending hospital schools. Unfortunately, many children suffer from multiple handicaps and a museum officer needs to know in advance exactly what these are in order to be able to cater for the group.

Because of the fact that a small group can often be taken by a museum education department, if arrangements are made in advance, many of these special problems can be unobtrusively and creatively dealt with. A sympathetic officer (or museum teacher) can arrange a project tailored in the last detail to the needs of the group, by collaborating closely with the regular teacher, and will be able to give individual attention that can seldom be spared at a school.

Advance Visit by the Teacher
If this is important with a normal school visit, it is absolutely essential where there are special needs. Only the teacher (and helpers) can really foresee what will be required – such as ramps for wheelchairs, special toilets and so forth – and only the teacher can judge what will benefit individual pupils, and can give the detailed briefing which the museum staff, teachers and attendants, will need.

Special Project
The museum officer will undoubtedly give students special treatment where possible. This might include handling objects, or giving permission to touch sculpture for those with visual handicaps, or some other exceptional concession like setting off machinery, chiming clocks and similar experiences. (See also Section 12, 'Handling Collections', pages 59–60.)

But it remains the responsibility of the class teacher to make sure that these sensory educational experiences are linked in with class work and intellectual development, in such a way as to demand a response from the class which is more than just enjoyment of a good visit. Many 'special' children are also highly intelligent. Perhaps even more than normal children, they will need to acquire every possible skill and accomplishment at school in order to survive after school.

Problems

Children or young adults with severe behavioural disturbance will obviously be regarded as a risk by museum officers, who must have a prior responsibility towards the safety of their collections. Such pupils might nonetheless be taken to museums in some circumstances, perhaps on a one-to-one basis, or to collections which are virtually unbreakable like those housed in a Transport Museum. But the sympathy and support of museum staff, especially the attendants, must be negotiated well in advance.

At least one such visit of highly disturbed and 'abusive' young people, completely harmless as they were confined to wheelchairs, almost came to grief because the attendants became extremely protective towards 'their' museum teacher in the absence (as they saw it) of proper restraint from the class teachers.

Duration of Visit

Probably this should always be shorter than for ordinary classes. Extra time for resting, before and after travelling, should be allowed for in the timetable.

Travel and Location

If a minibus or LEA bus is not available, and if the students are mobile, the nearest local museum should be the first to be visited. Absence of crowds and personal attention must be a major consideration rather than making visits to famous, well-known places. But if the famous places are your target, try to arrange a visit at a time most likely to be unpopular with the general visitor. The Education Officer will advise on this and, in the big national museums, might also have helpful suggestions about the less visited parts of the collection, which may well still contain 'famous' and very stimulating material.

Follow-up Work

The same criteria apply as do for any other class (see pages 36–40). It may also be possible to secure a follow-up visit from one of the museum teachers, which will add focus and significance to the event for the students and, no doubt, be extremely valuable to the museum staff who will be able to judge the needs and abilities of other special groups more easily in the future.

Taking advice from the HMI *Survey** of 1987, teachers at special schools should be just as demanding that their pupils are 'stretched'

* DES: Report by HM Inspectors:
 A survey of the use some pupils and students with Special Educational Needs make of Museums and Historic Buildings, 1987.
 INS 56/12/0196/4/88/NS2/87

intellectually by the museum experience in exactly the same way as teachers of other students, although it is easy to understand how the mere achievement of a happy and successful outing would seem at the time to be almost more important.

8
Follow-up work at school or college

It is taken for granted that some kind of intellectual follow-up to the museum visit will be required back at school. This means, at the lowest level, organising and making intelligible files of notes taken on the visit, and perhaps an occasional retrospective essay. But it is advisable not to kill children's enthusiasm by making them produce a homework essay entitled 'My visit to the Natural History Museum'. Whatever they write or do should be clearly structured and related to their current studies.

The purpose of follow-up work is twofold:
1 to reinforce and record the many experiences of the visit;
2 to create new links between the material seen at the museum and various aspects of study (or subject) at school.

The second aspect should enshrine the ultimate aim of the entire course and should have been decided on, preferably by discussion with the class, before the project started. The follow-up work should aim to allow the students to display and test what they have discovered and to show that they understand its significance within the context of their wider programme of studies, and through their product to communicate their enjoyment and experience with a wider audience.

Any of the following could be produced as part of coursework, or to entertain others both within and outside the school.
1 Dramatic performance, scripted or improvised by the class.
2 Dance performance possibly re-using dance steps shown during their visit to the museum. (This approach could be used in an historical exercise and/or in a multi-ethnic study.)
3 Musical performance.
4 Lectures and debates by class or classes.
5 Art/Crafts/Photographic exhibitions in the classroom, in other parts of the school, or even to be loaned to other institutions.
6 'Publishing' a book or books.

7 Production of a radio programme or a video tape, either to record some of the above; or as a record of the visit to the museum (or site); or as an entirely creative exercise using the museum and studies as a stimulus.
9 Computer quiz programme (or other computer project).

Follow-up visit from museum staff

This is always desirable if the museum can spare the staff. Unfortunately museums rarely can, but for those who are able to do this, their own work benefits enormously as they are able to judge whether or not their material is pitched at the right level, how the children reacted to the collection, and how much of the lectures or explanatory talks were recalled, and also how the material fitted in with work in the curriculum.

Some museum education staff also enjoy being invited to a school just for a brief ceremonial visit. This may be very undemanding of their time and attention, but extremely productive in helping to build up good relationships.

Discipline on museum visits

Discipline should not be a problem. The novelty of new surroundings, new faces and places, often cure behaviour problems.

For beginners, however, here are a few simple suggestions:
1 Make a meticulous plan and be sure that difficult children are thoroughly involved in its formulation.
2 Try not to use the visit as a threat; threats are often too close to challenges in the mind of a child. ('If you do that you will not be allowed to come to the museum.')
3 Emphasise the importance of pleasant behaviour, especially in the presence of strangers, and reward it by suitable signs of approval.
4 Offer rewards *after* the museum visit for good behaviour observed or reported while at the museum.
5 Make sure everyone in the class knows exactly where they are going and the names (if possible) of people they will meet.
6 Stay with your class at all times, and take part in the proceedings.
7 Keep the numbers small. The major reason for persistent troublesome behaviour is usually the desire to attract attention, and this becomes unnecessary if a student is one of five rather than one of 35.
8 A letter of apology is good policy for the school, and good practice for the student, if there has been a really serious incident.

Examples of thank you letters

LONDON BOROUGH OF BARNET
DIOCESE OF LONDON

ST. MARY'S C.E. PRIMARY SCHOOL
REGENTS PARK ROAD
FINCHLEY, LONDON, N31DH

Headteacher
Mrs Sheila Lumsden
01-346 0482

20 th. March, 1984.

Dear Miss Adams,

I am writing to thank you for making our day at Elmwood so worthwhile. The children thoroughly enjoyed the visit and I believe you have whetted their appetites for further visits. I think the slides and your talk helped them absorb a little of the eighteenth century atmosphere. I have been trying to plan it until. I look forward to further visits.

Yours sincerely,
Pamela Dawson

Foxdene Primary School
Victoria way,
Charlton,
London S.E.7.
June 10th 1985.

Dear Miss Adams,

Thank-you for taking us to listen to the beautiful Harpsicord music. Also thank-you for taking us around the Ranger's house and to see the beautiful instrument. The puzzles and the drawings were really good and the paintings were wonderful. The best part out of all was when Lee Handly was dressed up and I thought that he looked like the boy in the painting but my second choice was when you played that beautiful Harpsicord and once again thank- you very very much for taking us around the Ranger's House.

Yours sincerely Harjit Kaur
Dhillon.

THANKYOU

from PLUMCROFT JUNIOR SCHOOL SE18

36, Ashmage Cres. SE18 3EB.
20·1·83.

Dear Miss Adams,

I thought this notepaper happened to be appropriate because William, 1st Earl of Marshall, was born at Sarre in 1705.

Thank you for giving us such a wonderful day. We look forward to re-creating Dr Merlin's magic with a cure effect in the centre of our school hall as soon as we can hire the three costumes.

Please give me plenty of advance warning of any similar historical experiences on offer. I will be delighted to appear work in the Tudors with some musical preparation at school.

As preparation for our Kenwood visit all the children had worked with friends at musical improvisation for a Georgian celebration. The inspiration for that had been an extract from Stravinsky's firework music.

Briset School
Briset Road
Eltham SE9.
7th October 1985

Miss Adams,

Dear Miss Adams,

Thankyou for the day
Out It was good. The best parts were when we went upstairs and drew pictures of instruments. And when Scott James dressed up in a suit.

from
Shaun Holland.

Accidentally touching exhibits

Many pictures are wired in to the security system; a firm advance explanation to the class is less embarrassing than an apology to officials if the electronic alarm is set off accidentally. This may seem petty, or obvious, but it is only too easy for excited pupils to point to an important 'discovery' in a painting, and then the damage might be done.

Thank you letters

At the least, if a follow-up visit from the museum staff is not possible, it will be easy to arrange thank you letters from the children. The museum education staff will appreciate these as they would any other kind of feedback. (See examples on pages 38–39.)

Other feedback from a school could include tactfully phrased criticism, especially if written in such a way that it could become useful 'ammunition' for a small but ambitious museum education department which needs to prove that customers require some improvement before the department is granted money or additional resources.

9
Designing your own activity sheets for a museum project

Purpose

Worksheets – or 'activity sheets' – are indispensable. In spite of their obvious educational disadvantages, they remain the most practical aid for a visit for most schools. Museum education departments usually provide their own, but you may wish to design a set which is specially aimed at your own class (or school).

Worksheets should build upon and not obliterate the universal spirit of curiosity and wonder in a child. They should elicit original responses and not impose stereotyped concepts, visual or otherwise. They should act as a bridge and not a barrier between the object (collection) and the mind of the child. Worksheets should

be self-explanatory and allow the pupils complete autonomy in their answering.

Worksheets should fulfil the purpose of a notebook for older students – that is, a place for individual records and observations. But, unlike a notebook, the worksheet incorporates the teacher's guidance by selecting the objects to be studied and directing the pace of the work (usually by acting as a device to slow it down).

A well-designed worksheet helps the pupil to look longer, think harder, gain greater enjoyment and thus remember the experience of a museum visit for longer. Worksheets can and should be 'answered' as much by drawings as by writing. Drawing an object, however badly, stimulates the powers of observation in a unique way. It is a crucial part of the museum learning experience.

Subsequent work at school will reinforce further intellectual links and deductions, using the completed worksheet as evidence of the pupil's unique learning experience. Completed worksheets should be carefully stored and used as the basis of all follow-up work at school.

Worksheets provide specific choices within a general 'programme', allowing individuals to work at their own pace but keeping within a framework that is being followed by the whole group.

Points to avoid

Worksheets are not tests. Do not give the children the uneasy feeling that the visit to the museum is a 'test' of previous lessons.

Worksheets are not the same as *fact sheets*. These are purely to provide supplementary information. On a museum visit, fact sheets should be inessential, with the possible exception of technical or scientific collections. Your worksheets should be constructed to enable pupils to find necessary information from the existing museum labels. It should not be necessary to cope with more reading material at that stage.

Seen but not heard

Finally, and most important, the worksheet can almost replace the voice of the teacher. The worksheet will 'speak' for you. Do not explain what should be self-explanatory. If speech is unavoidable, keep it as short and quiet as possible. The other visitors will then see quiet, purposeful children, shepherded by a confident, efficient teacher.

41

Points to consider before starting to design the worksheets

1 Use a size of paper (such as A4) which you know will fit on the clipboards usually provided by museum education departments.

2 Have the worksheets typed and letrasetted. Badly printed sheets take just as long to produce as good ones and do not justify the money spent on them.

3 A long print run will be necessary to justify the cost of proper Instant Printing. These will then form part of the school stock for some time, therefore they should not be based on temporary museum/gallery exhibitions.

4 Questions should be brief. Adjust the language to the age-group addressed, but do not talk down to the children. A few hard or unfamiliar words are part of the fun so long as they are not too numerous.

5 The questions on one sheet should not send the children all over the gallery to find the answers. Each sheet should deal with *one* section of *one* display, in *one* display gallery (i.e. one room).

6 Avoid 'impossible' questions such as 'How many knobs can you see on the plaster ceiling?'

7 Use open-ended questions to elicit children's considered opinions when appropriate, e.g. 'Why might this picture frighten some people?'

8 Build on the 'detective within' – provide 'clues' to lead pupils to the answer or answers, but damp down the kind of competitiveness that leads to a 'race' and produces hasty work or poorly-observed drawings.

9 Resist the temptation to add reams of subsidiary information. Make pupils show you how clever they are by asking questions which make them use *their* eyes and *their* brains.

10 Drawing is gathering *visual information*. The standard of the drawing is not important. The time it took to produce is. That time was spent in observation.

11 Make sure children read at least part of the relevant museum labels, but do not encourage wholesale copying of labels.

12 Ideally, avoid using lazy or ugly visual 'props', such as:
Half completed drawings to fill in;
dotted lines to be joined;
little boxes to draw in;
stereotyped shapes or designs, e.g. hearts, or pin men.

Most children will make an effort at original drawing once they understand that it is the process of observing by them that counts, and not the finished product.

13 Be sparing in your use of professional artists' illustrations. They

42

greatly increase the cost of production, and might discourage timid children who compare their own 'bad' drawings with adult work.

14 Provide plenty of space for drawings and lines for written answers.

15 Avoid 'tick' or 'cross' answers except as a light-hearted game after the real work of observation and individual recording has been done. The same applies to 'colouring in' given pictures, or any other similar 'ready-made' approaches.

Action 1: planning the contents of the worksheets

Visit the museum or art gallery on your own. Reconnoitre the territory. Make priority lists of objects to be seen and firmly leave out the non-essential. Put yourself in the position of children in your class and try to choose some things which you know will attract them, as well as those which are important from the teachers' viewpoint. Make a diagram of the route followed in the museum by your scheme or 'trail'. Work out the time and the route you wish the children to follow. Allow enough time for each drawing or written answer. Write out questions in rough, check factual information from the museum labels. Make use of the museum education department's printed or other advice services.

Important!
Before you leave the museum make sure that the display will be there on the date you intend to visit it. This applies to long-term permanent shows as well as to temporary exhibitions, because museum displays are constantly being renewed, or removed for conservation, or loaned to other museums.

Action 2: deciding on format and making rough designs

Having decided on the theme and content of your scheme, in relation to your work in the classroom, decide which format you can afford to use. Broadly speaking, there are two types of worksheets:

(a) *Inclusive format*: i.e. questions, drawings, written answers all on one sheet (see page 45).
(b) *Exclusive format*: i.e. questions and instructions only, the answers and/or drawings to be carried out on separate blank or lined paper (see page 46).

The 'Inclusive' method requires a reasonable standard of design and is relatively expensive to produce. If you are not up to it, you might get help from other members of staff. The great advantage

of this method is that all the questions and answers are on one page, but this can make for a repetitive classroom display.

The 'Exclusive' method is cheaper and easier to produce, but it seems more like a test paper, and involves the pupils in the need to annotate each separate drawing, and put name, date and so on on each answer. The results will be less handy and compact but, because of the lack of uniformity, will produce a more interesting classroom display in the end.

Action 3: production and printing

Produce rough designs of your own lay-out in pencil. The 'copy' (words and questions) should be typed and proof-read. If you are able to obtain help from the education staff at the museum at this point, you will find it invaluable. They know the collection in the way an outsider cannot do.

A 'dummy run' using one or two children as guinea pigs would also produce a better final product. If you can do this, you will find out from children which questions are too hard, or too boring, and how long each task takes, and whether the museum displays provide the clues which you assumed they would.

Paste-ups for the printer are the next stage. If your school has people responsible for resources, you thankfully hand your material over at this point, and they will do the rest apart from the final proof-reading which it is important that you do yourself. In the absence of help in the school, consult your nearest Teachers' Centres for technical assistance.

Warning

Remember that worksheets in museums are ephemeral. As soon as the display in the museum changes, your worksheet becomes redundant; do not over-produce, therefore, in the belief that the job once done will never need re-doing.

Using paintings in art galleries as study material for worksheets

Many subject specialists can use paintings as part of the theme of their work. You may or may not be thinking of the paintings as 'works of art'. For example, a visit to the National Portrait Gallery might well have more to do with history than portraiture or art. Similarly, a visit to the art collection at the Imperial War Museum might not be specially to study war or weapons.

When you compose your worksheets for an art gallery visit, limit

Worksheet: example of 'inclusive' method

Gallery

JACOBEAN COSTUME
Find Edward Sackville, 4th Earl of Dorset(1590 - 1652). Unlike his
brother the 3rd Earl(portrait No. 3) he was admired by all who knew
him for his great learning and good manners. He became Earl in
1624.
What is he wearing in his ear?.................................
Draw his face - and his ear - and also his starched lace collar.

Draw his hat

Ranger's House, Blackheath

Worksheet: example of 'exclusive' method (answers on separate sheet)
NB: At the time this worksheet was produced Kenwood, The Iveagh Bequest was administered by GLC Historic Houses.

CLUES
"CHILDREN IN PAINTINGS"
Kenwood, The Iveagh Bequest

1. 'Mary had a little lamb' - and so do I. I also have a bunch of lily of the valley in my cap.
2. Although I carry a little stick I am very frightened of that large bouncing dog which is much bigger than I am.
3. My donkey is a bit lazy - he almost has to be dragged up the hill.
4. I am eating a bunch of white grapes too.
5. They have stolen my arrows and broken my bow, and tied me to a tree.
6. Up above your head so high
Round and round and round we fly —
Crowning a lady with a garland.
7. My job is to watch over our two carthorses eating their oats. I hold a long horse whip, but I don't use it.
8. We are having a lovely time dressing our kitten by candlelight. Poor little creature!
9. I am dressed in rags and so tired and hungry that I cannot stay awake on the way to the market.
10. I am the Light of the World.
11. I am going for a walk in the Piazza in Rome, with my mother and my aunt. My mother holds my hand.
12. I lean against my mother's knee while she is holding our baby wrapped in a warm red shawl.
13. We are at a picnic, drinking wine with the grown-ups, dressed in satins and silks - and speaking French.
14. We are carved from stone. We watch people gathering flowers.
15. My sash is blue to match the bow in my cap. I have a little grey and white kitten asleep on my lap.
16. That bad boy is allowing his dog to attack mine, I am terrified that he will kill the poor creature.
17. I am dancing and holding flowers in the lap of my muslin dress.
18. I carry pink flowers for Her Royal Highness. I wear a suit of red velvet. This is my employment, but she pays me nothing.
19. I have a short scarlet coat and a frilled shirt. Oh what a clever boy am I!
20. What's the joke? I can't stop laughing!
21. I hold a little dog in my arms. I have a sad face and a dark dress and I am very small.
22. I have a feathered hat and red ribbon rosettes on my brown breeches. I am with my sisters and parents and our dog. We are on holiday - in Rome.
23. Oh Dear, I can't do my sums!
I think I'm going to cry!
24. My sister wears a large hat and I wear a scarlet suit with buckled shoes. Our puppy does not like keeping still for this painting, so we are holding him.
25. I will be the 4th Earl when I grow up. But now I am about eight and dressed in pink satin. I lean on my mother's shoulder.
26. I have four lambs - rather charming though babyish considering I am almost grown up.
27. My portrait was painted with my favourite youngest aunt. We are both wearing white, with blue sashes. I have a broad brimmed hat but she has none.
28. Good Heavens! What next! We three are running around with no clothes on carrying grapes, wheat and apples.
29. We two brothers are enjoying a brisk gallop with our dogs.

John Jacob, Curator,
GLC Historic Houses

Gene Adams,
ILEA Museum Adviser

46

your requests so that the pupils' attention is focused on to a specific part of the painting.

Examples of questions about paintings	*Academic Subject*
* What actions are being carried out by the people in the painting? Select and draw *one* person. (Leave room for both written and drawn answers.)	(History)
* Draw *part* of the embroidered pattern on the dress of the woman in the centre of the painting.	(Costume)
* Draw the arm of the man holding the pitch fork.	(Art)
* List the musical instruments in this painting. Compose a tune that one might be playing.	(Music-Theory)
* Write a poem using the same title as this painting. Express the same ideas (or similar) to those you imagine the artist is conveying.	(English)
* Describe how this painting illustrates typical weather in the Highlands. Illustrate with a sketch from the relevant part of the painting.	(Geography or Maritime Studies)

10
Drawing in museums – a learning technique

Those of us who say 'I wish I could draw' always forget that once upon a time they could draw and did draw – unselfconsciously and with pleasure if not always very well. All children indeed enjoy drawing. They find it more fun than writing and the quickest way they have of getting the message across. (No wonder so many artists from Goethe to Picasso have written enviously of that innocent eye.) It can, however, be fugitive talent, dying early of neglect or killed off by competing interests and educational pressures. . . .

Sir Hugh Casson (1987) Introduction to *Drawings, Stephen Wiltshire*. London: Dent.

Worksheet: example

Queen Mary II(1662 - 94) was the wife of William III of Orange.
They were invited to be King and Queen of England when her father
King James II was deposed.

Find Queen Mary II. Draw the building in the background behind
the portrait.

Ranger's House,Blackheath

Worksheet: avoid using dotted lines where possible

Find the picture

Who is this lady? _____

Finish the drawing by looking at the painting, and colour it.

50

Worksheet: example of 'boxes' (to be avoided if possible)

THIS MAN

SAT ON THIS:

USED THIS FOR WRITING:

LIT THIS:

DRANK FROM THIS

HE MAY HAVE SEEN THESE FAMOUS PEOPLE:

who

and _____ who

AND HEARD OF THIS NEW INVENTION:

This was completed at
the GEFFRYE MUSEUM by:

Worksheet: example of a paper doll in a dress derived from a famous painting at Ranger's house.

Ranger's House, Blackheath

Worksheet: example with an artist's drawing

MUSIC ROOM

Here is an early 19th Century lady playing the harp. Draw other people of
the time listening to her music, or singing, or playing another instrument like
a recorder or a violin.

Kenwood Worksheets

Worksheet: example from the Science Museum

Introducing Nuclear Physics

This worksheet uses some of the demonstration experiments in Section 1 of the Nuclear Physics & Power Gallery. You may tackle the experiments in any order.

1
Find the experiment called 'Properties of Alpha, Beta and Gamma Radiation'.

Find what the five push-buttons do and then take readings to complete these tables:

A: Using Beta source, with red pointer at 10cm from detector:

FILTER	COUNT RATE
None (Air)	_____ cts/sec
Aluminium	_____ cts/sec
Lead	_____cts/sec

B: Using Gamma source, with red pointer at 10 cm from detector:

FILTER	COUNT RATE
None (Air)	_____ cts/sec
Aluminium	_____ cts/sec
Lead	_____cts/sec

C: Thickness of filters (estimate): about _____ millimetres.

Complete these sentences:

In this experiment _____ mm of aluminium stopped about _____ percent of

the beta radiation, but only about _____percent of the gamma radiation.

_____ mm of lead stopped about _____ percent of the gamma radiation.

Educational uses of drawing

The importance of drawing at various levels of a child's intellectual and emotional development is well understood within our education system. Most young children have been given pencils and paper from their earliest years and encouraged to 'draw', and their marks and scribbling rewarded by praise from parents or teachers who can see obvious signs of development in a toddler's motor skills.

The idea of self-expression in drawing follows closely and we can all applaud the primitive 'description' of a child's mood when expressed as brilliant 'happy' colour, or tight 'angry' lines, and so forth. The use of drawing as communication or message – an early substitute for spoken language-might next be recognised by the discerning adult. At a good primary school, parallel developments of drawing and writing (language) will be simultaneously encouraged.

At onset of puberty the self-consciousness that goes with it might upset the balance. It is at this point that the child's wish to be 'realistic' can override all else, and it is at this point that a teacher needs all his or her skills to help the child retain the use of drawing, at the least as a 'vehicle for learning'.

Taking records

During a museum visit, drawing as a vehicle for learning is an essential and most important technique to aid concentration, to develop powers of close observation and to impress visual information on the memory. No museum project should omit at least some sketching or drawing, even among older students.

Before photography everyone took it for granted that visual records had to be produced by drawing. Consequently, it was part of normal education until the beginning of this century. The invention of photography has taken some time to be incorporated into our range of visual skills, but by now we are able to understand that it does not always supersede drawing which still has a unique value to the individual as part of the learning process.

Drawing techniques: pen

For quick, bold drawings, you will get excellent results if you provide fine-tipped pens (black biro or fine fibre tips) rather than pencils. This is a practical suggestion based on many years' experience. Pen drawings like these cannot be rubbed out, and therefore encourage concentration and close observation. False beginnings can be thrown away and fresh paper issued for those which go

Example of worksheet completed by a child aged nine years

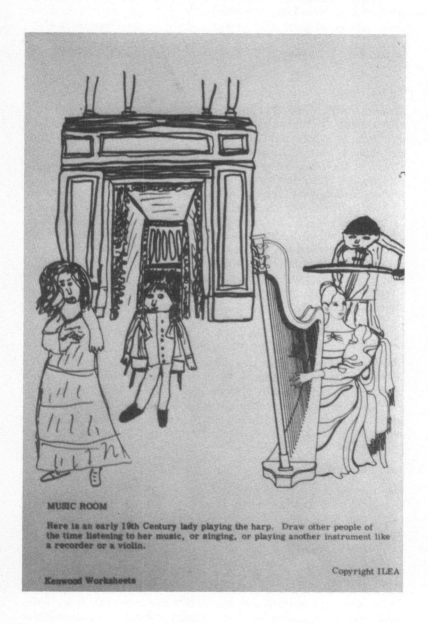

MUSIC ROOM

Here is an early 19th Century lady playing the harp. Draw other people of
the time listening to her music, or singing, or playing another instrument like
a recorder or a violin.

Copyright ILEA

Kenwood Worksheets

badly wrong. This style of 'now or never' drawing can be alarming, especially if the children have not tried it before, but given that the problems of confidence are overcome, the majority will find that their results surprise and please everyone, not least themselves. They will also take away with them a well-filled folder of drawings and notes.

Pencil

Drawing with a pencil is apparently easier, but unless the artist is very skilful, the results can often be much less inspiring. Too hard a pencil produces faint and indefinite lines; too blunt a point produces a blurred form or shape. But most of all, because the pencil is such a familiar tool, many children take it for granted and do not feel impelled to make that really special effort which a short museum visit, packed with many other activities, demands.

Also everyone has the idea that it does not matter if a drawing is 'not quite right' because it is easy to rub out a pencil line. Nervous or fussy children can spend all their time rubbing out and, when the visit is over, will have no work to show for it. Careless or distractable children will spend time losing their rubbers, or losing other people's, and generally the whole group will soon be thinking about correcting their drawings instead of observing the object and drawing it.

Art projects

For long, slow visits, or specialist art projects, the production of an expressive drawing and a 'work of art' might be the aim, which might be more important than the gathering of visual information. In that case different techniques, including pencils and rubbers, and (if the museum will allow it) more expressive media such as chalk or charcoal, may well be preferable.

Encouragement

As always, explicit encouragement will be the teacher's most powerful tool. Do not worry if only part of an object is drawn; while that has happened the whole has been gazed at, scanned and considered in a way it would not have been had it it not been the subject of a drawing.

Training

Drawing is, at one level, a skill, and like any other skill it improves with practice. Children who are trained always to use drawing as

well as writing as methods of observation and recording, are in an advantageous position in any museum project or field study.

In the secondary school, pupils may need a great deal of encouragement as they grow older and become more self-critical, but they will usually be persuaded to draw if they appreciate that the process of visual research and study is the reason for the activity, and not necessarily the end result. If each pupil draws a variety of objects (or parts of an object) at the museum, all will be contributing a unique aspect of their study to the final class project. These drawings will be used later for display and discussion at school, and this activity will reinforce the understanding that each individual's response to an object in the collection is different and is of value to him or herself, as well as to the rest of the group. A drawing can be regarded as a legitimate form of 'private notes'; it may be in a shorthand more meaningful to the artist than to anyone else, but not the less valuable because of that.

Quick sketches or slow studied drawings?

Museum visits have numerous objectives. The pupils will be expected to see many things, listen to many instructions and take in many new ideas. In their haste to do all that is required of them, they might only have five or fifteen minutes to slow down their pace and produce one or more drawings. In that case, it helps if the medium used aids rather than hinders the speed of the drawing.

On the other hand, if the main purpose of the visit is a long and concentrated attempt to produce one drawing of considerable aesthetic emphasis, rather than several quick sketches or simple outline drawings, then much more time must be allowed, possibly different drawing materials used, and a different balance to the programme must be built into the visit.

11
Travel and transport – getting to a museum

One of the great charms of museum education, for both teachers and pupils, is that it takes place out of school. However, this inevitably creates a new set of problems for the harassed organiser who has to decide on the most efficient method of transport.

The basic choice is between hiring a coach, which is expensive

but highly convenient, or using public transport, which (some might say) is exactly the reverse.

Hiring a coach

Use the LEA bus if it is available and convenient. Obviously it will save money for the school and possibly trouble for the organisers. The school with its own minibus is immensely advantaged. Otherwise you need your local coach service. Once you have discovered a reliable service, it is advisable to stick with it. Regular custom is a good way of inspiring reliability. However, no matter how reliable your friendly driver is, it is nearly always essential that at least one member of staff travelling has also carefully researched the route, because drivers occasionally get lost in unfamiliar parts of London. Make sure that the time of the return journey is clearly agreed (in writing) before you set out.

Specially recommended

Boat travel on canals or rivers, if well integrated into your project, can not only provide a unique experience but is also, historically speaking, of immense significance when one is studying London. However, boat travel is very slow and time-consuming, so allow extra time in the schedule.

Public transport

If the group is small and reliable enough to be allowed to travel independently, the local bus or train might save a great deal of cash, but not time. If you opt for public transport, do a careful dummy run on your own, noting down the possible snags and pitfalls, and allow plenty of extra time in your final timetable.

Travelling with full groups is cheapest but most exhausting on public transport. In crowded city streets it can also be dangerous. You will need as many adult helpers as you can obtain, perhaps one to every five children. For group bookings, you will need to make the arrangement well in advance of the date of the trip (see page 199).

For older children – 14 and upwards – provided you have parental and head teacher permission, it is usually highly beneficial to arrange to meet at the museum, having given explicit written and other travel instructions, and allowed extra time for latecomers. Treating pupils as mature citizens will pay in the end. Both the conforming and the rebellious teenager will respond, but training for this kind of independence must be started early and be carefully thought out.

Party travel
See Useful Addresses, pages 197–199.

12
'A handling collection' – the value of touch in a museum visit

Frustration

Anyone who has studied Piaget knows the value of 'touch' in the learning process and maturation of very young children. Anyone who has seen visitors in a museum surreptitiously fingering and touching objects which are clearly (and for very good reasons!) labelled 'Don't touch please', understands the problem from the point of view of curators.

Unfortunately, these needs are mutually exclusive in the great majority of museum situations. However, there are some areas of museum education where compromise is possible.

A 'Handling Collection' and study collections

Some museum education departments have small 'handling collections' of sturdy, unbreakable objects which may be touched and handed round a junior class under supervision. If your children are at that stage it is worth looking out for those museums. 'Study collections' fulfil a need for older students, who may require material which is not in a glass case and who can be trusted not to destroy the objects which they are studying.

'Please Touch' exhibitions for blind visitors

Some museums (for example, the British Museum) have provided exhibitions which people are encouraged to touch, using some of their massive stone sculptures. Teachers with children who have special problems can sometimes arrange special privileged touching exhibitions at a time when they are not offered to the general public. It is always worth asking for special treatment, even if you don't get it. You might get it another time, or you might draw attention to a need (see page 34).

59

Very large objects

Collections of transport vehicles are sometimes allowed to be climbed into. These might fulfil the need for 'hands on' experience. London Transport Museum in Covent Garden is an example, and the staff also encourage noise, something very exceptional in a museum context!

Museum loan collections of objects which can be used in a classroom

Most of these are supplied by sources outside London for the very good reason that London contains so many varied museums which people can visit. There are some loan collections within reach of London. For loan and hire collections, see Useful Addresses, pages 197–199.

A school museum

If you make your own collection, you will have the resource you need right where you need it (see next section). But you will also have the worries and responsibilities that go with looking after any collection, however mundane.

13
Your own school museum

Collections

Collecting is a serious occupation and running a museum is hard work. Even collecting matchboxes or bus tickets (ephemera) should be seen by children and staff as a responsible task needing appropriate skills and correct procedures. You may not realise it, but people collect almost any mundane object you care to mention. The mere existence of a collection creates a value where one did not exist before. For example, one bus ticket is not very significant, but five hundred bus tickets, each from a different area, create an entity which now 'represents' bus travel in different parts of the town (or country). It has become a 'collection': that is, *an instrument* which can be used to measure and compare and make deductions *about bus travel*.

So, however humble and commonplace the objects, one day – sooner than you realise – they may become irreplaceable. A museum, including your 'school museum' is essentially a place which conserves irreplaceable objects.

The first school museum was that created by Edward Alleyn's bequest on his death in 1620 of his collection of pictures to his charitable foundation comprising almshouses and a school for poor boys – the present Dulwich College, a boys' public school. Though added to, and no longer housed in the school, that museum is now a valued part of the national heritage (see Directory section, under Dulwich Picture Gallery, page 96).

Aim

Isolate the motive for forming the collection before beginning an activity which will expand into a big new task for busy people.

Here are some types of collection which might be relevant in a school:
* A Natural History collection – e.g. stones, fossils, shells, natural objects.
* A Local History Collection – e.g. old photographs, old clothes, family mementos, taped autobiographies, etc.
* A Design Collection – e.g. modern household utensils, china, cutlery, glass, etc.
* A permanent Art Collection from the school art department.
* A History of your School.

Take advice

Write to professional organisations and ask for specific advice. It costs little but will save pounds in the long run. Each different type of material requires a different type of conservation and display.

Written policy

Having decided whether this collection is for staff only, or a teaching exercise to train children in collecting, form a committee and create an agreed policy. This will ensure your project has continuity. Decide where the money will come from, and don't imagine it will 'cost nothing'. Invite the schoolkeeper to join the committee; this idea will make work for him and you will get nowhere unless he co-operates.

Collecting, conserving and cataloguing

These are the three essential activities in a museum. The professionals whom you consult will advise you how to start. Formulate their advice appropriately and add it to your written policy. It will lay down guidance for all and prevent future disputes.

Display

Effective display requires appropriate space and perhaps equipment such as glass cases. Before you launch your Opening Exhibition, you will need to solve practical problems created by display; these are, broadly, safety to objects and to viewers, and effective communication through arrangement and explanatory labels.

Storage

This comes before 'display' as an essential activity. It may boil down to the sole use of a strong locked cupboard, or it may entail a whole room or even several rooms. Whichever it is, make sure you have it before you start to collect – and it is essential that your schoolkeeper is of the same mind on this point.

Security

As with collecting, take advice from the experts. Your local police, fire officer and insurance representatives will gladly provide that.

Study facilities

If your museum is primarily a resource collection you will also need suitable study space, and perhaps furniture such as a large table, desks, chairs and cupboards. You will need to consider the question of a handling collection. Handling collections provide immense educational stimulus, especially for groups of children with special needs, such as those with poor vision or hearing, but handling collections by definition tend to be short-lived. If your collection is composed of an indestructable material – stone or iron perhaps – or if it is easily replaceable, you will be safe in allowing it to be handled.

The golden rule, as always, is, take advice from expert collectors.

Islington Schools Loan Collection
Ambler School
Blackstock Road
London N4 2DR
[01] 226 4708

Hackney Schools Study Collection
Orchard School
Holcroft Road
London E9 7BB
[01] 986 7244

14

Holiday activities in museums and art galleries

This is a growth area in museum education. In the 1950s there were
two or three museums in London which offered special 'Leisure
Activities' for children during the school holidays. These were the
Geffrye Museum, the Horniman Museum and to some extent the
Victoria and Albert Museum.

Nowadays almost all museums and galleries offer holiday
courses and projects. Some for children, some for whole families,
they take place during the three main school holidays, sometimes
even during half-term holidays. Saturday activities may also be
offered, as they are, for example, by the Geffrye and Horniman
Museums in London during term time.

Voluntary attendance

Children attend these events during their school holidays or week-
ends. If they do not enjoy themselves, they vote with their feet.
This creates a totally different teaching situation from that
normally found in school. Museum teachers and organisers of
holiday courses are also not compelled to accept attitudes which
they might have to put up with in a school. But 'difficult children'
are seldom found in self-selected groups.

Innovative teaching

Museum teachers can never forget that their courses must entertain
as well as educate. A dull course simply eliminates itself because
the customers fail to turn up on the second day. For this reason
alone, these courses can represent creative, innovative education at
its best, and are therefore well worth studying and observing by
school and other teachers, and by parents. In a happy, unpressured
atmosphere, fuelled by enthusiasm to find out what happens next,

63

PROGRAMME

RANGERS HOUSE SUMMER HOLIDAY COURSE (1984) FOR CHILDREN
"THE ART OF LIMNING"

Jacobean limners and painters at Rangers House (The Suffolk Collection)

ATTENDANCE IS FREE

WEEK 1. For juniors, children of 7-10
Monday July 30th-Friday August 3rd 1984

MORNING 10.30 - 12.00	AFTERNOON 2.00 - 4.00
Monday Introduction to course: "Painter & Limner". Worksheets in gallery	"Modern Miniature Painting" Talk and demonstration. Guest speaker/artist.
Tuesday Miniature painting	STUDIO
Wednesday Jacobean & Elizabethan portraits "in large" and "in small" Guest speaker	STUDIO Painting a portrait "in large"
Thursday 10.30 - 4.00 VISIT National Maritime Museum to see portrait of George Clifford (juniors) — Knole, Sevenoaks — Knole, Sevenoaks Kent - to see home of the Sackvilles. (seniors in week 2.)	
Friday Finish practicalwork ; write notes; set up workshop display for the afternoon.	3.00 Presentation of work by students to visitors.

WEEK 2. Monday 6th August - Friday 10th August 1984.
For Seniors; Children of 11 - 15

Programme as in week 1 except; that the day's outing will be a COACH VISIT to Knole Sevenoaks, Kent , to see the home of the Sackville family. Lady Anne Clifford, the famous diary, writer, was the wife of Richard 3rd Earl of Dorset whose portrait by William Larkin is at Rangers House.

WEEK 3. Monday 13th August - Friday 17th August 1984

DRAMA, MUSIC AND DANCING OF THE TUDOR PERIOD FOR BOTH AGE GROUPS

Ideally children should attend two weeks of the course, either the 1st or 2nd, plus the 3rd, when all will come together and pool knowldge and talents to compose and act their own MASQUE on a subject inspired by the life of the painter William Larkin whose grand portraits hang in the gallery of Rangers House and are the theme of this year's course.

ENROLMENT

Please complete and return enrolment forms. It is a great help in the organisation of the course to know how many children will at attending.

Organisers reserve the right to alter this programme.

Parties must be booked in advance.

Further information : Gene Adams, ILEA Museum Advisor. 633 2751/853 0035

Illustration of holiday course

64

ENROLMENT FORM (BLOCK CAPITALS PLEASE) (30th July - 17th August 1984)

NAME _____

AGE _____

ADDRESS _____

PHONE NO. _____

I would like to attend the following days of the course: (Please put ✓ if yes and ✗ if no).

		Morning session 10.30 - 12.00	Afternoon session 2.00 - 4.00
WEEK 1 JUNIOR	MON 30th July		
	TUES 31st		
	WED 1st Aug.		
	THURS 2 Aug.		
	FRI 3 Aug.		
WEEK 2 SENIOR	MON 6 Aug.		
	TUES 7 Aug.		
	WED 8 Aug.		
	THUR 9 Aug.	Visit	There will be a charge for a coach.
	FRI 10 Aug.		
WEEK 3 MIXED AGE	MON 13 Aug.		
	TUES 14 Aug.		
	WED 15 Aug.		
	THUR 16 Aug.		
	FRI 17 Aug.		2.00 —— 6.00

Please note THURSDAY and FRIDAY attendance essential.

SIGNATURE OF PARENT/GUARDIAN _____ DATE _____

PLEASE RETURN COMPLETED FORM TO
Miss Adams, 275 Kennington Lane, SE11
or
Ranger's House, Chesterfield Walk SE10

Learning Resources Branch

GLC Historic Houses.
Curator: John Jacob

RANGERS HOUSE SE10
Chesterfield walk, Blackheath

The house of the 4th Earl of Chesterfield, statesman and author of the famous "Letters" to his natural son. The bow-fronted Gallery he added to the house in 1749 with "the finest prospects in the world", now houses the remarkable series of Jacobean portraits by William Larkin from the collection of the Earls of Suffolk. Concerts are held in the house and there is a collection of musical instruments.

British Rail Greenwich or Blackheath
Bus 53

Tel: 853 0035
633 2751

PLEASE KEEP THIS HALF

CUT HERE

children can be seen learning at their own pace, and concentrating on activities which might be quite intellectually demanding, but which they have clearly approached as 'a bit of fun'.

There is little time for personal conflict and one seldom senses the stale relationships that can arise among groups who meet each other through obligation rather than choice.

Interaction with school education

A few museums extend holiday activities or projects into the school terms. This is a slight contradiction in that the attendance is no longer voluntary, but if the event is properly organised, the children will experience the considerable pleasures of making their individual choices within the class framework. If they then return to the museum under their own steam on a Saturday, as often happens, they will not only be paying the museum education department a great compliment, but they will be doubling the benefit of an already valuable experience to themselves and, by implication, to their school.

Parents' participation in museum holiday projects

Parents (or accompanying adults), like class teachers, have an important and even more subtle support role. Whether or not they should be actively involved depends on the type of event, or the age of the child. As most projects are 'one off' and, as has been explained, are often in the realms of educational innovation or experiment, it will be necessary to make enquiries and read any hand-out before joining. If in doubt, phone the Education Officer.

Some projects are daily repeats; some are continuous courses which require continuous attendance and might last days or even weeks (see page 63–64). If the event is accumulative, the children will be expected to contribute to some joint production – perhaps a play or a video – at the end of the time.

Broadly speaking, events for children of eight or nine years and upwards do not require parents to stay in the museum. But those for younger children do, and those aimed at whole families obviously do expect parents to join in.

Museum holiday courses are more than 'playgroups', though they also perform the simple function of keeping children safe and well occupied, and for that reason are, sadly, sometimes made use of by unscrupulous people, who forget that the crucial point of these courses is that the children should attend by choice.

For the museum, these courses have the serious purpose of educating its future patrons and supporters, no matter what form the courses may take, or what level they may be aimed at.

66

Special interests

Children with a special interest or talent can gain greatly from museum holiday projects and Saturday Clubs which offer a huge variety of specialist skills, from finding out how Botticelli painted with pigment mixed with egg, to 'hands on' scientific experimentation with special apparatus at the Science Museum (the 'Launch Pad'). Other places, such as the Dulwich Picture Gallery, or the Ranger's House, sometimes offer grand halls or galleries for young musicians and actors to display their performing talents to the public.

These exercises, as would be expected, are popular among well-to-do ambitious parents, but from the Museum Education Officer's point of view, they are not in any way exclusive. In fact, the continuous courses tend for obvious reasons to be aimed at the local community, while national museums have to cope with 'national' audiences. Wherever they come from, all children are welcome to these events, *provided they wish to be there* . . .

It is worth remembering that these 'Leisure Activities', as they were then called, were pioneered in London's Geffrye Museum during the 1940s and 1950s, and obtained their support from what was then one of Britain's most deprived child communities. Educational methods evolved at that time have been universally adopted and, with further refinements and new additions and updating, remain the foundation of all similar events organised today.

Where to find out more

Holiday events in museums are seasonal, and change often. You will find them advertised in national newspapers, such as *The Guardian* and *The Times*, in educational newspapers, such as *The Times Educational Supplement*, and in local papers; also in 'listings' magazines and by the London Tourist Board.

Useful addresses are The National Trust and Young NADFAS; for these, see pages 197 to 179.

Admission charges

Holiday activities are often free of charge. It is essential to have information from individual museums on this point.

Age groups

Normally from seven years upwards.

Preamble to the Directory

1 Advance booking in writing is *essential in every case*, whether or not there is a formal booking service at the museum/gallery.

2 Free worksheets (or other printed material), if offered, are for children attending educational events only.

3 Sample worksheets are usually supplied to teachers, sometimes with permission to photocopy for school use.

4 'Academic' Sixth Form provision refers to those studying for A-levels.

5 In-service museum courses for teachers aim to introduce teachers to the best use of a particular museum/gallery as a resource for learning in a cross-curricular situation. Other courses may be subject-based.

6 'Linked visits' – these are suggestions of other museums or galleries which might be useful in following up a theme. They are merely suggestions and in no way claim to present an exhaustive list. Not all of the linked visits are to other museums. They might include sorting offices (for postal history), churches (for architecture, or for biographical studies), new installations such as the Thames Flood Barrier (for engineering), and so on.

 There is not enough space to give full details, but a telephone number is given where possible, for readers to follow up for themselves. The full entries in the Directory are exclusively museums or art galleries. Additional ideas for subsequent editions would be welcomed.

7 'Less frequented galleries and suggested study topics' – the same provisos apply as above, but there are a few suggestions which could be used to get away from crowds in big museums, or provide a theme for a second project.

Every effort has been made to ensure that information given in this Directory is as accurate as possible. We apologise for any omissions and inaccuracies.

The Directory

KEY TO SYMBOLS

B Booking service

L Adult programmes (sometimes quite specialised) useful for teachers planning visits

P Set programme at fixed times: e.g. talks in galleries, films, illustrated talks.

R Lessons for school groups by arrangement: tailored to needs of party

90 Maximum permitted party size

Public restaurant or snack-bar (not specifically for children)

Room available for sandwiches (by arrangement)

Nearby park or open space

Coach park or space for coach within reach

Art studio for children (by arrangement)

Air Projects (formerly Air Gallery)

Address: 6 and 8 Rosebery
Avenue
London
EC1R 4TD

Telephone [01] 278 7751

Contact:
Education Officer

Exhibits: Changing exhibition
programme of lively and chal-
lenging new work by lesser-known
artists living in UK and abroad.

Hours: Monday–Friday,
11 am–6 pm
Saturday, 2–6 pm
Closed Sunday

Transport:
Tube – Chancery Lane,
Farringdon; Bus – 33, 19

Amenities

| B | L | P | R | | | | | |

Term time courses: *Teachers*:
one day or evening; other by
request. *Children*: all age
groups welcome; themes based
on current exhibitions.

Holiday courses: Occasional,
including activities in art, music,
drama. Local Community
Centre Saturdays and pm.

Materials from shop:
Postcards; magazines.

Research facilities:

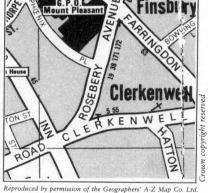

Reproduced by permission of the Geographers' A-Z Map Co. Ltd.

Special provision: 'English as a second language' courses related
to exhibition; Adult Education; Day Centre for Elderly; MIND
Day Centre.

Linked visits: Cockpit Gallery; Royal Academy. For other
contemporary art: Hayward Gallery, South London Art Gallery.
For permanent contemporary collections: Tate Gallery.

Comments: The issues raised in exhibitions are important and
reflect visually current concerns of contemporary art and society.
Talks to school groups by exhibiting artists form a valuable part
of their teaching method.

Admission: Free

Apsley House, see **Wellington Museum**

Banqueting House, Whitehall

Address: Whitehall
London
SW1

Telephone [01] 930 4179

Contact:
Department of the
Environment
Education Officer
(for free visit)
[01] 937 9561

Exhibits: Part of old Whitehall
Palace; designed by Inigo Jones;
decorated with a ceiling by Rubens;
the scene of court masques and
ceremonies, and site of the execution
of Charles I.

Hours: Tuesday–Saturday,
10 am–5 pm
Sunday, 2–5 pm

Transport: Tube – Embankment,
Westminster; Bus – 3, 11, 12, 24,
29, 53, 77, 88, 159

Amenities

B			100		♣	🚌

Term time courses: *Teachers*:
occasional courses.

Holiday courses:

Materials provided free:
Teachers' pack.

Materials from shop:

Research facilities:

Special provision:

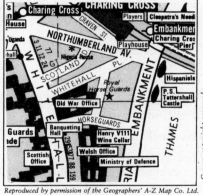

Reproduced by permission of the Geographers' A-Z Map Co. Ltd.

Linked visits: For historical themes: National Portrait Gallery.
For Inigo Jones's architecture: Queen's House, Greenwich
(National Maritime Museum).

Comments: Not possible to offer any form of direct teaching to
class of children.

Admission: Charge
School parties by appointment, usually in mornings.

Bear Gardens Museum, see **Shakespeare Globe Museum**

HMS *Belfast*

Address: Symons Wharf
Vine Lane
Tooley Street
London
SE1 2JH

Telephone [01] 407 6434

Contact:
Education Officer, Ext. 216
Secretary, Ext. 216

Exhibits: Famous World War II cruiser moored in the Thames opposite the Tower of London. Visitors explore all seven decks. A number of special exhibitions on board.

Hours: 1 Nov.–19 March, 11 am–4.30 pm
20 March–31 Oct., 11 am–5.50 pm

Transport: Tube – London Bridge, Tower Hill; Bus – 10, 42, 44, 47, 48, 70, 78

Amenities

| B | L | | R | 50 | | | |

Term time courses:

Holiday courses:

Materials provided free: Worksheets (list available); advisory sheets.

Materials from shop:

Research facilities:

Special provision: Further Education and tourist groups welcomed. Disabled groups welcomed subject to suitability of ship; check with Education Officer. Handling collection available for younger visitors or partially sighted, by arrangement. Talks offered to school groups.

Linked visits: Imperial War Museum; National Maritime Museum; Cabinet War Rooms.

Comments:

Admission: Charge

Bethnal Green Museum of Childhood

Address: Cambridge Heath
Road
London
E2 9PA

Telephone [01] 980 2415

Contact:
Education Enquiries,
980 3204/4315 981 1711

Exhibits: Toys, dolls and doll-
houses; Western children's
clothes; theatre puppets.

Hours: Monday–Thursday,
Saturday, 10 am–6 pm
Sunday, 2.30–6 pm
Closed Friday

Transport: Tube – Bethnal
Green; Rail – Cambridge Heath
Station; Bus – 8, 8a, 106, 253
(Bethnal Green Station); 6, 6a,
170, 256 (Cambridge Heath
Station, 5 min.)

Amenities

B	L	P	R				

Reproduced by permission of the Geographers' A-Z Map Co. Ltd.

Term time courses: *Teachers*:
occasional courses.

Holiday courses: Christmas,
Easter, summer.

Materials provided free:
Activity pack; teachers' pack.

Materials from shop:
Catalogue, postcards and other
children's books.

Research facilities: Lectures.

Special provision: For blind
and partially sighted, handling objects (by arrangement).

Crown copyright reserved

Linked visits: For toys, childhood costumes: Victoria and Albert
Museum; London Toy and Model Museum; Pollock's Toy
Museum; Museum of London; Gunnersbury Park Museum.
For Spitalfields silk: Victoria and Albert Museum; the nearby
locality of Spitalfields contains many silk weavers' houses – see
Spitalfields Heritage Centre.

Comments: For detailed educational advice, contact Education
Officer, Victoria and Albert Museum.

Admission: Free

74

Bexley Museum, see **Hall Place**

British Museum

Address: Great Russell Street
London
WC1B 3DG

Telephone [01] 636 1555

Contact:
Education Officer, Ext. 508
Secretary (Bookings),
Ext. 510/511

Exhibits: Antiquities –
Egyptian, West Asiatic. Greek
and Roman, Pre-historic,
Romano-British, Oriental,
Mediaeval and later. Coins,
medals, prints and drawings.

Hours: Monday–Saturday,
10 am–5 pm
Sunday, 2.30–6 pm

Transport: Tube – Tottenham
Court Road, Holborn;
Bus – 14, 24, 29, 68, 73, 77, 188,
196, 7, 8, 19, 22, 25, 38, 55

Amenities

B	L	P	R		¶¶		♣	

Term time courses: *Teachers*:
Regular programme or various
courses (write for calendar of
events). *Sixth Form*: Study
days and, for non-academic
students, 'tailormade' talks.

Holiday courses: Christmas,
Easter, summer.

Materials provided free:
Annual programme for
teachers available in August.
Some video loans to schools;
worksheets for children.

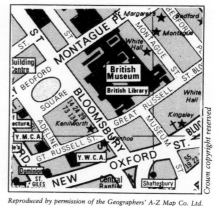

Materials from shop: Catalogue; books; postcards; charts;
facsimile objects.

Research facilities: Reference library, public lectures.

Special provision: Direct teaching available for all age levels if
pre-booked. All disabled groups, provided sufficient warning
given. Regular handling exhibitions especially for blind (consult
Education Officer).

British Museum cont.

Linked visits: For Roman material: Museum of London; Lullingstone Roman Villa; Verulamium. For Egyptian material: Horniman Museum. For Oriental material: Victoria and Albert Museum. For clocks: Clock Museum at Guildhall Library.

Comments: Try to limit your visit to one theme. Timing is extremely important. With such an enormous collection it is easy to exhaust and confuse children. Allow plenty of time for rest and refreshments and remember that this is not a once in a lifetime visit – merely one of many.

Less crowded galleries: Oriental* (Room 34, for world religions; ceramics; sculpture) Assyrian* (Room 16, etc., for junior Bible studies) Prints and Drawings (Room 67, for history and art history) Celtic* (Rooms 38–40, adjunct to Roman Britain) Greek and Roman (Basement 83–5) Clock Gallery (Room 44, clocks and watches, for science and maths and art projects).
* Children's Trails available

Admission: Free

British Museum (Ethnography), see **Museum of Mankind**

British Museum (Natural History), see **Natural History Museum**

British Piano and Musical Museum, see **Musical Museum**

Bromley Museum

Address: The Priory
Church Hill
Orpington
Kent
BR6 0HH

Telephone 0689 31551

Contact:
Curator

Exhibits: Interesting mediaeval building which houses local archaeological finds; includes good Roman and Saxon displays; some foreign pre-history; geology; ethnography; Victorian; 17th century fire engine.

Hours: Monday–Wednesday, Friday, 9 am–6 pm
Saturday, 9 am–6 pm
Closed Thursday, Sunday

Transport: Rail – to Orpington; Bus – 51 from station, 61, 94 nearby

Amenities

B	L		R	30			♠	🚌

Term time courses:

Holiday courses:

Materials provided free:

Materials from shop:

Research facilities:

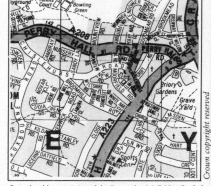

Special provision: Disabled groups, except deaf and hard of hearing (by advance arrangement).
Wheelchair access and disabled toilets in park. Evening classes for further education groups.

Linked visits:

Comments: Talks can be arranged for school groups (all ages).

Admission: Free

Bruce Castle Museum

Address: Lordship Lane
Tottenham
London
N17 8NU

Telephone [01] 808 8772

Exhibits: 18th century red brick manor house, contains museum of local history and important collection of postal history. Sir Rowland Hill, inventor of Penny Post, once kept a school here.

Hours: Monday, Tuesday, Thursday, Friday 10 am–5 pm Saturday, 10 am–12.30 pm; 1.30–5 pm Closed Wednesday, Sunday, Bank Holidays

Transport: Tube – Wood Green, then Bus – 123, 243, 243A

Amenities

B			30				

Term time courses: *Teachers*: by request. *Sixth Form*: by request.

Holiday courses:

Materials provided free: Worksheets (photocopies by request).

Materials from shop: Catalogue; postcards.

Research facilities: Archives; lectures.

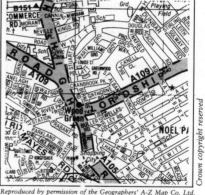

Reproduced by permission of the Geographers' A-Z Map Co. Ltd.

Special provision: Disabled groups (except wheelchairs) by arrangement.

Linked visits: For history of postal services; National Postal Museum. For modern postal service: Mount Pleasant Sorting Office.

Comments: Film and local history slide shows. Events, including art, drama and music, sometimes held at the house.

Admission: Free

79

Cabinet War Rooms

Address: Clive Steps
King Charles Street
London
SW1A 2AQ

Telephone [01] 930 6961

Contact:
Curator

Exhibits: The extraordinary protected underground accommodation used by Winston Churchill and the War Cabinet and the Chiefs of Staff of the armed forces during World War II.

Hours: Tuesday–Sunday, 10 am–5.50 pm

Transport: Tube – Westminster; Bus – 3, 24, 29, 77, 77A, 109, 172, 184, 11, 88, 170, 12, 53, 70, 76, 159

Amenities

Term time courses:

Holiday courses:

Materials provided free:
Teacher information and sample worksheet.

Materials from shop:
Catalogue; postcards; books; posters; other.

Research facilities: Contact Education Officer at Imperial War Museum.

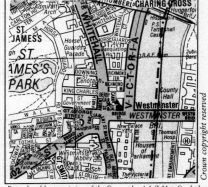

Reproduced by permission of the Geographers' A-Z Map Co. Ltd.

Crown copyright reserved

Special provision:

Linked visits: Imperial War Museum; National Army Museum; Royal Air Force Museum; HMS *Belfast*; Houses of Parliament.

Comments: Essential visit for any serious study of World War II; further pursuit of the theme at Imperial War Museum.

Admission: Charge

80

Care of Buildings Exhibition

Address: Building Conservation
Trust
Apartment 39
Hampton Court Palace
East Molesey
Surrey
KT8 9BS

Telephone [01] 943 2277

Contact:
Education Officer

Exhibits: 25 rooms show full-size reconstructions of parts of everyday buildings, mainly houses, showing how they are built and need to be maintained.

Hours: Monday–Saturday, 9.30 am–5 pm
Sunday, 12 noon–5 pm

Transport: Rail – from Waterloo, Vauxhall, Clapham Junction, Wimbledon or Surbiton to Hampton Court; Bus – 11, 131, 216, 267, 467

Amenities

B		R	🎓40	🍴	📚	🌲	🚌

Term time courses:

Holiday courses:

Materials provided free: Questionnaire on the exhibition.

Materials from shop:

Research facilities: Reference library.

Special provision: Not suitable for disabled groups.

Linked visits: For history of architecture: Sir John Soane Museum (suitable for sixth form level); any actual historic buildings.

Comments: The exhibition shows *modern* (not historic) building techniques. Older students preferred – small groups (5–6) plus own tutor to explain, recommended. A 'Surgery' operates on Tuesdays at which a qualified surveyor is available to answer technical questions.

Admission: Charge

Carlyle's House

Address: 24 Cheyne Row
Chelsea
London
SW3

Telephone [01] 352 7087

Contact:
Curator

Exhibits: An early 18th century house where Thomas and Jane Carlyle lived from 1834 until their deaths, containing a wealth of personal relics of the writer.

Hours: April–end Oct., Wednesday–Sunday, 11 am–5 pm Closed Monday, Tuesday, Good Friday

Transport: Tube – Sloane Square (17 min. walk); Bus – 5, 7, 8, 19, 22, 25, 38, 55, 68, 77, 172, 179, 188, 239, 501

Amenities

				🏛 20					

Term time courses:

Holiday courses:

Materials provided free:

Materials from shop:
Catalogue; postcards.

Research facilities:

Special provision: Not suitable for disabled groups; many stairs and small rooms.

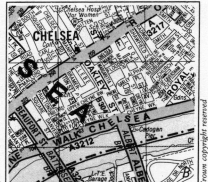

Reproduced by permission of the Geographers' A-Z Map Co. Ltd.

Linked visits: For Victorian literary figures: Dickens House; National Portrait Gallery (biographical information and portraits).

Comments: Suitable for small groups of older students studying Carlyle and 19th century literature. Very evocative and beautifully-preserved house in a quiet street near the Chelsea Embankment.

Admission. Charge. Free to members of National Trust (schools can become corporate members).

82

Chartered Insurance Institute Museum

Address: 20 Aldermanbury
London
EC2V 7HY

Telephone [01] 606 3835

Contact:
Education Officer

Exhibits: An extensive collection of 'Fire Marks', memorabilia relating to the history of fire-fighting and insurance; hand-drawn fire engines.

Hours: Monday–Friday, 10 am–4 pm

Transport: Tube – Moorgate, St Paul's; Bus – 15, 25

Amenities

| B | L | | R | 🔥20 | | | | |

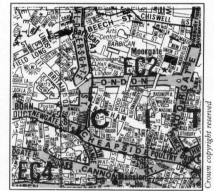

Reproduced by permission of the Geographers' A-Z Map Co. Ltd.

Crown copyright reserved

Term time courses:

Holiday courses:

Materials provided free:

Materials from shop:

Research facilities:

Special provision:

Linked visits: For Fire of London and more fire engines: Museum of London.

Comments: A very small museum; a short talk can be arranged, contact Education Officer. Small groups essential – probably best for older students.

Admission: Free

83

Chatham Historic Dockyard

Address:
Visitors' Centre
The Old Pay Office
Church Lane
Chatham Dockyard
Chatham
Kent

Telephone 0634 812551

Contact:
Visitor Manager, Ext. 2115

Exhibits: Historic 18th and 19th century docks; shed for building tall ships; 18th century dry docks, and many fascinating buildings connected with maritime naval industry; where the *Victory* was built.

Hours: Summer, Wednesday–Sunday, 10 am–6 pm

Transport: Rail – from Charing Cross or Victoria to Chatham, then Bus – 101, 104, 105

Amenities

B			200	⏰	🍎		🚌	

Term time courses:

Holiday courses:

Materials provided free: Teachers' leaflet.

Materials from shop: Guide book; other.

Research facilities:

Special provision: Can take parties up to 200.

Linked visits: National Maritime Museum; Madame Tussaud's (*son et lumière* of Battle of Trafalgar); Historic Ship Collection; Westminster Abbey (Nelson's funeral effigy). Out of London: The *Victory*, Portsmouth.

Comments: The newly-established Visitors' Centre shows an excellent introductory slide tape and provides a guide if required. Thereafter a day could be spent walking around docks and related buildings such as naval quarters, church, workshops. The docks and area also have a strong connection with Dickens.

Admission: Charge. Special rate for school parties – contact Visitor Manager.

84

Chessington Zoo, see Zoo (Chessington)

Chiswick House

Address: Burlington Lane
Chiswick
London
W4 2RP

Telephone [01] 995 0508

Exhibits: Exquisite Palladian villa designed (1725–9) by the third Earl of Burlington; modelled on Palladio's Villa Capra, Vicenza; standing in extensive gardens.

Hours: 15 Mar.–15 Oct., daily, 9.30 am–6.30 pm
16 Oct.–14 Mar., weekdays, 9.30 am–4 pm; Sunday, 2–4 pm
Grounds open daily throughout the year

Transport: Tube – Hammersmith, then Bus – 290

Amenities

B			𝕮𝕮𝕮 30		♠	

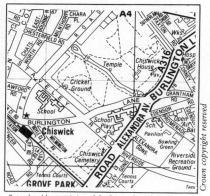

Reproduced by permission of the Geographers' A-Z Map Co. Ltd.

Term time courses:

Holiday courses:

Materials provided free:

Materials from shop:
Catalogue; postcards.

Research facilities:

Special provision:

Linked visits: For English Palladian architecture: Marble Hill House.

Admission: Charge
For school parties, telephone the house direct on [01] 995 0508.

85

Church Farm House Museum

Address: Greyhound Hill
Hendon
London
NW4 4JR

Telephone [01] 203 0130

Contact:
Curator

Exhibits: 17th century farmhouse; period furnished kitchen (*c.* 1859), six temporary exhibitions each year on local and social history and decorative arts.

Hours: Monday, Wednesday–Saturday, 10 am–1 pm; 2–5.30 pm
Tuesday, 10 am–1 pm
Sunday, 2–5.30 pm

Transport: Tube – Hendon Central; Bus – 183, 143, 113

Amenities

B			R	30			🌲 🚌

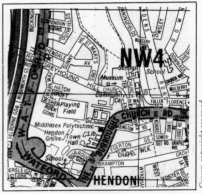

Reproduced by permission of the Geographers' A-Z Map Co. Ltd.

Crown copyright reserved

Term time courses:

Holiday courses:

Materials provided free: Occasionally worksheets are produced for special exhibitions.

Materials from shop: Catalogue; postcards; other material.

Research facilities:

Special provision:

Linked visits:

Comments: Talks given to school groups if pre-booked; all ages.

Admission: Free

86

Cockpit Gallery

Address: Cockpit Annexe
Princeton Street
London
WC1

Telephone [01] 405 5334

Exhibits: About eight photographic exhibitions arranged annually, each lasting about one month. Many exhibitions are produced by community, youth and school groups. Exhibitions can be hired.

Hours: Monday–Friday,
10 am–6 pm
(school/FE terms only)

Transport: Tube – Holborn;
Bus – 5, 7, 8, 19, 22, 38, 55, 68, 77, 172, 179, 188, 239, 501 (Red Arrow); Rail – Waterloo, London Bridge

Amenities

| B | L | | R | 30 | | | | |

Term time courses: By arrangement.

Holiday courses:

Materials provided free:

Materials from shop:

Research facilities:

Special provision:

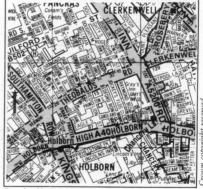

Reproduced by permission of the Geographers' A-Z Map Co. Ltd.

Linked visits: For study of photography: Science Museum (photographic gallery); National Portrait Gallery; The Photographers' Gallery; Half Moon Gallery.

Comments: Talks given to school groups.
School groups can be assisted in production of own exhibitions.

Admission: Free

Commonwealth Institute

Address: Kensington High Street London W8 6NQ

Telephone [01] 603 4534

Contact:
Chief Education Officer, Ext. 211
Senior Teacher, Ext. 224
Schools Liaison, Ext. 83

Exhibits: Exhibitions on all Commonwealth countries; Education Centre, including activities room for pre-booked groups; courses, seminars, AVA Centre; shop; library and Information Centre.

Hours: Monday–Saturday, 10 am–5.30 pm; Sunday, 2–5 pm

Transport: Tube – High Street Kensington, Earls Court; Bus – 9, 27, 28, 31, 33 (not Sunday), 49, 73; Green Line 701, 704, 714, 716

Amenities

B	L	P	R		🍴	🍎	🌲	🚌

Term time courses: *Teachers*: one or two days. *Sixth Form*: study days (GCSE and A-Level geography, economics, history, R.E.

Holiday courses: Christmas, Easter, summer.

Materials provided free: Worksheets.

Materials from shop: Postcards; books; posters and other.

Research facilities: Reference library.

Reproduced by permission of the Geographers' A-Z Map Co. Ltd.

Special provision: For all disabled groups: induction loop in activities room for deaf, disabled toilets and lift.

Linked visits: For other ethnic collections: Horniman Museum; Museum of Mankind (Ghana, Australia, Aborigine); Victoria and Albert Museum (for Indian heritage).

Comments: Special emphasis in teaching on tactile handling experience. Permanent education staff combined with visiting commonwealth staff produce authenticity in project visits. Some materials available for hire or loan. Schools service adds an essential multi-cultural dimension to the curriculum. *NB:* Coach park is limited and cannot be booked.

Admission: Free

88

Courtauld Institute Galleries, University of London

Address: Woburn Square
London
WC1H 0AA

Telephone [01] 387 0370

Contact:
Secretary

Hours: Monday–Saturday,
10 am–5 pm
Sunday, 2–5pm

Exhibits: A delightful museum where a number of the masterpieces of European painting (14th to 20th centuries) can be appreciated in an atmosphere of calm and restrained luxury. Especially noteworthy are the French Impressionists, e.g. *Bar at the Folies-Bergère* (Manet) and many others.

Transport: Tube – Goodge Street, Russell Square; Bus – 24, 29, 134, 77, 68, 188

Amenities

B	L	P	R	🐾25			🌲	

Term time courses:

Holiday courses:

Materials provided free:

Materials from shop:
Catalogue; postcards; other.

Research facilities: Collections in store may be visited by scholars and serious researchers (adult) by appointment.

Special provision: Not suitable for disabled groups.

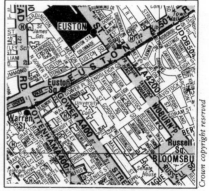

Reproduced by permission of the Geographers' A-Z Map Co. Ltd.

Crown copyright reserved

Linked visits: National Gallery (Impressionists, also Renaissance art); Tate Gallery.

Comments: Brief talk from curator can be arranged for students 11–18. Essential visit for A-level art history students. Two main collections permanently on view are:
 Princes Gate Collection of Old Master Paintings and Samuel Courtauld Collection of Impressionist and Post-Impressionist Paintings.
NB: Address changing later in 1989; check before visiting.

Admission: Charge. School parties free up to secondary level.

Cricket Memorial Gallery

Address: Lord's Cricket Ground
London
NW8 8QN

Telephone [01] 289 1611

Contact:
Education Officer

Exhibits: Paintings, trophies, *objets d'art* concerning cricket and its history.

Hours: Cricket days, Monday–Saturday, 10.30 am–5 pm
Other times by appointment

Transport: Tube – St John's Wood; Bus – 2, 74, 159

Amenities

B	L	P	R	30	¶¶		♠	🚌

Term time courses:

Holiday courses:

Materials provided free: Reading list.

Materials from shop: Catalogue; postcards; books; posters; other.

Research facilities: Reference library (by arrangement); archives; public lectures (by arrangement).

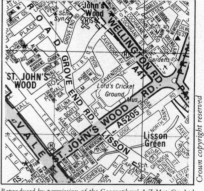

Reproduced by permission of the Geographers' A-Z Map Co. Ltd.

Special provision: Disabled groups helped where possible if pre-booked.

Linked visits: National Portrait Gallery (biographical themes).

Comments: Age groups preferred, 11–18. Film shows can be provided (advance arrangement).

Admission: Charge. School parties free if pre-booked.

90

Cutty Sark Clipper Ship

Address: King William Walk
Greenwich
London
SE10 9BL

Telephone [01] 858 3445

Contact:
Bookings [01] 853 3589

Exhibits: Last remaining tea clipper (*c.* 1896) in the world, fully rigged.

Hours: Summer,
Monday–Saturday,
10 am–6 pm; Sunday,
12 noon–6 pm
Winter closing, 5 pm

Transport: Rail – Charing Cross or London Bridge to Greenwich; Bus – 108, 177, 180

Amenities

B			40			♠

Term time courses:

Holiday courses:

Materials provided free:

Materials from shop: Teachers' guide, contains worksheets for duplication; postcards; books and other.

Research facilities: Consult Education Officer at National Maritime Museum for advice.

Reproduced by permission of the Geographers' A-Z Map Co. Ltd.

Special provision: Disabled can visit upper cargo hold only.

Linked visits: For maritime and ship history: National Maritime Museum; Historic Ship Collection. For tea cultivation: Royal Botanic Gardens, Museum. For modern tea-growing countries: Commonwealth Institute. For history of tea-drinking: Victoria and Albert Museum; Museum of London.

Comments: Also moored nearby, *Gipsy Moth IV* (yacht belonging to Sir Francis Chichester).

Admission: Charge. Reduced charge for pre-booked school parties (15 or more).

Cuming Museum

Address: 155–7 Walworth
Road
London
SE17 1RS

Telephone [01] 703 3324/
5529/6514

Contact:
Curator

Exhibits: Local history
exhibitions about Southwark;
archaeological, (Roman)
bygones, and 'London
superstitions'.

Hours: Telephone for opening
hours

Transport: Tube – Elephant and
Castle; Bus – 12, 35, 40, 45, 68,
171, 176, 184

Amenities

B	L		R	35				

Term time courses:

Holiday courses:

Materials provided free:
Material worksheets; activity
sheets; information leaflets on
local history and archaeology.

Materials from shop:

Research facilities: Reference
library.

Reproduced by permission of the Geographers' A-Z Map Co. Ltd.

Special provision: For disabled groups, if possible by
arrangement. Brailed leaflets can be obtained sometimes. No
wheelchairs.

Linked visits: For history of London: Museum of London. For
Southwark association with Dickens: Dickens House.

Comments: Materials can be available for handling, by
arrangement.

Admission: Free

92

Dr Johnson's House

Address: 17 Gough Square
London
EC4A 3DE

Telephone [01] 353 3745

Contact:
Curator

Exhibits: Letters and prints referring to Johnson and his period in the charming, tall early 18th century house where he lived for many years.

Hours: May–Sept., Monday–Saturday, 11 am–5.30 pm
Oct.–April, Monday–Saturday, 11 am–5 pm

Transport: Tube – Temple, Chancery Lane; Bus – any to Fleet Street or Ludgate Circus

Amenities

B			𝕸𝕸𝕸 20					

Term time courses:

Holiday courses:

Materials provided free:

Materials from shop:

Research facilities:

Special provision:

Reproduced by permission of the Geographers' A-Z Map Co. Ltd.

Crown copyright reserved

Linked visits: Museum of London (background to 18th century London); St John's Gate, Clerkenwell (now Museum of the Order of St John; then headquarters of *The Gentleman's Magazine* edited by Edward Cave, visited by Dr Johnson and other literary figures of the 18th century); Kenwood (Dr Johnson's summer house now in grounds); British Museum (MSS).

Comments: Suitable for older students only. Small groups essential.

Admission: Charge

93

The Design Museum

Address: Shad Thames
London
SE1 4ND

Telephone [01] 403 6933

Contact:
Education Officer

Exhibits: Brand new building on beautiful river site housing temporary exhibitions of mass-produced design; a design review of new and spectacular products; and a study collection of the history of design.

Hours: (to be decided)
Tuesday–Sunday Closed Monday

Transport: Tube – Tower Hill; London Bridge; Bus – 42, 188, 78, Thamesline River Bus

Amenities

B	L	P	R	👥20	🍴		🚌

Term time courses: *Teachers*: one day courses.

Materials from shop: Postcards; books (educational); charts and posters.

Research facilities: Specialist reference library (Tuesday–Saturday) archives (hours by appointment).

Special provision: For the deaf: induction loop in lecture theatre; sign language programmes. In lecture theatre – special film shows.

Reproduced by permission of the Geographers' A-Z Map Co. Ltd.

Crown copyright reserved

Linked visits: For history of Art and Design: Victoria and Albert Museum; British Museum; British Library. For modern engineering: Science Museum. For architecture: RIBA. For 19th century engineering design: Tower Bridge; Kew Bridge Steam Museum.

Comments: Newly opened museum and still unestablished style of education. Preference expressed so far for older students (11–18). A talk will be offered if requested. The museum is situated on the bank of the Thames, within short distance of Tower Bridge. Outside patio for sandwich-break and dramatic river view.

Admission: Charge

Dickens' House, Museum and Library

Address: 48 Doughty Street
London
WC1N 2LF

Telephone [01] 405 2127

Contact:
Education Officer
Schools Officer
Secretary

Exhibits: Furniture, pictures, books, letters, manuscripts and memorabilia, all connected with Dickens, plus the house itself and some reconstructed rooms.

Hours: Monday–Saturday, 10 am–5 pm

Transport: Tube – Russell Square, Holborn; Bus – 19, 38, 55, 171, 172, 17, 18, 46

Amenities

B			R	50				

Reproduced by permission of the Geographers' A-Z Map Co. Ltd.

Term time courses:

Holiday courses:

Materials provided free:
Sample worksheet for copying.

Materials from shop:

Research facilities: Library.

Special provision:

Linked visits: For Dickens: British Museum (MSS); Chatham Historic Dockyard; Cuming Museum (Southwark); National Portrait Gallery. For general 19th century background: Museum of London. For a contemporary literary figure: Carlyle's House.

Comments: Suitable for small groups.

Admission: Charge

95

Dulwich Picture Gallery

Address: College Road
Dulwich
London
SE21 7BG

Telephone [01] 693 5254

Contact:
Education Officer
Museum Teacher

Exhibits: Fine 19th century building designed by Sir John Soane, housing outstanding collection of Old Master paintings by Canaletto, Cuyp, Van Dyck, Gainsborough, Murillo, Poussin, Raphael, Rembrandt, Rubens and others; also the Founders' Mausoleum.

Hours: Tuesday–Saturday,
10 am–1 pm; 2–5 pm
Sunday, 2–5 pm Closed Monday

Transport: Rail – Victoria to West Dulwich; London Bridge to North Dulwich; Bus – 3, 12

Amenities

| B | L | | R | 35 | | | ♠ | 🚌 |

Reproduced by permission of the Geographers' A-Z Map Co. Ltd.

Term time courses: *Sixth Form*: two weeks in July and individually arranged study days.

Materials provided free: Worksheets.

Materials from shop: Books; catalogue; postcards; other.

Research facilities: Archives.

Special provision: Wheelchair access. Slow learners welcomed.

Linked visits: For 18th century painting and architecture: National Gallery; Kenwood; Sir John Soane Museum. For 18th century French furniture and paintings: Wallace Collection. For 18th century furniture and decorative arts and costume: Victoria and Albert Museum.

Comments: Termly concerts for schools, held in Gallery during weekdays, open to public. Priority treatment for project bookings from Special Schools. Some education activities include: drama, dancing, art, music and scientific games, dressing in costume. Museum teacher will visit schools. Slides available for loan.

Admission: Charge

Epping Forest Museum

Address: Rangers Road
Chingford
London
E4 7QH

Telephone [01] 529 6681

Contact:
Education Officer

Exhibits: Unique timber-framed royal Tudor hunting grandstand, built by Henry VIII and used by Elizabeth I. Displays show wildlife of Epping Forest and describe its history.

Hours: Monday–Friday,
9 am–5 pm
Parties by appointment

Transport: Tube – Walthamstow, then rail; Rail – Liverpool Street to Chingford; Bus – 97, 255, 102, 179

Amenities

B		R	35			🌲 🚌

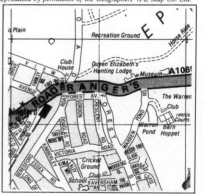

Term time courses: *Sixth Form*: study days can be individually arranged.

Holiday courses:

Materials provided free:

Materials from shop: Postcards; leaflets.

Research facilities: Help and advice from Curator.

Special provision: Guided tours for Adult Education Groups. Disabled groups welcome, but no special facilities; discuss needs with education officer.

Linked visits: For Tudor history and architecture: Hampton Court (Tudor kitchen); Museum of London; Geffrye Museum and Ranger's House (for junior Tudor projects and social history). Out of London: Weald and Downland Museum (Singleton, Chichester, West Sussex) (technical and architectural construction); Knole House, Kent.

Comments: Introductory talks are offered to pre-booked school groups.

Admission: Free

Erith Museum

Address: Erith Library
Walnut Tree Road
Erith
Kent

Telephone 0322 526574

Contact:
Education Officer, Ext. 221

Exhibits: Displays showing history of Erith, including Lesnes Abbey, the *Great Harry*, and local industries; and Edwardian kitchen.

Hours: Monday, Wednesday, Saturday, 2–5 pm

Transport: Rail – from Charing Cross or London Bridge to Erith; Bus – 269, 122A

Amenities

B		R 30			♠	🚌

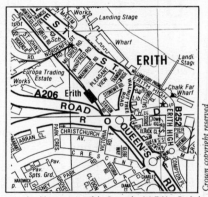

Reproduced by permission of the Geographers' A-Z Map Co. Ltd.

Term time courses:

Holiday courses:

Materials provided free: Worksheets; local history fact sheets.

Materials from shop: Postcards; other.

Research facilities: Reference library.

Special provision:

Linked visits: Greenwich Local History Centre ('Woodlands').

Comments:

Admission: Free

98

Fenton House

Address: Windmill Hill
Hampstead
London
NW3 6RT
(entrance Hampstead Grove)

Telephone [01] 435 3471

Contact:
Custodian

Exhibits: Attractive furnished 17th century house with fine walled garden; houses the superb Benton-Fletcher collection of early keyboard instruments, and the Binning collection of porcelain (English, Continental and Chinese).

Hours: March, Saturday, Sunday only, 2–6 pm; last admission 5 pm
April–end Oct., Saturday–Wednesday, 11 am–6 pm
Closed Thursday, Friday

Transport: Tube – Hampstead;
Bus – 210, 268

Amenities

B	L		R	25				

Term time courses:

Holiday courses:

Materials provided free:

Materials from shop:
Catalogue; guidebook; postcards.

Research facilities:

Special provision: Not suitable for disabled groups.

Reproduced by permission of the Geographers' A-Z Map Co. Ltd.

Crown copyright reserved

Linked visits: For musical instruments: Victoria and Albert Museum; Ranger's House (Dolmetsch collection of musical instruments and 18th century harpsichord).

Comments: Public lectures (occasional). Short introductory talk to groups on arrival. Suitable for small groups only, older children preferably.

Admission: Charge. Free to members of National Trust (schools can become corporate members). Reduction for school parties.

Forty Hall

Address: Forty Hill
 Enfield
 Middx
 EN2 9HA

Telephone [01] 363 8196

Contact:

Exhibits: Jacobean building (1629) with permanent collection of 16th and 17th century furniture; fine plaster ceilings. Also in old barn, local and natural history collections.

Hours: Oct.–Easter, Tuesday–Sunday, 10 am–5 pm Easter–Sept., Tuesday–Friday, 10 am–6 pm; Saturday, Sunday, 10 am–8 pm
Closed Monday

Transport: Tube – Oakwood; Bus – 135, 231; Green Line, 715, 715A to Enfield Town

Amenities

Term time courses:

Holiday courses:

Materials provided free:

Materials from shop:
Catalogue; postcards; other.

Research facilities:

Special provision:

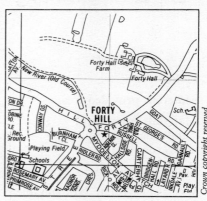

Reproduced by permission of the Geographers' A-Z Map Co. Ltd.

Linked visits: For Jacobean decorative art and costume: Victoria and Albert Museum; Ranger's House (Jacobean portraits); National Portrait Gallery (social and biographical history); Ham House.

Comments: Attractive house in charming local park.

Admission: Free

100

Foundling Hospital, Art Gallery and Museum

Address: 40 Brunswick
Square
London
WC1N 1AZ

Telephone [01] 278 2424

Contact:
Curator

Hours: Monday–Friday,
10 am–4 pm
Closed Saturday, Sunday,
public holidays and when in
use for conferences (check
by telephone)

Exhibits: Many paintings, including
Hogarth, Gainsborough and
Reynolds, and other artists
associated with this 18th century
Foundation. Music scores by
Handel; memorabilia of the
Foundling Hospital and foundlings
who lived there.

Transport: Tube – Russell Square;
Rail – to Euston, Kings Cross

Amenities

B			30			🌲 🚌

Term time courses:

Holiday courses:

Materials provided free:

Materials from shop:
Catalogue; *Story of the
Foundling Hospital* (for
primary schools); postcards;
other.

Research facilities:

Special provision:

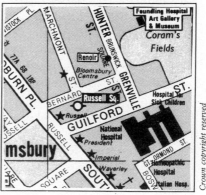

Linked visits: For 18th century
social history: Geffrye Museum. For medical/social history of
childbirth and midwifery: Science Museum (Wellcome Medical
History Collection).

Comments: Advance visit by teacher essential; this is a working
institution, but it has an interesting collection of paintings and
objects (mainly 18th century) relating to its foundation as an
orphanage, and a fine reconstructed 18th-century meeting room;
small relics of individual babies (e.g. brooches, rings/tokens) are
of special interest.

Admission: Charge

Geffrye Museum

Address: Kingsland Road
Shoreditch
London
E2 8EA

Telephone [01] 739 8368
739 9893

Contact:
Education Officer
Secretary

Exhibits: English furniture and decorative arts in a series of room settings (1600–1930). 18th century woodworker's shop, open hearth kitchen, small but interesting collection of paintings.

Hours: Tuesday–Saturday, Bank Holiday Monday, 10 am–5 pm Sunday, 2–5 pm

Transport: Tube – Liverpool Street, Old Street; Bus – 22, 48, 67, 149, 243, 22A

Amenities

B L		R	🎭40	🍴	🍎	🌲		🖌

Reproduced by permission of the Geographers' A-Z Map Co. Ltd.

Crown copyright reserved

Term time courses: *Teachers*: one and half day courses. *Sixth Form* days: by arrangement.

Holiday courses: Christmas; Easter; summer, Saturdays.

Materials provided free: Worksheets; puzzles; trails.

Materials from shop: Catalogue; postcards; books; posters; other objects.

Research facilities: Reference library; archives; lectures.

Special provision: Disabled groups welcomed; wheelchair visitors limited due to small galleries.

Linked visits: For social history: Museum of London; also National Portrait Gallery; National Army Museum (for 17th century Civil War); Ranger's House (Tudor project).

Comments: Established education service. Art room used for Saturdays, holidays and special projects. Child-sized costumes for demonstration (two children only) in school visits. Original early 18th century Almshouses.

Admission: Free. School bookings need to be made one term in advance.

Geological Museum

Address: Exhibition Road
London
SW7 2DE

Telephone [01] 938 8765

Contact:
Education Officer
Secretary

Exhibits: The story of the Earth; Britain before Man; regional geology of Britain with its rocks, fossils and minerals; gemstones; economic geology; British fossils.

Hours: Weekdays, 10 am–6 pm
Sunday, 2.30–6 pm

Transport: Tube – South Kensington; Bus – 9, 14, 30, 45, 49, 73, 74, 264; C1

Amenities

	L	P	R	🎭200		🍎📚	🌲	

Term time courses: *Teachers*: occasional one day. *Sixth Form*: A-level practical week courses April/May.

Holiday courses: Easter, summer, Saturday film shows.

Materials provided free: Printed material for teachers.

Materials from shop: Postcards; books; slides; other.

Research facilities: Reference library; lectures.

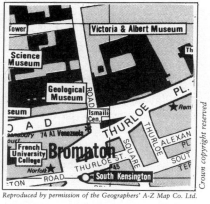

Reproduced by permission of the Geographers' A-Z Map Co. Ltd.

Crown copyright reserved

Special provision: Further education courses in evenings in conjunction with University of London. Most disabled groups.

Linked visits: For dinosaurs and fossils: Natural History Museum. For gemstones: Victoria and Albert Museum (jewellery collection); Science Museum (combine with visit to 'Treasure of the Earth').

Comments: Handling collections sometimes available during lessons. Use of the Second Gallery (upstairs) for minerals is recommended as less crowded and quieter. New display: 'Treasures of the Earth' showing industrial and chronological uses of natural resources.

Admission: Charge. Pre-booked school parties free.

103

Greenwich Borough Museum Plumstead Library

Address: 232 Plumstead
High Street
London
SE18 1JL

Telephone [01] 855 3240

Contact:
Acting Education Officer

Exhibits: Items illustrating history and natural history of London Borough of Greenwich; small but high quality teaching collection of reproduction historical costumes (Roman–Victorian).

Hours: Tuesday, Thursday, Friday, Saturday,
10 am–1 pm; 2–5 pm
Monday, 2–8 pm
Closed Wednesday, Sunday

Transport: Rail – Plumstead;
Bus – 96, 99, 122, 272, 180, 269

Amenities

B		P	R	👥30		🍎		

Term time courses:

Holiday courses: Christmas, Easter, summer and Saturday morning club (ages 5–12).

Materials provided free: Worksheets; action sheets (related to temporary exhibitions).

Materials from shop:

Research facilities: Small reference library.

Reproduced by permission of the Geographers' A-Z Map Co. Ltd.

Crown copyright reserved

Special provision: No wheelchairs – museum is difficult to access with two flights of stairs. But museum staff willing to make special arrangements, where possible, for various disabled groups.

Linked visits: Greenwich Local History Centre ('Woodlands'), Erith Museum.

Comments: School loan objects collection. Introductory talks can be given to schools, by arrangement.

Admission: Free

104

Greenwich Local History Centre

Address: 'Woodlands'
90 Mycenae Road
Blackheath
London
SE3 7SE

Telephone [01] 858 4631

Contact:
Education Officer

Hours: Monday, Tuesday,
Thursday, 9 am–8 pm
Saturday, 9 am–5 pm
Closed Wednesday, Friday

Exhibits: 'Woodlands' houses
archives and local history
material about the London
Borough of Greenwich. Sources
available include maps, posters,
photographs, postcards, books,
local newspapers, census
information, prints.

Transport: Rail – Charing Cross
or London Bridge to Westcombe
Park or Blackheath; Bus – 53, 54,
75, 108, 108B (to the *Royal
Standard*, Blackheath)

Amenities

| B | L | | R | 🎎25 | | | 🌲 | 🚌 |

Term time courses: *Teachers*:
occasional one day in
cooperation with Gordon
Teachers Centre. *Sixth Form*:
by arrangement with individual
schools, half or one day.

Materials provided free:
Worksheets (list provided).

Materials from shop:
Postcards; books; posters.

Research facilities: Reference
library; archives.

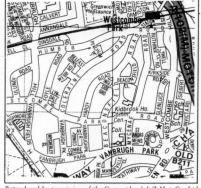

Reproduced by permission of the Geographers' A-Z Map Co. Ltd.

Crown copyright reserved

Special provision: Further Education: half day visits. Disabled
groups: special arrangements can be made for most except
wheelchairs and delicate (too many stairs). Staff will visit latter
groups.

Linked visits: For local history: Greenwich Borough Museum,
Plumstead; Erith Museum; Hall Place, Bexley. For 18th century
local history: Ranger's House.

Comments: Use of original documents in special courses.

Admission: Free

Gunnersbury Park Museum

Address: Gunnersbury Park
London
W3 8LQ

Telephone [01] 992 1612

Contact:
Curator
Secretary

Exhibits: Fine mansion, housing local and social history, archaeology, transport, costume, toys, dolls, crafts, industries including laundry, Victorian kitchen (limited hours). Temporary exhibitions.

Hours: March–Oct., Monday–Friday, 1–5 pm; Saturday, Sunday, Bank Holidays, 2–6 pm
Nov.–Feb., Monday–Friday, 1–4 pm; Saturday, Sunday, Bank Holidays, 2–4 pm

Transport: Tube – Acton Town; Bus – E3 to Pope's Lane

Amenities

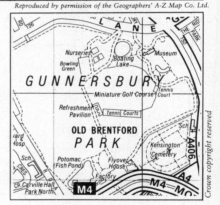

Reproduced by permission of the Geographers' A-Z Map Co. Ltd.

Crown copyright reserved

Term time courses: By arrangement.

Holiday courses: Summer.

Materials provided free: Teachers' information and publicity leaflets.

Materials from shop: Postcards; books (for schools); posters; other.

Research facilities: Reference library; archives; public lectures.

Linked visits: For social history: Museum of London. For toys: Victoria and Albert Museum; Bethnal Green Museum.

Comments:

Admission: Free

Hackney Museum

Address: Central Hall
Mare Street
London
E8 1HE

Telephone [01] 986 6914

Contact:
Curator

Exhibits: Local history collection:
household objects; toys; clothing;
medical; educational.

Hours: Tuesday–Friday,
10 am–12.30 pm, 1.30 pm–5 pm
Saturday, 1.30 pm–5.00 pm
Closed Monday and Sunday

Transport: Tube – Bethnal Green
and then Bus 253 or 106;
Train – Hackney Central

Amenities

B								

Term time courses:

Holiday courses:

Materials provided free: Quiz
sheets for children.

Materials from shop:

Research facilities:

Special provision: Wheelchair
access and disabled toilet.

Reproduced by permission of the Geographers' A-Z Map Co. Ltd.

Crown copyright reserved

Linked visits: For East End history: Hackney Archives (Dalston);
Ragged School Museum; Spitalfields Heritage Centre. For local
history London: Greenwich Museum; Greenwich Local History
Centre; Church Farm Museum; Bromley; Hall Place, Bexley;
Wandsworth and others. For social history: Geffrye Museum;
Museum of London. Out of London: For Labour history:
National Museum of Labour History, 303 Corn Exchange Bldgs.,
Cathedral Street, Manchester [061 832 0691].

Comments: Newly established museum, still relying on small
staff, but keen to make contact with schools and teachers,
especially those of Hackney.

Admission: Free

107

Hall Place, Bexley

Address: Bourne Road
Bexley
Kent
DA5 1PQ

Telephone 0322 526574

Contact:
Assistant Curator,
Ext. 221

Exhibits: House dates from 1540
with 17th century additions.
Permanent exhibition (London
Borough of Bexley); changing displays
(local history theme).

Hours: Monday–Saturday,
10 am–5 pm (or dusk in winter)
Summer only, Sunday, 2–5 pm

Transport: Rail – to Bexley;
Bus – 132, 189, 401, 725;
Green Line 715, 715A to Enfield
Town

Amenities

Term time courses:

Holiday courses:

Materials provided free:
Worksheets; local history fact
sheets.

Materials from shop:
Postcards; posters; other.

Research facilities: Reference
library; archives;
photographic library.

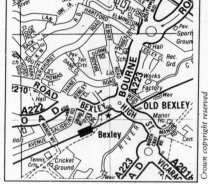

Linked visits: For local history: Erith Museum; Greenwich Local
History Centre ('Woodlands'); Greenwich Borough Museum,
Plumstead.

Comments: Museum is part of the Local Studies Service. A
limited service, by appointment only, to schools, which can
include a talk from Curator.
Erith Museum is a subsidiary of Hall Place.

Admission: Free

Ham House

Address: Richmond
Surrey
TW10 7RS

Telephone [01] 940 1950

Contact:
Resident Officer

Exhibits: Wonderful 17th century mansion of Duke of Lauderdale (1616–82), on bank of the Thames; contains outstanding collection of 17th century furniture, paintings and wall hangings original to the house; restored 17th century garden.

Hours: Tuesday–Sunday, 11 am–5 pm Closed Monday

Transport: Tube – Richmond, then bus (below); Rail – Waterloo to Richmond, then Bus – 71 (to Sandy Lane) or 65 (to *Fox and Duck Inn*), then walk

Amenities

Term time courses:

Holiday courses:

Materials provided free:

Materials from shop: Guidebook; catalogue; postcards.

Research facilities: For educational advice only consult education officer, Victoria and Albert Museum.

Special provision: Guided tours available.

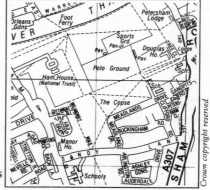

Reproduced by permission of the Geographers' A-Z Map Co. Ltd.

Linked visits: Victoria and Albert Museum (furniture and decorative art of 17th century); National Portrait Gallery and National Army Museum (for history of 17th century Civil War and biographical information about the Lauderdales).

Comments: Closed Mondays. Restaurant closed in winter. House is owned by National Trust and administered by Victoria and Albert Museum.

Admission: Charge. Free to members of National Trust. Pre-booked parties of children free.

Hampton Court Palace

Address: East Molesey
Surrey
KT8 9AU

Telephone [01] 977 8441

Contact:
Education Officer
(enquiries for free book
for schools)

Hours: Summer,
Monday–Saturday,
9.30 am–6 pm; Sunday,
11 am–6 pm; Winter,
Monday–Saturday, 9.30
am–5 pm; Sunday, 2–5 pm

Exhibits: Tudor palace (1514) with
17th and 18th century additions by
Wren and William Kent; tapestries,
paintings and wood carvings;
astronomical clock; outside, maze
and Great Vine (planted 1769).

Transport: Rail – Waterloo to
Hampton Court; Bus – 111, 131,
216, 267, 461; Green Line, 713,
715, 716, 718, 726, 728;
Boat – from Westminster Pier
(telephone [01] 930 0921)

Amenities

B L		60	⚒	🍎	🌲	🚌

Term time courses: *Teachers*:
occasional one day courses.

Holiday courses: Christmas
(occasional), summer.

Materials provided free:
Worksheets.

Materials from shop:
Catalogue; postcards; books
for schools and for public;
posters; other.

Research facilities: Public
lectures in summer.

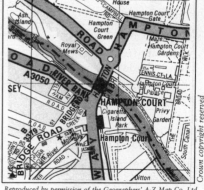

Reproduced by permission of the Geographers' A-Z Map Co. Ltd.

Linked visits: For Tudor architecture: Epping Forest Museum.
For Wren period/18th century architecture: Kensington Palace
(Orangery); Royal Hospital, Chelsea; St Paul's and City churches;
Geffrye Museum; Museum of London.

Comments: School groups of all ages are welcomed but direct
teaching cannot normally be offered except during occasional
courses. If travelling by boat allow extra time.

Admission: Charge. Schools free October to March.

110

Hatfield House

Address: Hatfield
Herts
AL9 5NQ

Telephone 070 72 62823

Contact:
Assistant Curator

Exhibits: Seat of Marquis of Salisbury, built 1607–11 by the Cecil family; many Elizabethan relics and portraits, also later family portraits.

Hours: 26 March–9 Oct.,
Tuesday–Saturday, 12 noon–5 pm
Sunday, 2–5.30 pm
Closed Mondays except Bank Holidays; closed 10 Oct.–25 March

Transport: Rail – Kings Cross to Hatfield

Amenities

Term time courses:

Holiday courses:

Materials provided free:

Materials from shop:
Catalogue; postcards; other.

Research facilities:

Special provision:

Linked visits: Museum of London; Victoria and Albert Museum; Ranger's House (for Tudor projects); National Portrait Gallery; Queen's House (National Maritime Museum).

Comments: School parties can be given guided tour; pre-booking essential. An out of London visit as part of a Tudor project; the House contains many paintings and objects of various centuries, but is essentially a fine example of an Elizabethan mansion and illustrates Tudor history.

Admission: Charge

111

Hayward Gallery

Address: South Bank Centre
Belvedere Road
South Bank
London
SE1 8XZ

Telephone [01] 921 0916
(Education Department)

Contact:
Museum Teacher

Exhibits: Changing exhibitions
of artists, mainly 20th century.

Hours: Monday–Wednesday,
10 am–8 pm
Thursday–Saturday,
10 am–6 pm
Sunday, 12 noon–6 pm

Transport: Tube – Waterloo,
Embankment; Rail – to
Waterloo; Bus – 1, 4, 68, 70,
76, 149, 168A, 171, 176, 188,
502, 507

Amenities

Term time courses:
Occasional, usually evenings.

Holiday courses: Occasional,
Christmas.

Materials provided free:
Teachers' pack; postcards and
other material from Resource
Centre.

Materials from shop: Current
catalogues; postcards; books;
other.

Research facilities:

Reproduced by permission of the Geographers' A-Z Map Co. Ltd.

Special provision: All disabled welcome. Help and wheelchairs
can be provided. Sandwich room occasionally available if pre-
booked.

Linked visits: Mainly for modern art: Tate Gallery; Serpentine
Gallery; Whitechapel Art Gallery. For historical art: National
Gallery; Courtauld Institute Galleries.

Comments: Education handled by South Bank Centre Education
Department, [01] 921 0951.

Admission: Charge varies with exhibitions. Pre-booked school
parties at reduced rates.

112

Heritage Motor Museum

Address: Syon Park
Brentford
Middx

Telephone [01] 560 1378

Contact:
Education Officer

Exhibits: Excellent display of British cars, from 1895 to modern record-breakers. Over 100 cars on display.

Hours: Daily, 10 am–5.30 pm (except Christmas and Boxing Day)

Transport: Tube – Gunnersbury; Bus – 237, 267, 117 (Brent Lea)

Amenities

B			40	‖	⌂	♠	🚌	✎

Term time courses:

Holiday courses:

Materials provided free:
Worksheets.

Reproduced by permission of the Geographers' A-Z Map Co. Ltd.

Materials from shop:
Catalogue; postcards; other.

Research facilities:

Special provision: Disabled groups must be pre-booked; there is wheelchair access.

Linked visits: Science Museum (for history of cars); Vestry House Museum (for the Bremer car 1892–4); Gunnersbury Park Museum. Out of London: National Motor Museum, Beaulieu, Hants.

Comments: Audio visual shows are included in display.

Admission: Charge

Historic Ship Collection of the Maritime Trust

Address: St Katharine's Dock
London
E1

Postal address:
c/o St Katharine Haven Ltd
Ivory House
London
E1 8AT

Telephone [01] 481 0043

Contact:
Schools Officer

Exhibits: Veteran steam coaster (1890), steam tugs, Nore lightship and Thames sailing barge tell the story of Britain's coastal trade, fishing, etc. Exhibitions on board.

Hours: Daily, 10 am–5 pm (or dusk in winter)

Transport: Tube – Tower Hill; Bus – 9A, 42, 78

Amenities

Term time courses:

Holiday courses:

Materials provided free: Worksheets.

Materials from shop: Postcards; posters.

Research facilities:

Special provision:

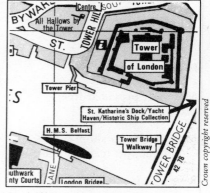

Reproduced by permission of the Geographers' A-Z Map Co. Ltd.

Linked visits: For further studies on both ships and docks: National Maritime Museum; Chatham Historic Dockyard, Kent.

Comments: Introductory talk to pre-booked groups. All ages welcome. Also available for school visits, Schooner *Kathleen and May*, now at St Mary Overy Dock close to Southwark Cathedral.

114

Houses of Parliament, see **Parliament**

Hogarth's House

Address: Hogarth Lane
Great West Road
London
W4 2QN

Telephone [01] 994 6757

Contact:
Education Officer
Secretary

Amenities

B			🎗20		🌲	

Exhibits: Small house displaying many of the engravings and other relics associated with the artist William Hogarth who lived here.

Hours: Weekdays, 11 am–6 pm
Sunday, 2–6 pm
Oct.–March, closed Tuesday

Transport: Tube – Turnham Green and walk (approx. 1 mile)

Term time courses:

Holiday courses:

Materials provided free:

Materials from shop:

Research facilities:

Special provision:

Reproduced by permission of the Geographers' A-Z Map Co. Ltd.

Linked visits: National Gallery (for Hogarth paintings); Tate Gallery; Sir John Soane Museum; Foundling Hospital (portrait of Capt. Coram); Spitalfields Heritage Centre; Guildhall Library (engravings and maps); Museum of London (18th century social history); National Portrait Gallery (biographical).

Comments: The house and its garden is very small and stands on a busy road.

Admission: Free

115

Horniman Museum and Library

Address: London Road
London
SE23 3PQ

Telephone [01] 699 4911/
1872/2339

Contact:
Education Officer, Ext. 32
Senior Teacher, Ext. 38

Hours: Weekdays, 10.30
am–6 pm Sunday, 2–6 pm

Exhibits: Ethnographic displays
illustrating man's beliefs, arts and
crafts; musical instruments from all
over the world; natural history
displays of mammals, birds, fish,
reptiles, invertebrates; aquarium
and bee hive.

Transport: Rail – to Forest Hill;
Bus – P4, 12, 185 (pass the
museum); 63, 122, 124, 171, 194,
12A (close by)

Amenities

B	L		R		♯♯	🍎	🌲	

Term time courses: *Teachers*:
introduction to Museum
courses; half day or one day
courses. *Sixth Form*: study days.
Adult Further Education
courses.

Holiday courses: Christmas,
Easter and summer, Saturdays.
Occasional entrance fee.

Materials provided free:
Printed material for teachers;
colouring sheets for children.

Materials from shop:
Catalogue; postcards; books; charts; slides.

Research facilities: Reference library; public lectures.

Special provision: All disabled groups welcomed (blind, partially
sighted, deaf, part hearing, delicate, slow learners, wheelchairs);
advance booking required.

Linked visits: For ethnography: Museum of Mankind. For
Commonwealth studies: Commonwealth Institute. For natural
history: Natural History Museum.

Comments: A long established and flourishing education service.
Parking opposite Museum in Sydenham Rise.

Admission: Free

116

Imperial War Museum

Address: Lambeth Road
London
SE1 6HZ

Telephone [01] 735 8922

Contact:
Education Officer, Ext. 241

Hours: Monday–Saturday,
10 am–5.50 pm
Sunday, 2–5.50 pm

Exhibits: Two world wars; aspects of 20th century history, including weapons, uniforms, documents, paintings, posters, photographs.

Transport: Tube – Lambeth North, Elephant and Castle; Bus – 1, 3, 10, 12, 44, 45, 53, 68, 109, 141, 155, 159, 171, 172, 176, 177, 184, 188

Amenities

B		P	R	🍴50	🍴		🌲

Term time courses: *Teachers*: occasional. *Sixth Form*: days, about two a term (A-level).

Holiday courses: Christmas Easter, summer. Quizzes and film shows only.

Materials provided free: Worksheets; teachers' information.

Materials from shop: Catalogue; postcards; posters; books; document packs; slides and tapes.

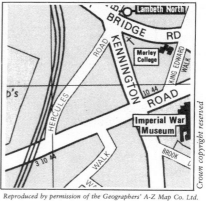

Reproduced by permission of the Geographers' A-Z Map Co. Ltd.

Crown copyright reserved

Research facilities: Reference libraries; photographic archives; lectures.

Special provision: Regular programmes of films and videos of 20th century history (main cinema). Disabled groups if booked in advance.

Linked visits: National Army Museum. Cabinet War Rooms; HMS *Belfast*; Museum of Artillery; Royal Air Force Museum. For social history: Museum of London.

Comments: See separate entries for visits. For extra educational advice, or back-up service to visit, apply Education Officer. Current building programme causes some closures.

Admission: Free

117

Jewish Life, Museum of, see London Museum of Jewish Life

Jewish Museum

Address: Woburn House
Tavistock Square
London
WC1H 0EP

Telephone [01] 388 4525

Contact:
Secretary

Hours: Tuesday–Friday,
Sunday 10am–4pm
Closed Saturday

Exhibits: Unique collection of articles illustrating Judaism and history of the Jewish community in England; 16th century Italian synagogue ark. Scrolls, wedding rings, illuminated marriage contracts, Hanukah lamps, Passover plates, portraits.

Transport: Tube – Euston, Euston Square, Russell Square; Rail – to Euston; Bus – 18, 30, 68, 77A

Amenities

B	L	P	R	25			♠	🚐

Materials provided free: Worksheets (primary and secondary).

Materials from shop: Postcards.

Research facilities:

Special provision: Disabled groups: flat access for wheel-chairs, but no special toilets.

Linked visits: Spitalfields Heritage Centre (telephone [01] 377 6901).

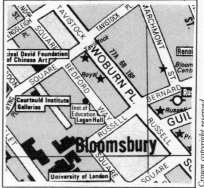

Reproduced by permission of the Geographers' A-Z Map Co. Ltd.

Comments: British Museum (for world religions); London Museum of Jewish Life, Barnet. Two short audio-visual programmes (on Judaism) are shown for secondary and primary age levels. Talks can be given to school groups, especially 14–18 age range, if pre-arranged.

Admission: Free

Johnson's House, see **Dr Johnson's House**

Keats House

Address: Wentworth Place
Keats Grove
London
NW3 2RR

Telephone [01] 435 2062

Contact:
Assistant Curator

Hours: Telephone for
opening times

Exhibits: Attractive early 19th
century furnished house in pretty
garden; displays of letters,
paintings and other material
associated with the poet John
Keats and his circle.

Transport: Tube – Hampstead or
Belsize Park (15 min. walk);
Rail – Hampstead Heath (North
London Line); Bus – 24, 46, C11,
268 nearby

Amenities

B		R 25			♠ 🚌

Term time courses: No
courses at house, but curator
would go to schools (on
request).

Holiday courses:

Materials provided free: Quiz
sheet.

Materials from shop:
Catalogue and book list;
postcards; posters; other.

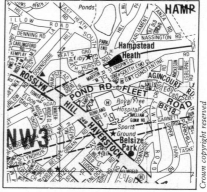

Research facilities: Reference
library (by appointment) (8000–10,000 books).

Special provision: Unsuitable for disabled groups.

Linked visits: National Portrait Gallery; British Museum: British
Library (MSS).

Comments: Guided tours provided by arrangement – over 12s
preferred. House small and specialist, no education staff, but
curator would welcome more school visits. Close to Hampstead
Heath (South End Green).

Admission: Free

Kensington Palace

Address: Kensington Gardens
London
W8 4PX

Telephone [01] 937 9561

Contact:
Education Officer
Secretary (to book free visit)

Hours: Monday–Saturday,
9 am–5 pm
Sunday, 1–5 pm

Exhibits: 17th and 18th century
State Apartments, rooms lived
in by Queen Victoria as a child;
a collection of ladies' and
gentlemen's court dress from
1750–1950.

Transport: Tube – Notting
Hill Gate, High Street
Kensington, Queensway
Bus – 12, 88 to Queensway, 27,
28, 31, 52 to High Street
Kensington

Amenities

B	L		100			♠	

Term time courses: *Teachers*:
occasional one day courses.

Holiday courses: Occasional.

Materials provided free:
Activity sheets.

Materials from shop: Guide
book; postcards.

Research facilities: Reference
library.

Special provision: Education
Room for schools; including
child-size replica costumes.

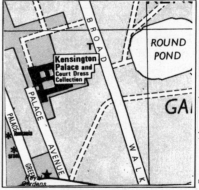

Linked visits: For costume: Victoria and Albert Museum
(costume collection); Bethnal Green Museum; Museum of
London. For Queen Victoria: National Portrait Gallery. Out of
London: Osborne House, Isle of Wight.

Comments: For 18th century architecture: Orangery at this Palace.
Contact Curator of Court Dress at Kensington Palace. A new
and sumptuous display of this fine collection of costumes worn
by ladies and gentlemen for presentation at Court, *c.* 1750–1950.

Admission: Charge. For free educational visit telephone [01] 937
9561.

120

Kenwood, The Iveagh Bequest

Address: Hampstead Lane
London
NW3 7JR

Telephone [01] 348 1286

Contact:
Education Service Secretary

Hours: April–Sept.,
10 am–7 pm
Oct., Feb. March,
10 am–5 pm
Nov.–Jan., 10 am–4 pm

Amenities

Exhibits: Neo-classical house
remodelled by Robert Adam for
the first earl of Mansfield;
furniture, paintings (including
Rembrandt, Gainsborough and
Reynolds); special exhibitions in
August.

Transport: Tube – Hampstead,
Archway, or Golders Green (then
bus 210); Bus – 210

B	L	P	R	𝄞50	🍴	🍎	🌲	🖌

Term time courses: *Teachers*:
occasional one day.

Holiday courses: Christmas.

Materials provided free:
Worksheets; quizzes, some art
material (occasionally).

Materials from shop:
Postcards; catalogue; slides;
other.

Special provision: Disabled
groups (except blind) if pre-
booked and in small groups.
Wheelchair access to ground
floor.

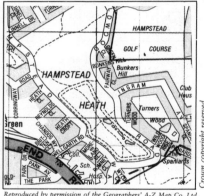

Linked visits: For other buildings by Robert Adam: Syon House;
Osterley Park House. For original drawings by Adam: Sir John
Soane Museum. For 18th century social history: Geffrye Museum;
National Portrait Gallery; Museum of London. For 18th century
paintings: National Gallery; Dulwich Picture Gallery; Tate Gallery
(British collection); National Portrait Gallery. Out of London:
Scone Palace, Perth, Scotland (for further research into
Mansfield family, and portraits of Lord Mansfield and Dido
Belle).

Comments: For help with art historical research, apply Curator.
Coaches must park in Hampstead Lane.

Admission: Free

121

Kew Bridge Engines Trust and Water Supply Museum

Address: The Pumping Station
Green Dragon Lane
Brentford
Middx

Telephone [01] 568 4757

Contact:
Education Officer

Exhibits: World's largest collection of Cornish beam engines which pumped West London's water supply for over a century.

Hours: Saturday, Sunday, Bank Holiday Monday, engines in steam, 11 am–5 pm Weekdays, static exhibition, 11 am–5 pm

Transport: Tube – Gunnersbury, then bus; Rail – to Kew Bridge; Bus – 27, 65, 237, 267

Amenities

weekends

Materials provided free: Teachers' pack.

Materials from shop: Postcards; posters; other. Write to shop manager for further details.

Research facilities: Archive/ study room in course of development.

Special provision: Small archive study room (use by arrangement only). Various related special events, demonstrations and displays. Apply Curator for current calendar of events.

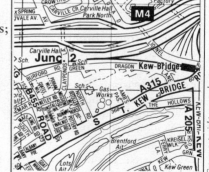

Reproduced by permission of the Geographers' A-Z Map Co. Ltd.

Linked visits: Science Museum.
Out of London: The British Engineerium, Hove, West Sussex.

Comments: Guided tours if pre-booked. School parties of all ages are welcome, but most organise own activities.

Admission: Charge (varies according to whether engines are in steam or static).

Kew Gardens, see **Royal Botanic Gardens**

Kew Palace

Address: Kew Gardens
Richmond
Surrey
TW9 3AB

Telephone [01] 940 3221

Contact:
Education Officer
(to book free visit,
telephone [01] 977 8441)

Amenities

Exhibits: A fine 17th century house occupied by the Royal Family in 1730 and restored to look as it was when George III and Queen Charlotte lived there.

Hours: April–Sept., daily 11 am–5.30 pm

Transport: Tube – Kew Gardens; Rail – Kew Gardens (North London Line), or from Waterloo to Kew Bridge; Bus – 27, 65, 90B, 237, 267

Term time courses:

Holiday courses:

Materials provided free:
Teacher information in course of preparation.

Materials from shop: No shop.

Research facilities:

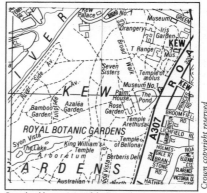

Reproduced by permission of the Geographers' A-Z Map Co. Ltd.

Special provision: Further Education, very occasionally.

Linked visits: For social history: National Portrait Gallery; Geffrye Museum; Museum of London; Victoria and Albert Museum (18th century costume, decorative art, musical instruments).

Comments: No talks or guided tours.

Admission: Charge. Free to pre-booked parties.

123

Knole House

Address: Sevenoaks
Kent
TN15 0RP

Telephone 0732 450608

Contact:
Education Officer
Secretary

Exhibits: Originally an ecclesiastical palace of 15th century, then the seat of the Sackville family (now National Trust). Important collection of late 17th century upholstered furniture; fine paintings associated with the Sackville family; sumptuous furnished State Apartments.

Hours: April–Oct.,
Wednesday–Saturday, 11 am–5 pm;
Sunday, 2–5 pm
Closed Monday, Tuesday, and
Nov.–March

Transport: Rail – Charing Cross, London Bridge to Sevenoaks

Amenities

B						🌲 🚌

Term time courses:

Holiday courses:

Materials provided free:
Guidebook for teachers.

Materials from shop:
Postcards; guidebook;
slides; other.

Research facilities:

Special provision:

Linked visits: For Tudor/
Jacobean projects: Ranger's
House; Geffrye Museum;

Reproduced by permission of the Geographers' A-Z Map Co. Ltd.

Victoria and Albert Museum; National Portrait Gallery.

Comments: Dreamlike mansion set in enormous deer park makes an essential component in study of the Sackvilles, the Cliffords and/or Tudor/Jacobean period.

Admission: Charge
Free to members of National Trust (schools can become corporate members). Party rates (not Tuesday or Friday) if pre-booked.

Leighton House

Address: 12 Holland Park Road
Kensington
London
W14 8LZ

Telephone [01] 602 3316

Contact:
Education Officer

Exhibits: Victorian artist's studio house, designed by Lord Leighton himself; large collection of Victorian art; Arab Hall lined with Islamic tiles; contemporary and historic exhibitions through the year.

Hours: Monday–Saturday, 11 am–5 pm
Closed Sunday

Transport: Tube – High Street Kensington; Bus – 27, 31, 28, 33, 49, 9, 73

Amenities

B	L		R	🎭 25			♣	

Term time courses: *Sixth Form*: half day seminars (art history) (A-level). *Non academic*: by arrangement with school.

Holiday courses:

Materials provided free:

Materials from shop: Postcards; posters.

Research facilities:

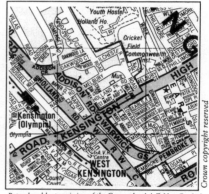

Reproduced by permission of the Geographers' A-Z Map Co. Ltd.

Crown copyright reserved

Special provision: Further Education: Evening lectures.

Linked visits: For late Victorian art and design: Victoria and Albert Museum; William Morris Gallery; Tate Gallery.
For A-level students only: Linley Sambourne House (late 19th century, original furnishings), [01] 994 1019 or 622 6360, phone for booking.

Comments: Older students preferred – from 14+.

Admission: Free

Livesey Museum

Address: 682 Old Kent Road
London
SE15 1JF

Telephone [01] 639 5604

Contact:
Education Officer

Exhibits: Changing
exhibitions, often with local or
social history theme.

Hours: Monday–Saturday,
10 am–5 pm

Transport: Tube – Elephant
and Castle; Rail – to New Cross
Gate, New Cross; Bus – 21, 53,
78, 141, 177

Amenities

B	L		R	♔♔♔ 30			🌲	🚌

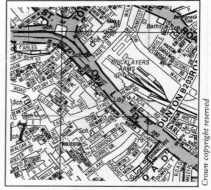

Term time courses:

Holiday courses: Easter,
summer.

Materials provided free:
Worksheets.

Materials from shop:
Postcards; other.

Research facilities:

Special provision: Talks offered to OAPs. Disabled groups (blind,
delicate, and slow learners) by special arrangement.

Linked visits: Cuming Museum.

Comments: Changing exhibitions, often with local history
theme; theme of educational activities change accordingly.
Video shows usually incorporated into exhibitions.
Also drama or craft activities occasionally.

Admission: Free

Living Steam Museum, see **Kew Bridge Engines Trust**

London Museum, see **Museum of London**

London Museum of Jewish Life

Address: 80 East End Road
Barnet
London
N3

Telephone [01] 346 2288

Contact:
Education Officer

Exhibits: Collections and displays illustrating the social and cultural history of London's Jewish community; tailoring workshop; bakery; Worker's Circle office; documents and photographs.

Hours: Monday–Thursday,
10.30 am–5 pm
Sunday, 10.30 am–4.30 pm

Transport: Tube – Finchley Central; Bus – 143

Amenities

| B | L | P | R | 🧑‍🤝‍🧑 25 | 🍴 | | 🌲 🚌 | |

Term time courses: *Sixth Form*: Tour and short talk. School groups of 12+ preferred.

Holiday courses:

Materials provided free: Maps of East End of London; bibliography.

Materials from shop:

Research facilities:
Photographic and documentary archives.

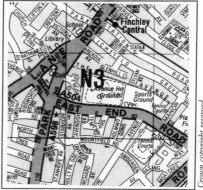

Reproduced by permission of the Geographers' A-Z Map Co. Ltd.

Crown copyright reserved

Special provision: Pensioners and all age groups welcome.

Linked visits: Jewish Museum (for religious and liturgical collections); Spitalfields Heritage Centre (for East End life and small surviving 19th century synagogue building).

Comments: This is a small specialist museum housed at the Sternberg Institute.

Admission: Free

127

London Planetarium

Address: Marylebone Road
London
NW1 5LR

Telephone [01] 486 1121
(for school bookings)

Contact:
Education Officer
(Madame Tussauds)
[01] 935 6861

Exhibits: Planetarium show, with audio and visual effects, on various aspects of astronomy. Astronomers' Gallery of the famous.

Hours: Daily, 11 am–4.30 pm Schools programmes at 11 am, Tuesday–Friday during term-time

Transport: Tube – Baker Street; Bus – 2, 13, 18, 27, 30, 74, 113, 176

Amenities

B	L	P	R	418	¶¶	⌂	♠	🚌

Term time courses: *Teachers*: occasional promotional evenings.

Holiday courses: Pre-recorded show on during holidays.

Materials provided free: Teacher's pack (free between September and May) and worksheet sample for photocopying.

Materials from shop: Catalogue (to personal callers only).

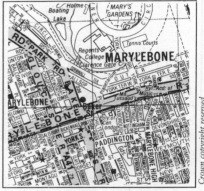

Reproduced by permission of the Geographers' A-Z Map Co. Ltd.

Crown copyright reserved

Research facilities:

Special provision: For deaf and partially hearing: loop system. For slow learners: special programme 10.40 am Mondays. There are *no* lifts for wheelchairs. General programmes every 40 mins from 12.15–4.30 pm.

Linked visits: Planetarium in Old Royal Observatory, Greenwich (contact Education Officer, National Maritime Museum).

Comments: Teachers admitted free as observers to schools programme: apply [01] 935 6861, also for inclusion on mailing list. Talks can be arranged for school groups (all ages).

Admission: Charge. Party rate for 10 or more.

London Toy and Model Museum

Address: 21–23 Craven Hill
London
W2

Telephone [01] 262 7905
262 9450

Contact:
Education Officer
Schools Officer
Secretary

Exhibits: Extensive collection of model trains, static and working; dolls, teddy bears, mechanical toys of all kinds; large working garden railway.

Hours: Tuesday–Saturday, 10 am–5.30 pm
Sunday, 11 am–5.30 pm
Closed Monday, except Bank Holiday

Transport: Tube – Paddington, Lancaster Gate; Bus – 88, 12

Amenities

B	L		R	🧑90	🍴	📖	🌲	🚌

Term time courses: *Teachers*: by arrangement. *Sixth Form*: by arrangement.

Holiday courses:

Materials provided free: Worksheets (nominal charge); quiz (free).

Materials from shop: Catalogue; postcards; posters, other.

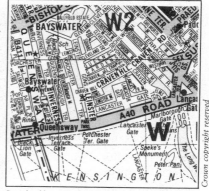

Research facilities:

Special provision: Further education: specialist groups can visit outside normal opening hours, by arrangement.

Linked visits: Bethnal Green Museum; Victoria and Albert Museum; Pollock's Toy Museum; Gunnersbury Park Museum.

Comments: Video shows in the displays.

Admission: Charge

London Transport Museum

Address: Covent Garden
London
WC2E 7BB

Telephone [01] 379 6344

Contact:
Education Officer
Schools Officer

Hours: Daily, 10 am–6 pm (except 24–26 Dec.)

Exhibits: Trains, underground rolling stock, horse and motor buses, trolley buses, trams, models, illustrating the growth of London's transport systems and their impact. Unique working exhibits.

Transport: Tube – Covent Garden, Charing Cross, Leicester Square; Rail – to Charing Cross; Bus – 1, 4, 6, 9, 11, 13, 15, 55, 68, 77, 77A, 77C, 168, 170, 171, 176, 188, 239, 502, 513 to Aldwych

Amenities

B	L		R	🧑🧑🧑 80			🌲 🚌

Term time courses: *Teachers*: one day courses once a term and others occasionally. *Sixth Form*: by arrangement

Holiday courses: Occasional

Materials provided free: Sample worksheets and teachers' pack.

Materials from shop: Buy further worksheets from shop.

Research facilities: Reference library; archives.

Special provision: Disabled groups catered for if pre-booked.

Linked visits: Science Museum (transport section); Museum of London (development of London and social history). For travel and transport in general: Heritage Motor Museum. For railway development in London: North Woolwich Station Museum.

Comments: An opportunity for the 'hands on' museum experience in a museum which allows and expects visitors to participate fully and does not object to children's noise. Coach park for setting down and picking up point only.

Admission: Special rate for pre-booked groups. Free for handicapped children. Free preparatory visit for teacher, arranged through education officer.

London Zoo, see Zoo (London)

Lullingstone Roman Villa

Address: Lullingstone
Nr Dartford
Kent

Telephone 0322 863467

Contact:
Education Officer

Exhibits: Fine mosaic floors in place and some original flint walls of grand Roman villa; now sheltered with modern roof which enables visitors to view the villa in comfort, protected from the weather.

Hours: 15 March–15 Oct., Monday–Saturday, 9.30 am–6.30 pm

Transport: Rail – to Eynsford

Amenities

B						🌲	🚌

Term time courses:

Holiday courses:

Materials provided free:

Materials from shop:
Guidebooks; postcards; other.

Research facilities:

Special provision: Disabled can see all exhibits on ground floor.

Linked visits: British Museum (for Roman projects); Museum of London (for Romans in Britain); Cuming Museum (local Southwark Roman remains); St Bride's Crypt and Church Museum. Out of London: Verulamium, St Albans, Herts.

Comments: Surrounded by beautiful open countryside; take picnic lunch. This historic site makes an excellent complement to visits to the Roman collections in glass case museums. Check opening in 1989.

Admission: Charge. School parties free if pre-booked.

131

Madame Tussaud's Waxworks

Address: Marylebone Road
London
NW1

Telephone [01] 935 6861

Contact:
Group Booking Officer

Exhibits: Exhibition of life-sized wax figures of famous people dating from early 19th century to the present day. *Son et lumière* of battle of Trafalgar.

Hours: Daily, 10 am–6 pm (but groups booking in advance sometimes get in earlier than 10 am)

Transport: Tube – Baker Street; Bus – 2, 13, 18, 27, 30, 74, 113, 176

Amenities

B					🍴	🍎	🌲	🚌

Term time courses:

Holiday courses:

Materials provided free: Worksheets and free guidebook from party booking office.

Materials from shop: Personal callers only: postcards; posters.

Research facilities:

Reproduced by permission of the Geographers' A-Z Map Co. Ltd.

Crown copyright reserved

Special provision: Disabled groups – only three wheelchairs at any one time. Blind may touch exhibits if pre-booked.

Linked visits: Other historic wax models at Westminster Abbey (funeral effigies, including Nelson). National Portrait Gallery (for biographical history); Museum of London, Geffrye Museum (for social history).

Comments: Talks are not given. All ages welcomed.

Admission: Charge. Discount for groups above 10 in number.

Marble Hill House

Address: Richmond Road
Twickenham
Middx
TW1 2NL

Exhibits: Exquisite English 18th century Palladian villa of Henrietta Howard, Countess of Suffolk, mistress of George II.

Telephone [01] 892 5115

Contact:
Curator, [01] 348 1286 (at Kenwood)
Attendant (at house)

Hours: Feb.–Oct.,
Saturday–Thursday, 10 am–5 pm
Nov.–Jan., Saturday–Thursday,
10 am–4 pm
Closed Friday

Transport: Rail – Waterloo to St Margarets

Amenities

B		R				

Term time courses: *Teachers*: occasional one day. *Sixth Form*: by arrangement.

Holiday courses: Occasional.

Materials provided free: Worksheets.

Materials from shop: Guidebook; postcards; other.

Research facilities: Apply to Assistant Curator at Kenwood, [01] 348 1286.

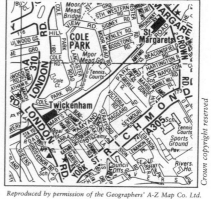

Reproduced by permission of the Geographers' A-Z Map Co. Ltd.

Crown copyright reserved

Special provision: If pre-booked, some disabled groups admitted. Wheelchair access to ground floor only.

Linked visits: Chiswick House; Orleans House; Victoria and Albert Museum; Strawberry Hill (Horace Walpole's house; by appointment only, contact Principal's Secretary, St Mary's College, [01] 892 0051, for information).

Comments: The house is situated in a beautiful park on the bank of the river Thames, ideal for a day visit using river transport.

Admission: Free

Michael Faraday's Laboratory and Museum

Address: The Royal Institution of Great Britain
21 Albemarle Street
London
W1X 4BS

Telephone [01] 409 2992

Contact:
Librarian and Archivist
Secretary

Exhibits: Michael Faraday's Magnetic Laboratory, where many of his discoveries were made, restored to its 1845 form. Unique collection of original apparatus.

Hours: Tuesday and Thursday, 1–4 pm

Transport: Tube – Green Park, Piccadilly; Bus – 14, 19, 22, 38

Amenities

	L			♬♬♩ 25/30			🌲

Royal Inst.

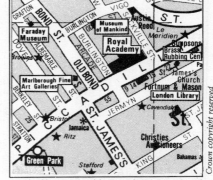

Reproduced by permission of the Geographers' A-Z Map Co. Ltd.

Crown copyright reserved

Term time courses:

Holiday courses:

Materials provided free:

Materials from shop:
Catalogue; postcards.

Research facilities: Library (RI).

Special provision: Christmas lectures on scientific subjects for children (museum open simultaneously).

Linked visits: Science Museum.

Comments: This is a small specialist museum contained within the Royal Institution which was founded in 1799 for the encouragement and promotion of science. Membership provides access to lectures and discourses on science for the lay person and to a valuable scientific library. For further information, apply to Administrative Secretary to the museum, address above.

Admission: Charge. Members of Royal Institution free.

Museum of Artillery, Woolwich (in the Rotunda)

Address: Greenhill
Repository Road
London
SE18

Telephone [01] 854 2242

Contact:
Curator, Ext. 3127

Exhibits: Housed in the Rotunda (based on the shape of a circular tent) designed by Nash (1820), a collection of guns and cannon from 14th to 20th century.

Hours: Summer, weekdays, 12 noon–5 pm; Saturday, Sunday, 1–5 pm
Winter, weekdays, 2–4 pm; Saturday, Sunday, 1–4 pm

Transport: Tube – New Cross, then bus to Woolwich; Bus – 53, 75 (stop outside Royal Artillery barracks), 122A to Queen Elizabeth Hospital

Amenities

B		R ♟♟♟ 100			🌲	

Materials provided free: Worksheets.

Materials from shop: Guidebook; postcards; other.

Special provision: Disabled; help can be arranged for small parties (maximum 10) if pre-booked.

Linked visits: National Army Museum; Imperial War Museum (for military studies). Sir John Soane Museum (for architecture). Out of London: Royal Pavilion, Brighton, East Sussex (designed by Nash).

Comments: Short introductory talk if required. All ages welcome.

Admission: Free

Museum of Childhood, see **Bethnal Green Museum**

135

Museum of Garden History

Address: St Mary-at-Lambeth
(next Lambeth Palace)
London SE1

Telephone [01] 261 1891

Contact: Director

Hours: Monday–Friday
11 am–3 pm
Closed Saturday
Sunday 10.30–5.30 pm
Closed winter (2nd Sunday
Dec.–1st Sunday March)

Exhibits: restored church of
St Mary-at-Lambeth; now
commemorates the 17th
century Tradescant family,
famous collectors of rare
plants and 'curiosities';
owners of London's first
public museum known as
'The Ark' in 1628.

Transport: Tube – Victoria
or Waterloo and Bus 507;
Bus – 3, 77, 159, 170

Amenities

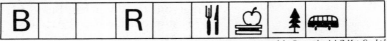

Term time courses: Short talk
provided to groups if
requested and pre-booked.

Materials from shop: Postcards;
books; prints; plants; other.

Special provision: Wheelchair
access but no disabled toilet.

Linked visits: For horticulture:
Royal Botanic Gardens Kew;
Chelsea Physic Garden. Out of
London: For early museum
collections: Ashmolean, Oxford.
For herbal medicine: Wellcome Collection at Science Museum;
British Pharmaceutical Society, Lambeth Road (older students
or teachers).

Comments: Charming replica 17th century 'Knott Garden';
unique Tradescant family tomb, carved elaborately with signs
and symbols of a famous collector of 'rarities' from a crocodile
to antique sculpture. Also tomb of Captain Bligh, (1754–1817),
commander of H.M.S. Bounty. In fine weather, this churchyard
is delightful for picnics; otherwise, refreshments are available
inside museum.

Admission: Free (but donations appreciated).

Museum of London

Address: London Wall
London
EC2Y 5HN

Telephone [01] 600 3699

Contact:
Education Officer,
Ext. 238
Bookings, Ext. 200

Exhibits: Archaeological finds and historic materials, illustrating the growth and character of London from the Thames in pre-history to the present day.

Hours: Tuesday–Saturday, 10 am–6 pm; Sunday, 2–6 pm; Closed Monday

Transport: Tube – St Paul's, Barbican (closed Sunday), Moorgate, Mansion House; Bus – 4, 6, 8, 9, 9A, 11, 15, 22, 25, 141, 279A, 501, 502, 513

Amenities

B	L		R	60	⑂	🍎	🌲	🚌

Term time courses: *Teachers*: half day courses. *Sixth Form*: half or one day courses.

Holiday courses: Christmas, Easter, summer. For children over eight and family groups.

Materials from shop: Postcards; catalogue; books, other.

Research facilities: Reference library; lectures.

Special provision: Disabled groups catered for if pre-booked.

Reproduced by permission of the Geographers' A-Z Map Co. Ltd.

Crown copyright reserved

Linked visits: For study of development of London: Guildhall Library; London Transport Museum; Geffrye Museum; National Portrait Gallery. For social history: GLC Records Office, Clerkenwell.

Comments: Worksheets and other teaching material is supplied for classes but not free. This museum has excellent modern education facilities. A small handling collection is used during some visits. The museum is extremely popular and galleries can become crowded. Advance booking is absolutely essential to avoid disappointment.

Admission: Free

Museum of Mankind

Address: Burlington Gardens
London
W1X 2EX

Telephone [01] 437 2224

Contact:
Education Officer
School Bookings Information
Desk, [01] 323 8043

Exhibits: Changing exhibitions
to illustrate the variety of non-
Western societies and cultures;
for example, Amazonian Indians,
Micronesia, North American
Indians.

Hours: Monday–Saturday,
10 am–5 pm
Sunday, 2.30–6 pm

Transport: Tube – Green Park,
Piccadilly; Bus – 3, 6, 12, 13, 15,
53, 88, 159 to Regent Street, 9,
14, 19, 22, 38, 506 to Piccadilly

Amenities

B	L	P	R	😀😀😀 100		🍎	🌲

Term time courses: *Teachers*:
occasional one or two days.
Sixth Form: occasional one or
two days.

Holiday courses: Christmas,
Easter, summer.

Materials provided free:
Worksheets.

Materials from shop: No
catalogue available. Postcards;
books; posters; other.

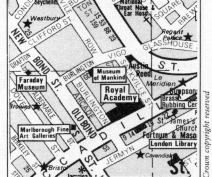

Reproduced by permission of the Geographers' A-Z Map Co. Ltd.

Crown copyright reserved

Research facilities: Reference
library; public lectures; regular film showings.

Special provision: Sometimes, by special arrangement, for blind,
partially sighted and those in wheelchairs.

Linked visits: For ethnography: Horniman Museum;
Commonwealth Institute.

Comments: This collection could also be used in aesthetic
projects as a rich source of craft designs, e.g. textiles, basketry,
woodcarving, etc.

Admission: Free

Museum of the Moving Image (MOMI)

Address: South Bank
London
SE1 8XT

Telephone [01] 928 3535

Contact:
Education Officer

Hours: Tuesday–Saturday,
10 am–8 pm
Sunday, 10 am–6 pm
Closed Monday

Exhibits: MOMI tells the story of the moving image from earliest times to the present day, concentrating on items relating to the history and contemporary practices of cinema and television.

Transport: Tube – Waterloo (South Bank exit); Bus – 1, 5, 68, 70, 171, 177, 188, 502, 507

Amenities

B	L	P	R	👥 50	🍴		🌲		

Term time courses: *Teachers*: one day and half day; occasional workshops; variable fee. *Sixth form*: study days.

Holiday courses: Occasional.

Materials provided free: List from Education Officer. Worksheets for children.

Research facilities: Library and archives in other departments of British Film Institute (contact address above for further information).

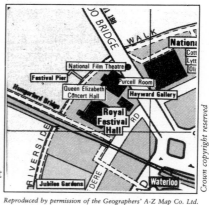

Reproduced by permission of the Geographers' A-Z Map Co. Ltd.

Special provision: Social history days for pensioners. Special needs classes will be catered for on request.

Linked visits: Bethnal Green Museum, Pollock's Toy Museum (for early lantern slides). Science Museum (for film and camera technology). Out of London: National Museum of Photography, Bradford, West Yorks.

Comments: This is the first museum of its kind in Britain. It is closely connected with the National Film Theatre and with the British Film Institute. Video, films and slide shows will be shown regularly. No free educational visit.

Admission: Charge

Museum of the Order of St John
Clerkenwell

Address: St John's Gate
St John's Lane
Clerkenwell
London
EC1M 4DA

Telephone [01] 253 6644

Contact:
Curator
Assistant Curators

Exhibits: The museum is housed in a 16th century gatehouse which was once the entrance to the mediaeval priory of the Knights of St John; modern Order of St John supports St John Ambulance; collection comprises paintings, silver, medals, furniture and medical instruments.

Hours: Tuesday and Friday, 10 am–6 pm Saturday, 10 am–4 pm Other times by arrangement

Transport: Tube – Farringdon; Bus – 4, 5, 243, 277, 279

Amenities

B	L	P	R	🙊50	🍎	🌲

Term time courses:

Holiday courses:

Materials provided free:

Materials from shop: Catalogue; postcards.

Research facilities: Reference library; archives.

Special provision: Guided tours at 11.00 am and 2.30 pm on Tuesday, Friday and Saturday.

Linked visits: Dr Johnson's House.

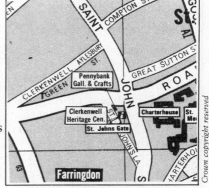

Reproduced by permission of the Geographers' A-Z Map Co. Ltd.

Comments: Talks can be given to children by arrangement, all ages. The gatehouse museum is very small, but the two collections are quite numerous and each merits an hour at least. The nearby Grand Priory Church (foundation 15th century) and Norman Crypt can also be seen, if pre-booked.
Also St James, Clerkenwell, 18th century parish church. Apply to Anthony Weaver, Clerkenwell Heritage Centre, Unit G1, 33 St John's Square, London, EC1. Telephone [01] 250 1039.

Admission: Free – donations requested.

140

Musical Museum

Address: 368 High Street
Brentford
Middx
TW8 0BD

Telephone [01] 560 8108

Contact:
Curator

Exhibits: Housed in a former
church building; ten reproducing
piano systems, three 'pipe organs';
music boxes; street pianos, barrel
pianos, harmoniums.

Hours: April–Oct. only, Saturday,
Sunday, 2–5 pm

Transport: Tube – Gunnersbury,
then Bus – 237 or 267 (alight near
gasholder)

Amenities

B			R	𝄞𝄞𝄞 40					🚌	

Term time courses:

Holiday courses:

Materials provided free:

Materials from shop:
Postcards; books; posters;
other.

Research facilities:

Special provision:

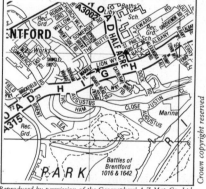

Reproduced by permission of the Geographers' A-Z Map Co. Ltd.

Crown copyright reserved

Linked visits: For other collections of musical instruments:
Victoria and Albert Museum (musical instruments); Horniman
Museum (ethnic instruments); Fenton House (early keyboard);
Museum of Mankind (ethnic); Ranger's House (Dolmetsch
collection); Kneller Hall (military instruments).

Comments: Guided tour (1½ hours) can be arranged if
prebooked. Concerts fortnightly during summer evenings. Send
SAE for concert list, party form PV15, or any information.
Although some other collections of musical instruments are listed
above, this is a unique collection of mechanical keyboard
instruments and there is nothing exactly like it.

Admission: Charge (special rate for school parties).

National Army Museum

Address: Royal Hospital Road
Chelsea
London
SW3 4HI

Telephone [01] 730 0717

Contact:
Education Officer, Ext. 28

Exhibits: History of the British
Army, 1485–1982, and forces
in former colonies, especially
India. Uniforms, weapons,
paintings, medals, documents;
colours and other military relics.

Hours: Monday–Saturday,
10 am–5 pm; Sunday,
2–5.30 pm

Transport: Tube – Sloane
Square (15 min. walk);
Bus – 11, 19, 22, 39, 137
(Pimlico Road)

Amenities

Term time courses: *Teachers*:
occasional one day. *Sixth
Form*: by arrangement.

Holiday courses: Easter,
summer.

Materials provided free:
Teacher information; sample
worksheet.

Materials from shop:
Postcards; books; other.

Research facilities: Reference
library.

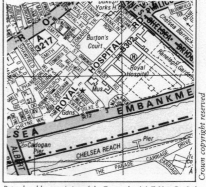

Reproduced by permission of the Geographers' A-Z Map Co. Ltd.

Crown copyright reserved

Special provision: Disabled groups by arrangement.

Linked visits: For military projects: Imperial War Museum;
Tower of London (Royal Armouries); Museum of Artillery,
Woolwich. For World Wars I and II: Imperial War Museum;
Cabinet War Rooms; Royal Air Force Museum, Hendon; HMS
Belfast. For 17th century Civil War: National Portrait Gallery.

Comments: Modern museum; usually less crowded than bigger
national collections.

Admission: Free

142

National Gallery

Address: Trafalgar Square
London
WC2N 5DN

Telephone [01] 839 3321

Contact:
Education Officer, Ext. 286
Secretary, Ext. 290

Hours: Weekdays,
10 am–6 pm; Sunday, 2–6 pm

Exhibits: European paintings
from about 1250–1900:
Leonardo da Vinci, Rembrandt,
Van Gogh and many others.

Transport: Tube – Charing
Cross, Leicester Square; Rail – to
Charing Cross; Bus – 12, 53, 24,
29, 3, 11, 88, 159, 170, 1, 1A, 6,
9, 13, 15, 15A, 77, 77A, 172, 176

Amenities

| B | L | P | R | 👥 60 | 🍴 | 🍎 | 🌲 | |

Term time courses: *Teachers*:
three day and one day. *Sixth
Form*: one day.

Holiday courses: Christmas,
Easter, summer.

Materials provided free:
Worksheets; teachers' leaflets
and monthly programme.

Materials from shop:
Catalogue; postcards; books
for schools as well as for
general public; posters; slides;
other material.

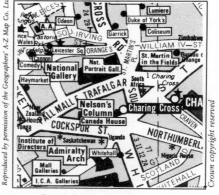

Reproduced by permission of the Geographers' A-Z Map Co. Ltd.

Crown copyright reserved

Research facilities: Reading room and catalogues; public
lectures; continuous audio-visual programmes.

Special provision: For most disabled groups (except blind) by
special arrangement. Lift and ramps for wheelchairs. Special
worksheet for slow learners.

Linked visits: For 17th and 18th century art: Tate Gallery (British
collection); Dulwich Picture Gallery; Kenwood, The Iveagh
Bequest; Wallace Collection. For Renaissance art and
Impressionists: Courtauld Institute Galleries. For prints and drawings
by Old Masters: British Museum; Victoria and Albert Museum.

Comments: Imaginative and entertaining holiday projects for
children. Teachers of all subjects benefit from gallery in-service
courses to discover the considerable cross-curricular potential in
the collection.

Admission: Free

National Maritime Museum

Address: Romney Road
Greenwich
London SE10 9NF

Telephone [01] 858 4422

Contact:
Education Officer, Ext. 245
Schools Officer, Ext. 277
Secretary

Hours: Summer, Easter
Monday–31 Oct., Weekdays,
10 am–6 pm, Sunday, 2–6 pm
Winter, 1 Nov.–Thursday
before Easter, Weekdays,
10 am–5 pm, Sunday, 2–5 pm

Exhibits: British maritime history,
actual craft, ship models,
instruments, paintings, uniforms,
medals, swords, etc. Figureheads,
state barges, archaeology of water
transport. Old Royal
Observatory; Planetarium.

Transport: Rail – from Charing
Cross, London Bridge, or Cannon
Street to Maze Hill or Greenwich;
Bus – to Main Building, 108B,
177, 180; to Old Royal
Observatory, 53, 54, 75

Amenities

B	L		R			🍎	🌲	🚌

Term time courses: *Teachers,
Sixth Form*: occasional.

Holiday courses: Occasional

Materials provided free:
Worksheets; fact sheets.

Materials from shop: Postcards
catalogue; books; other.

Research facilities: Reference
library; archives; public lectures.

Special provision: Adult
education classes. For blind
and partially sighted, handling
collection (by special arrangement).

Linked visits: For study of ships: Historic Ship Collection; *Cutty
Sark* Clipper Ship (*Gipsy Moth IV* nearby); HMS *Belfast* (Schooner
Kathleen and May nearby). Docks: Chatham Historic Dockyard.
Architecture: Banqueting House, Whitehall; Hampton Court
Palace. Samuel Pepys projects: Queen's House (see page 159).

Comments: In addition to its fine collection of maritime history,
the museum is housed in one of the most beautiful buildings in
London, and includes the Queen's House (Inigo Jones).

Admission: Charge (children under seven free).

National Portrait Gallery

Address: St Martin's Place
London
WC2H 0HE

Telephone [01] 930 1552

Contacts:
Education Officer, Ext. 252
Schools Officers,
Ext. 278, 253
Secretary, Ext. 239

Exhibits: Portraits of famous faces in British history (social, military and cultural) from the 15th century to the present day; frequent temporary exhibitions.

Hours: Monday–Friday, 10 am–5 pm; Saturday, 10 am–6 pm; Sunday, 2.30–6 pm

Transport: Tube – Leicester Square, Charing Cross; Rail – to Charing Cross; Bus – 12, 53, 24, 11, 29, 88 and others

Amenities

B	L	P	R	🚶🚶🚶 35/90			🌲	🖌️

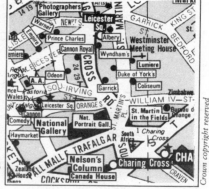

Reproduced by permission of the Geographers' A-Z Map Co. Ltd.

Crown copyright reserved

Term time courses: *Teachers:* one day courses (occasional joint courses with other places). *Sixth Form:* days, by arrangement.

Holiday courses: Christmas, Easter, summer.

Materials provided free: Worksheets.

Materials from shop: Postcards; catalogue; books; slides; other.

Research facilities: Public lectures; library and archives at Carlton House (write to Education Officer).

Special provision: Open University (May–August); University of London extra mural (October–December) and other organisations upon request. Some disabled groups (delicate, wheelchair, slow learners), by arrangement.

Linked visits: For social history: Geffrye Museum; Museum of London; National Army Museum; Imperial War Museum. Portraits for art: Tate Gallery; Kenwood; Ranger's House.

Comments: Entrance charge for holiday courses for children. No infants (five to eight years). Special art sessions for children during projects.

Admission: Free

National Postal Museum

Address: King Edward Building
King Edward Street
London
EC1A 1LP

Telephone [01] 235 8000

Exhibits: The Reginald M. Philips Victorian Collection of issued stamps and essays. Various exhibitions on post office themes held every year.

Hours: Monday–Thursday, 10 am–4.30 pm
Friday, 10 am–4 pm

Transport: Tube – St Pauls; Bus – 8, 25, 22, 4, 141

Amenities

B		P	R	👥👥👥 60			🌲	🚌

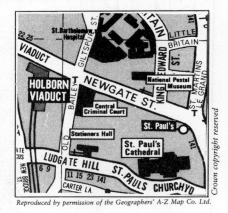

Reproduced by permission of the Geographers' A-Z Map Co. Ltd.

Crown copyright reserved

Term time courses:

Holiday courses:

Materials provided free: Worksheets (on current exhibitions).

Materials from shop: Catalogue; postcards; other.

Research facilities: Reference library; archives.

Special provision: Talks given to school groups on request.

Linked visits: For postal history: Bruce Castle Museum.

Comments: Photographs of Penny Black stamps available. Video shows included in exhibition.

Admission: Free

Natural History Museum
British Museum

Address: Cromwell Road
South Kensington
London
SW7 5BD

Telephone [01] 938 9123
938 9090
(for educational enquiries)

Contact:
Education Officer
Secretary (Bookings)
[01] 938 9090

Exhibits: Exhibitions include human biology; introducing ecology; dinosaurs and their living relatives; man's place in evolution; origin of species; British natural history; minerals; animal groups and fossils.

Hours: Weekdays, 10 am–6 pm
Sunday, 1–6 pm

Transport: Tube – South Kensington; Bus – 14, 30, 45, 49, 74, 39A (Saturday only)

Amenities

B	L	P		90	¶¶	🍎	♣	

Term time courses: *Teachers*: evening, half day or full day. *Sixth Form*: at Christmas, two special one-day symposia.

Holiday courses: Easter, summer.

Materials provided: List available; worksheets, teacher packs. (Free samples and then order as specified.)

Materials from shop: Catalogue; postcards; books for schools and general public; posters; slides; other.

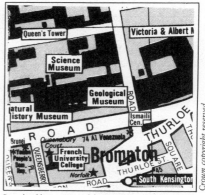

Reproduced by permission of the Geographers' A-Z Map Co. Ltd.

Crown copyright reserved

Research facilities: Museum Teachers' Centre provides materials, reference literature and advice.

Special provision: For blind and partial sighted (by arrangement), also occasional exhibitions. Deaf and partially hearing – lecture room has hearing loop.

Linked visits: For fossils and dinosaurs: Geological Museum. For natural history: Horniman Museum, and numerous small local museums such as Epping Forest Museum, Forty Hall, etc.

Comments: Volunteer guides give talks to 6–11 year-old school groups. Occasional artist in residence, working with children in art projects with natural history themes.

Admission: Charge

147

North Woolwich Station Museum

Address: Pier Road
London
E16 2JJ

Telephone [01] 474 7244

Contact:
Passmore Edwards Museum
(see below)
Admin Officer
(Old Station)
[01] 474 7244

Exhibits: Superbly restored
Victorian station with platform
canopy and restored ticket office;
restored locomotives, some 'in
steam'; relics, models, documents
on history of Great Eastern
Railway.

Hours: Monday–Saturday,
10 am–5 pm
Sunday and Bank Holidays,
2–5 pm

Transport: Tube – Stratford then
Bus 69; Rail – Charing Cross to
Stratford, then train to North
Woolwich

Amenities

Term time courses: *Teachers*:
occasional day courses.

Holiday courses: Summer:
children's activities

Materials provided free:
Worksheets; art materials.

Materials from shop:
Postcards, books, other.

Research facilities:

Special provision:

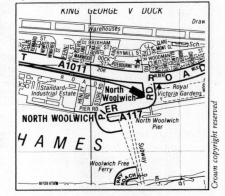

Linked visits: For history of transport: Science Museum; London
Transport Museum. For social history of travel in London:
Museum of London.

Comments: This museum is a branch of the Passmore Edwards
Museum. For an educational visit to the Old Station, or for
further information about educational facilities there, contact
Extension Services, Passmore Edwards Museum [01] 534 0276.

Admission: Free

Old Royal Observatory, Greenwich (and Planetarium in South Building)

Address: National Maritime
Museum
Romney Road
Greenwich
London
SE10 9NF

Telephone [01] 858 4422

Contact:
Schools Officer, Ext. 277

Exhibits: Flamsteed House,
designed by Wren on orders of
Charles II for the first
Astronomer Royal, John
Flamsteed, and his Observatory;
house furnished as in late 17th
century; also 18th and 19th
century observatory buildings;
interesting displays of nautical
instruments and clocks.

Hours: As National Maritime
Museum

Transport: As National
Maritime Museum

Amenities nearby

B		R		¶¶		♠	

Term time courses:

Holiday courses:

Materials provided free:

Materials from shop:
Guidebooks; postcards; other.

Research facilities: Apply
National Maritime Museum.

Special provision:

Linked visits: For astronomy:
London Planetarium. For clocks: British Museum; Clock Museum
at Guildhall Library.

Comments: The Old Royal Observatory comes for
administrative purposes under the National Maritime Museum.
However, it well merits a visit on its own account either from
historical or architectural or scientific standpoints. It is
beautifully situated on a hill overlooking Greenwich.

Admission: See National Maritime Museum.

149

Old St Thomas' Operating Theatre and Herb Garret

Address: Chapter House
St Thomas Street
London
SE1

Telephone (Guy's Hospital)
[01] 407 7600

Contact:
Curator, Ext. 2739, 3140

Exhibits: Artefacts and medical instruments relating to medical and especially surgical history at Guy's and St Thomas' Hospitals, 18th–19th centuries; also 19th century female operating theatre.

Hours: Monday, Wednesday, Friday, 12.30–4 pm
Tuesday, Thursday, by prior arrangement (minimum group of 16 persons)

Transport: Tube – London Bridge; Bus – 70, or any route to Borough High Street or London Bridge

Amenities

B		R	🙎🙎🙎 50				

Term time courses:

Holiday courses:

Materials provided free:

Materials from shop:

Research facilities:

Special provision: Disabled groups: delicate and slow learners accepted by special arrangement out of normal opening hours.

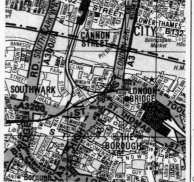

Reproduced by permission of the Geographers' A-Z Map Co. Ltd.

Linked visits: Science Museum (Wellcome Medical History Collection).

Comments: Only suitable for older children (11 and upwards). All pre-booked groups are given half hour talk on early 19th century surgery.

Admission: Charge

Orleans House Gallery

Address: Riverside
Twickenham
Middx
TW1 3DJ

Telephone [01] 892 0221

Contact:
Education Officer
Secretary

Exhibits: Early 18th century
Octagon Room surviving from a
Thameside villa once lived in by the
Duc d'Orleans. The magnificent
domed room is now used for
concerts and the adjoining wing as an
art gallery for changing exhibitions
on various themes.

Hours: April–Sept.,
Tuesday–Saturday, 1–5.30 pm;
Sunday, 2–5.30 pm
Oct.–March, Tuesday–Saturday,
1–4.30 pm; Sunday, 2–4.30 pm

Transport: Rail – from Waterloo to
Twickenham or St Margarets;
Bus – 33, 90B, 202, 270, 290
(weekdays), 33, 90B, 290 (Sundays)

Amenities

B									

Term time courses:

Holiday courses:

Materials provided free:

Materials from shop:

Research facilities:

Special provision:

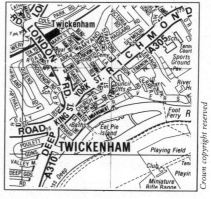

Linked visits: For 18th century
architecture: Marble Hill
House; Strawberry Hill.
(Horace Walpole's house; by
appointment only, contact principal's secretary, St Mary's
College, [01] 892 0051, for information.)

Comments: Could be incorporated in local studies or as part of
Thames environmental project. Very beautiful walks in
surrounding park. Ferry boat across the river to Ham House.

Admission: Free

Osterley Park House

Address: Isleworth
Middx
TW7 4RB

Telephone [01] 560 3918

Contact:
Residential Officer

Exhibits: An elegant house situated in a large landscaped park; state rooms and original furniture designed by Robert Adam in late 18th century (including notable 'Etruscan Room').

Hours: Tuesday–Sunday, 11 am–5 pm
Bank Holiday Monday, 11 am–5 pm

Transport: Tube – Osterley; Bus – 9, 116 (to Osterley station)

Amenities

Term time courses:

Holiday courses:

Materials provided free:

Materials from shop: Guidebook; postcards; other

Research facilities: Contact education department at Victoria and Albert Museum for advice and help.

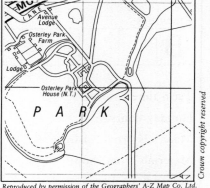

Reproduced by permission of the Geographers' A-Z Map Co. Ltd.

Crown copyright reserved

Special provision: Guided tours can be provided.

Linked visits: For Robert Adam architecture: Syon House; Kenwood; Sir John Soane Museum (for original Adam drawings). For late 18th century art and history: Victoria and Albert Museum.

Comments: Restaurant closed in winter.

Admission: Charge

152

Parliament

Address: Public Information
 Office
 House of Commons
 London
 SW1A 0AA

Telephone [01] 219 4750
 219 6573

Contact:
Education Officer

Exhibits: The new Palace of
Westminster, which
incorporates the ancient (11th
century) Westminster Hall,
was designed by Sir Charles
Barry and built in 1840–50.

Hours: By arrangement

Transport: Tube –
Westminster; Bus – 3, 11, 12,
24, 29, 53, 70, 76, 77, 88, 109,
170, 172, 184, 500

Amenities

B				🚻 48				

see
below

inc.
staff

Term time courses:

Holiday courses:

Materials provided free:

Materials from shop:
Speaker's Art Fund bookstall,
St Stephen's Hall; guidebook
and other.

Research facilities:

Special provision: New audio
visual programme available for
loan from CSL Visions, [01]
883 1186.

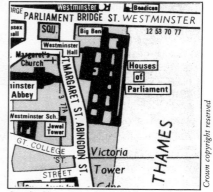

Linked visits: For history of London: Museum of London;
Guildhall Library. For 19th century architecture, Gothic
Revival: Victoria and Albert Museum.

Comments: Programme suitable for GCSE or A-level courses.
Autumn visits for schools (September–October).
Apply by 25 April to education officer (see above). Other specific
visits through a Member of Parliament.

Admission: Charge

153

Passmore Edwards Museum

Address: Romford Road
Stratford
London
E15 4LZ

Telephone [01] 534 0276

Contact:
Principal Assistant Curator
Assistant Curators

Exhibits: Permanent displays of archaeology, local history, biology and geology relating to geographical county of Essex. Special exhibitions; nature reserve; North Woolwich old station (new museum).

Hours: Monday–Friday,
10 am–6 pm
Saturday, 10 am–5 pm
Sunday, Bank Holidays, 2–5 pm

Transport: Tube – Stratford;
Bus – 25, 86, 169

Amenities

B			R	👥👥👥 30		🍎📚	🌲	

Term time courses: *Teachers*: occasional evening courses 4.15–6 pm.

Holiday courses: Easter, summer.

Materials provided free: Worksheets.

Materials from shop: Catalogue; postcards; books.

Research facilities: Archives (by arrangement); public lectures.

Special provision: Adult education courses, evenings. Disabled groups (wheelchairs not suitable for nature reserve, but accepted in Museum).

Linked visits: For natural history studies: Epping Forest Museum.

Comments: Handling sessions for schools by arrangement with 'Extension Services' for schools.
North Woolwich Station Museum – New railway museum under management of Passmore Edwards Trust at Pier Road, London, E16 2JJ. Enquiries: [01] 474 7244.

Admission: Free

154

Planetarium, see **London Planetarium; Old Royal Observatory**

Pollock's Toy Museum

Address: 1 Scala Street
London
W1

Telephone [01] 636 3452

Contact:
Secretary

Exhibits: Toys and dolls of all sorts, including some folk toys and many 19th century ones. Housed in the small rooms of a typical London 19th century house.

Hours: Weekdays, 10 am–5 pm
Closed Sunday, Bank Holidays

Transport: Tube – Goodge Street;
Bus – 14, 24, 29, 73, 134, 176

Amenities

B			40 prim 30 sec			🌲	

Term time courses:

Holiday courses:

Materials provided free:
Teachers' leaflet.

Materials from shop: Large selection of toys, especially traditional toys (see below).

Research facilities:

Special provision:

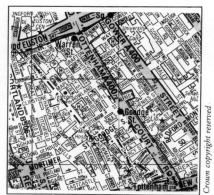

Reproduced by permission of the Geographers' A-Z Map Co. Ltd.

Linked visits: For toys: London Toy and Model Museum; Bethnal Green Museum; Victoria and Albert Museum; Museum of London.

Comments: Sometimes possible to arrange a toy theatre showing if pre-booked. Toy shop with excellent selection of toys on ground floor. Small groups (fewer than 20) strongly advisable.

Admission: Charge

Prince Henry's Rooms

Address: 17 Fleet Street
London
EC4

Telephone [01] 353 7323

Contact:
Education Officer
Secretary

Exhibits: House which survived the Great Fire of London (1666); great room with outstanding plasterwork ceiling; shows small exhibition on life and times of Samuel Pepys.

Hours: Monday–Friday, 1.45–5 pm
Saturday, 1.45–4.30 pm

Transport: Tube – Temple; Bus – 4, 6, 9, 9A, 11, 15, 45, 46, 63 and others

Amenities

Term time courses:

Holiday courses:

Materials provided free:

Materials from shop: Books; postcards.

Reproduced by permission of the Geographers' A-Z Map Co. Ltd.

Crown copyright reserved

Research facilities:

Special provision

Linked visits: For Samuel Pepys and the Great Fire: Museum of London; National Portrait Gallery; St Olave's Church, Hart Street (Pepys memorabilia).

Comments: Suitable for a small group of older students. The name Prince Henry's Rooms derives only from a decorative motif incorporating name and date of Henry, son of James I.

Admission: Charge

156

Public Record Office

Address: Chancery Lane
London
WC2

Telephone [01] 878 3666

Contact:
Curator
Education Officer

Exhibits: New thematic display, including Domesday Book, Shakespeare's will, 1225 reissue of Magna Carta, and other important material up to the 20th century.

Hours: Monday–Friday, 1–4 pm

Transport: Tube – Chancery Lane, Temple; Bus – 2, 6, 8, 9, 11, 15, 15A, 25, 171, 501, 502, 513

Amenities

B	L			🌲🌲🌲 25			🌲		

Reproduced by permission of the Geographers' A-Z Map Co. Ltd.

Term time courses:

Holiday courses:

Materials provided free:

Materials from shop:

Research facilities: Archives; census records.

Special provision:

Linked visits: For other archives relating to London: GLC Records Office, Clerkenwell. For documents and MSS: British Library.

Comments: Important resource for older students of history.

Admission: Free

157

Queen's Gallery, The

Address: Buckingham Palace
London
SW1

(Entered from Buckingham
Gate)

Telephone [01] 930 4832

Contact:
Enquiries

Exhibits: Long-term
exhibitions held of pictures and
works of art in the Royal
collection.

Hours: Tuesday–Saturday,
11 am–5 pm
Sunday, 2–5 pm
Closed Monday

Transport: Tube – Victoria;
Rail – to Victoria; Bus – 2, 11,
24, 36 and others to Victoria,
then walk

Amenities

B	L			30			♠	

Term time courses:

Holiday courses:

Materials provided free:

Materials from shop:
Catalogue; postcards; books;
other.

Research facilities:

Special provision: Not suitable for disabled groups.

Linked visits: For art and decorative arts: Victoria and Albert
Museum; National Gallery.

Comments: A small attractive gallery showing remarkable
exhibitions of rarely seen treasures from the extraordinary rich
royal collections of paintings, drawings, sculpture, furniture,
ceramics, silver, etc. Small groups of older students
recommended.

Admission: Charge

158

Queen's House, Greenwich

Address: National Maritime
 Museum
 Romney Road
 Greenwich
 London
 SE10 9NF

Telephone [01] 858 4422

Contact:
Education Officer, Ext. 245

Exhibits: Classical style house
designed by Inigo Jones and
begun in 1616 for Anne of
Denmark, consort of James I;
now incorporated in National
Maritime Museum; fine
collection of paintings; material
relating to Samuel Pepys.
Splendid marble galleried hall
with painted ceiling.

Hours: As National Maritime
Museum

Transport: As National
Maritime Museum

Amenities

B									

Term time courses:

Holiday courses:

Materials provided free:

Materials from shop:
Guidebook; postcards; other.

Research facilities: As
National Maritime Museum.

Special provision:

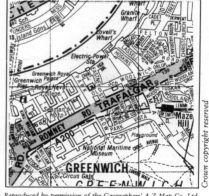

Reproduced by permission of the Geographers' A-Z Map Co. Ltd.

Linked visits: For 17th century architecture: Banqueting House,
Whitehall. For biographical and historical background: National
Portrait Gallery. For Samuel Pepys: St Olave's Church, Hart Street
(Pepys' church at the time of his diary, containing a portrait
bust of Mrs Pepys). For Restoration portraits: Ranger's House.

Comments:

Admission: See National Maritime Museum

Queen's Mews, see **Royal Mews**

Ragged School Museum Trust

Address: 46–48 Copperfield Road
Bow
London
E3 4RR

Telephone [01] 232 2941

Contact:
Education Officer

Exhibits: Huge Victorian Canalside Building, once Dr Barnardo 'Ragged School'; East End History; 'sweatshop rag trade'; re-created Victorian classroom for visiting schools (lessons by arrangement).

Hours: By arrangement only

Transport: Tube – Mile End; Bus – 10, 25, 253; Train – Stepney East

Amenities

B		R				🌲	🚌

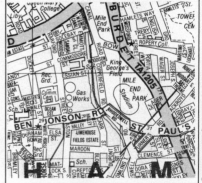

Term time courses: *Teachers*: occasional courses.

Holiday courses:

Materials provided free:

Materials from shop:

Research facilities:

Special provision: 'Victorian lesson' using actual classroom furniture, children in costume; the kind of role playing which greatly delights primary age children.

Linked visits: For East End history: Spitalfields Heritage Centre; Salvation Army Museum. For Social history: Geffrye Museum; Museum of London.

Comments: This is a 'newly saved' group of canal-side buildings with much potential, but as yet, not many items in the collection. Organisers are very anxious to make contact with schools, especially local and East End. As it is open 'by arrangement', schools will be guaranteed full attention from the management, and no competition with visiting groups! Ideal for students who require individual treatment.

Admission: Free

Ranger's House

Address: Chesterfield Walk
Blackheath
London
SE10

Telephone [01] 853 0035

Contact:
Curator, [01] 348 1286
(at Kenwood)
Head Attendant (at house)

Hours: Daily, 10 am–5 pm, including Sunday (closes 4 pm, Nov.–Jan.)

Exhibits: House associated with Lord Chesterfield in the 18th century; now contains the Suffolk collection including Jacobean portraits by William Larkin; later 17th century Royal portraits; some 18th century portraits. New galleries show Dolmetsch collection of musical instruments.

Transport: Rail – to Blackheath or Greenwich (15 min. walk); Bus – 53 (passes house), 54, 75; Green Line 701; Boat – to Greenwich from Westminster and Charing Cross piers

Amenities

B		P	R	30				🌲	🚌	✎

Term time courses: *Teachers* and *Sixth Form* by arrangement.

Holiday courses: Summer (three weeks).

Materials provided free: Worksheets; teachers' information; art material (during projects).

Materials from shop: Books; postcards; slides.

Special provision: Small disabled groups welcomed if pre-booked. Wheelchair lift to ground floor only.

Reproduced by permission of the Geographers' A-Z Map Co. Ltd.

Linked visits: For Tudor/Jacobean projects: Museum of London; Geffrye Museum; National Portrait Gallery. For musical instruments: Victoria and Albert Museum; Fenton House.

Comments: Day projects for all age groups by arrangement. One child-size replica costume in the house reflects the portrait of a Howard boy aged 4½ (in the Suffolk Collection) and is used in junior visits.

Admission: Free

Royal Academy of Arts

Address: Burlington House
Piccadilly
London
W1V 0DS

Telephone [01] 734 9052

Contact:
Education Officer
Secretary

Exhibits: Major fine art exhibitions throughout the year. The Michelangelo *Tondo* can be seen by appointment. Full educational programme related to each exhibition.

Hours: Daily, 10 am–6 pm (including weekends)

Transport: Tube – Green Park, Piccadilly; Bus – 9, 14, 19, 22, 38, 73

Amenities

B	L	P		👪50	🍴		🌲	

Term time courses: *Teachers*: one day or half day conference with each exhibition. *Sixth Form*: study days.

Holiday courses:

Materials provided free: Teacher's pack with each exhibition.

Materials from shop: Postcards; posters; books; slides; other.

Research facilities:

Reproduced by permission of the Geographers' A-Z Map Co. Ltd.

Special provision: Most disabled groups, but not blind or partially sighted. There is wheelchair access. Pre-booking essential.

Linked visits: For sculpture: Victoria and Albert Museum; British Museum. For contemporary art: Serpentine Gallery; Tate Gallery; Whitechapel Art Gallery; Hayward Gallery. For projects on Reynolds and other Royal Academicians: National Gallery; Kenwood.

Comments: The Education department is a relatively new feature. Officers are anxious to develop work with schools in relation to current exhibitions.

Admission: Charges vary with exhibition.

162

Royal Air Force Museum

Address: Grahame Park Way
Hendon
London
NW9 5LL

Telephone [01] 205 2266

Contact:
Education Officer
Secretary

Exhibits: Over 100 years of aviation history; 40 aircraft and 12 galleries of general exhibits. Battle of Britain and Bomber Command museums in same complex.

Hours: Monday–Saturday, 10 am–6 pm
Sunday, 2–6 pm

Transport: Tube – Colindale; Bus – 79

Amenities

B		P	R	👥 180	🍴	📚🍎	🌲	🚌

Materials provided free: Sample worksheets (for duplication) for teachers.

Materials from shop: Catalogue; postcards; posters and other.

Research facilities: Reference library; archives.

Special provision: For blind and partially sighted; special guide provided.

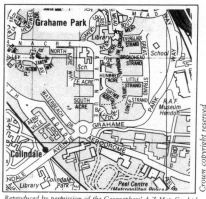

Reproduced by permission of the Geographers' A-Z Map Co. Ltd.

Linked visits: For design engineering and aircraft engineering: Science Museum. For World War II: Imperial War Museum; National Army Museum.

Comments: Audio visual shows daily. Film shows Tuesday–Friday pm. (Programmes changed weekly and taken from film archives). Free entrance to RAF Museum, but entrance charges to two new associated sections, Bomber Command Museum and Battle of Britain Museum.

Admission: Free

Royal Armouries, see Tower of London

Royal Botanic Gardens, Kew

Address: Kew
Richmond
Surrey
TW9 3AB

Telephone [01] 940 1171

Contact:
Education Officer
Assistant
Secretary, Ext. 4615

Exhibits: World-wide collection of plants. Museum display: plants used by man (wood, rubber, sugar, oil, medical plants, dyes, etc.) and changing exhibition. Marianne North picture gallery.

Hours: Garden: 10 am–4–8 pm (depending on season)
Museums: 10 am–3.45 pm (summer 4.45 pm, Sundays 5.45 pm)
Glasshouses: 11 am–3.45 pm (summer)

Transport: Tube – Kew Gardens; Rail – Kew Gardens (North London Line), or from Waterloo to Kew Bridge; Bus – 27, 65

Amenities

B			R	🙆🙆🙆 40	🍴		🌲	🚌

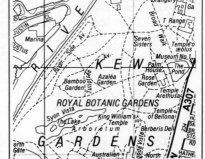

Reproduced by permission of the Geographers' A-Z Map Co. Ltd.

Crown copyright reserved

Materials provided free: Teachers' information.

Materials from shop: Guidebook; postcards; other.

Research facilities: Library

Linked visits: For medical history: Science Museum (Wellcome Medical History Collection); Chelsea Physic Garden. For natural history: Horniman Museum; Natural History Museum. For horticultural history: Chelsea Physic Garden. For Tradescant family: Museum of Garden History, St Mary's Church, Lambeth. For trade and geographical developments: Commonwealth Institute; National Maritime Museum. For related ethnographical studies: Museum of Mankind. For women's studies: Marianne North Gallery.

Comments: The new Princess of Wales Conservatory (opened 1987) is well worth visiting.

Admission: Charge

164

Royal Engineers Museum

Address: Brompton Barracks
Chatham
Kent ME4 4UG

Telephone 0634 44555,
Ext, 2312

Contact:
Assistant Curator

Hours: Tuesday–Friday, Bank
Holiday Mondays, 10 am–5 pm
Sunday 11.30 am–5 pm
Closed Monday

Exhibits: Collections
illustrating lives and work of
Britain's soldier engineers,
housed in fine Edwardian 'Anglo
Indian' style building; military,
imperial, social and political
history from 1066–1945;
decorative arts; uniforms;
General Gordon; survey and
engineering instruments.

Transport: Rail: Chatham or
Gillingham then Bus from
station to Brompton

Amenities

Term time courses: All ages,
talk by arrangement.

Materials provided free: List
of worksheets, worksheets,
teachers' pack.

Materials from shop:
Postcards; books.

Research facilities: Reference
library (by arrangement);
archives.

Special provision: Wheelchair
access and disabled toilets.

Linked visits: For engineering and scientific collections: Science
Museum; Kew Bridge Steam Museum. For army history: National
Army Museum; Royal Artillery, Woolwich; Royal Armouries
(Tower of London); World War I and II all forces: Imperial
War Museum – Wallace Collection (Armour).

Comments: A rewarding visit for older children following a
theme relating to warfare or engineering. This museum is some
distance from London but set in pleasant open grounds with
interesting buildings and echoes of Britain's Imperial past.

Admission: Free

165

Royal Hospital Museum

Address: Royal Hospital Road
Chelsea
London
SW3 4SL

Telephone [01] 730 0161

Contact:
Curator, Ext. 203

Exhibits: A grand building designed by Sir Christopher Wren; includes a small museum: exhibits include medals, uniforms of the Chelsea Pensioners, and plans and maps of the building.

Hours: Monday–Saturday, 10 am–12 noon; 2–4 pm Sunday, 2–4 pm, April–Sept.

Transport: Tube – Sloane Square; Bus – 11, 39, 137

Amenities

B							🌲	🚌

Term time courses:

Holiday courses:

Materials provided free:

Materials from shop:
Catalogue; postcards; brochure.

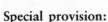

Reproduced by permission of the Geographers' A-Z Map Co. Ltd.

Research facilities:

Special provision:

Linked visits: For Wren buildings: St Paul's; Hampton Court Palace; various city churches (e.g. St Bride's). For military history: National Army Museum (adjacent to Royal Hospital). For social history: Museum of London; Victoria and Albert Museum.

Admission: Free

Royal Mews

Address: Buckingham Palace
Road
London
SW1W 0QH

Telephone [01] 930 4832

Contact:
Office Keeper, Ext. 3634
for enquiries, bookings

Exhibits: Her Majesty's
carriages, horses, harness, etc.,
used on all state occasions; state
coach (1761), glass coach, Irish
state coach and others.

Hours: Wednesday, Thursday,
2–4 pm (closed if there is a
carriage procession, and if Bank
Holiday falls on Wednesday or
Thursday)

Transport: Tube – Victoria
Rail – to Victoria; Bus – 2, 11,
24, 36 and others to Victoria,
then walk

Amenities

B						🌲 🚌

Term time courses:

Holiday courses:

Materials provided free:

Materials from shop: *Royal
Mews Book* available on
arrival; postcards; other.

Research facilities:

Special provision:

Reproduced by permission of the Geographers' A-Z Map Co. Ltd.

Crown copyright reserved

Linked visits: For horse transport and other coaches: London
Transport Museum; Museum of London. Out of London:
Whitbread's Hop Farm, Paddock Wood, Kent. Telephone 0622
872068.

Comments: No talks given, but staff will be available at various
carriage houses to answer questions. All ages of children
welcomed.

Admission: Charge

Royal Military School of Music

Address: Kneller Hall
Twickenham
Middx
TW2 7DU

Telephone [01] 898 5533

Contact:
Curator

Exhibits: Unique collection of musical instruments, mostly wind instruments and percussion as used in military bands of the 18th century; some early court stringed instruments.

Hours: Monday–Friday, 10 am–4 pm

Transport: Tube – Hounslow East; Rail – from Waterloo to Whitton; Bus – to Whitton: 33, 281

Amenities

				50			♣	🚌	

Term time courses:

Holiday courses:

Materials provided free:

Materials from shop: Catalogue; souvenirs; records; other.

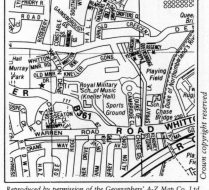

Reproduced by permission of the Geographers' A-Z Map Co. Ltd.

Research facilities: Reference library; archives.

Special provision:

Linked visits: For other non-military musical collections: Horniman Museum; Victoria and Albert Museum; Fenton House.

Comments: Concerts on Wednesday evenings. Can offer talks by special arrangement to upper age schoolchildren and adults.

Admission: Charge

168

Salvation Army Museum

Address: 117–21 Judd Street
Kings Cross
London
WC1H 9NN

Telephone [01] 387 1656

Contact:
Curator, Ext. 14
Schools Officer

Exhibits: 'The Salvation Army Story' – flags, banners, instruments, music, photographs, drawings, uniforms, caps, bonnets, books, documents, china and porcelain, pewter, silver, badges, brooches.

Hours: Monday–Friday, 9.30 am–3.30 pm
Saturday by appointment

Transport: Tube – Kings Cross; Bus – 14, 18, 30, 46, 73, 77, 214, 221, 239

Amenities

B	L	P	R	👥 100	🍴	📚	🌲	🚌	✍️

Term time courses:

Holiday courses:

Materials provided free: Teachers' information pack; students' information pack.

Materials from shop: Postcards; catalogue; books (educational); slides; tapes; other.

Research facilities: Reference library; archives; public lectures.

Reproduced by permission of the Geographers' A-Z Map Co. Ltd.

Crown copyright reserved

Special provision: Disabled groups, if pre-booked, help given where possible.

Linked visits: For social history: Museum of London, Spitalfields Heritage Centre. For religious studies: Wesley's House.

Comments: Short introductory talk to pre-booked groups. All ages welcome. Some events include activities such as puzzles, drama and music. Loan films and videos can be obtained from: CTVC Film Library, Foundation House, Walton Road, Bushey, Watford WD2 2JF.

Admission: Free

169

St Bride's Crypt and Church Museum

Address: Fleet Street
 London
 EC4Y 5AU

Telephone [01] 353 1301

Contact:
Secretary

Exhibits: Church rebuilt by Wren after the Great Fire; in crypt, small and excellent display showing Roman pavement; displays relating to Great Fire, printers and printing, local Fleet Street history; baptismal church of Samuel Pepys.

Hours: Daily, 8.30 am–5.30 pm
Sunday, 8.30 am–8 pm

Transport: Tube – Blackfriars, St Pauls, Chancery Lane; Bus – 15, 15A, 6, 9, 11

Amenities

B	L		R	🪑50	🍴	🍎📚	🌲	

nearby

Term time courses:

Holiday courses:

Materials provided free:

Materials from shop:
Postcards; other.

Research facilities:

Special provision:

Linked visits: For social history of London: Museum of London. For history of printing: Science Museum. For Romans: Museum of London. For Samuel Pepys: Museum of London; National Portrait Gallery; St Olave's Church, Hart Street.

Comments: Guided tours by arrangement, any age.

Admission: Free

170

Science Museum

Address: Exhibition Road
South Kensington
London
SW7 2PD

Telephone [01] 938 8000
(Enquiries) 938 8222

Contact:
Education Officer (telephone
number 938 8222)
Secretary, Ext. 688 (enquiries
only; *all bookings by letter*)

Exhibits: All branches of physics,
chemistry, mathematics,
astronomy; industrial machinery;
early transport; and related
subjects; also Wellcome Medical
History galleries (4th floor).

Hours: Weekdays, 10 am–6 pm
Sunday, 2.30–6 pm

Transport: Tube – South
Kensington; Bus – 9, 14, 30, 33,
45, 49, 52, 73, 74

Amenities

B	L	P	180 lectures	🍴	🍎	🌲	

Reproduced by permission of the Geographers' A-Z Map Co. Ltd.

Term time course: *Teachers*:
one day (four or five per year).

Holiday courses: Christmas,
Easter, summer, for children
and/or family.

Materials provided free: List
available: worksheets (one free
sample); one free resource
pack, 'visit planning pack' (then
order as required).

Materials from shop: Catalogue;
posters and other material.

Crown copyright reserved

Research facilities: Library; public lectures; teacher enquiry desk.

Special provision: For disabled (by special arrangement).

Linked visits: For transport: London Transport Museum;
Heritage Motor Museum, Syon Park. For working machines:
Kew Bridge Engines Trust; Tower Bridge; Thames Barrier. For
flight and aviation: Royal Air Force Museum, Hendon. For
astronomy and space: Old Royal Observatory; London
Planetarium; Geology Museum.

Comments: Limited handling sessions for juniors in Wellcome
Medical History Collection (by arrangement). Schools
programme gives details of talks. 'Launch Pad' gives hands-on
exploration of many principles of physics and maths.

Admission: Charge

171

Serpentine Gallery

Address: Kensington Gardens
London
W2 3XA

Telephone [01] 402 6075
723 9072

Contact:
Museum Teacher

Exhibits: Small attractive gallery with changing exhibitions of contemporary, usually young, artists; emphasis on new experimental work.

Hours: April–Oct., daily, 10 am–6 pm
Nov.–March, daily, 10 am–dusk

Transport: Tube – Lancaster Gate, South Kensington; Bus – 9, 12, 52, 73, 88 (pass nearby)

Amenities:

Term time courses: *Teachers*: occasional.

Holiday courses: Occasional, Summer, Christmas.

Materials provided free: Teachers' information.

Materials from shop: Guidebooks (current exhibition); postcards.

Research facilities:

Special provision: Ideal ground-level gallery for wheelchair access and small groups of disabled children would receive special attention.

Linked visits: For contemporary art: Hayward Gallery; Whitechapel Art Gallery; Tate Gallery.

Comments: Newly-established education service anxious to develop this work – some complementary practical art activities occasionally.

Admission: Free

172

Shakespeare Globe Museum

Address: 1 Bear Gardens
London
SE1

Telephone [01] 928 6342

Contact:
Education Officer
Secretary

Exhibits: Exhibition of Elizabethan
theatre history; development and
influence of players, playwrights
and playhouses, through visual
materials and scale models.

Hours: Monday–Saturday,
10 am–5 pm
Sunday, 2–6 pm

Transport: Tube – Mansion
House, London Bridge; Bus – any
to London Bridge, and 18, 176A,
149, 95, 70, 44

Amenities

B	L		R	🪑 30			🚌

Term time courses:

Holiday courses:

Materials provided free:
Occasionally worksheets
provided.

Materials from shop:
Postcards, Books (for schools),
Posters, Model theatres.

Research facilities: Archives;
Public Lectures.

Special provision:

Reproduced by permission of the Geographers' A-Z Map Co. Ltd.

Crown copyright reserved

Linked visits: For life and time of Shakespeare: Public Record
Office (Shakespeare's Will); Museum of London; National
Portrait Gallery; British Library (MSS). For live performances:
Barbican Theatre; National Theatre, South Bank; St George's
Circular Theatre, 49 Tufnell Park Road, London, N7 – phone
[01] 607 1128.

Comments: Space is limited; one gallery only.
Drama activities sometimes offered. Information available about
proposed new Shakespeare Theatre, an exciting project to
reconstruct the original Globe Theatre.

Admission: Charge

173

Sir John Soane Museum

Address: 13 Lincoln's Inn
Fields
London
WC2A 3BP

Telephone [01] 405 2107

Contact: Curator

Hours: Tuesday–Saturday,
10 am–5 pm
Closed Sunday, Monday,
and Bank Holidays

Exhibits: A unique house,
designed by Sir John Soane,
architect (early 19th century), to
display his antiquities. He lived,
worked and taught students in the
house. Also includes Hogarth's
The Rake's Progress.

Transport: Tube – Holborn;
Bus – 8, 22, 25, 55, 68, 77, 77A,
77C, 170, 172, 188, 239, 501

Amenities

	L	P	R	👥👥👥 20			🌲	🚌

Term time courses: *Sixth
Form*: three-quarter hour
guided tour by arrangement.

Holiday courses:
Materials provided free:

Materials from shop: Catalogue,
guide book; postcards; slides;
leaflet (short description); othe-

Research facilities: Reference
library (by arrangement);
archives (by arrangement);
public lecture tour, Saturdays,
2.30 pm.

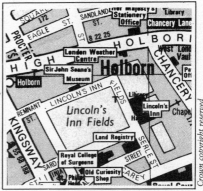

Reproduced by permission of the Geographers' A-Z Map Co. Ltd.

Special provision:

Linked visits: For study of classical antiquities: British Museum.
For history or social history: Victoria and Albert Museum;
National Portrait Gallery. For the study of Robert Adam, whose
drawings are in this collection: Kenwood; Syon House; Osterley
Park House; Victoria and Albert Museum.

Comments: Parties limited to 20 children plus teacher(s). Suitable
mainly for older students. Note, steps to front door. No lift for
wheelchairs. Noteworthy: special display of Hogarth's series of
paintings *The Rake's Progress.*

Admission: Free

174

South London Art Gallery

Address: Peckham Road
London
SE5 8UH

Telephone [01] 703 6120

Contact:
Keeper

Exhibits: About 10 exhibitions arranged annually, each lasting three weeks, advertised in *London Gallery Guide*.

Hours: Tuesday–Saturday,
10 am–6 pm
Sunday, 3–6 pm during exhibitions

Transport: Tube – Elephant and Castle, then Bus 12 or 171; Oval, Vauxhall, Victoria, then bus 36, 36A, 36B

Amenities

Reproduced by permission of the Geographers' A-Z Map Co. Ltd.

Crown copyright reserved

Term time courses:

Holiday courses:

Materials provided free:

Materials from shop:

Research facilities:

Special provision:

Linked visits: For contemporary art: Hayward Gallery; Serpentine Gallery; Whitechapel Art Gallery.

Comments: Mainly of interest to older students specialising in art.

Admission: Free

Spitalfields Heritage Centre

Address: 17–19 Princelet Street
London
E1 6QE

Telephone [01] 377 6901

Contact:

Hours: Tuesday–Thursday,
10 am–5 pm – *visits by
arrangement only*

Exhibits: An 18th century
weaver's house with a 19th
century synagogue in the
back garden; study centre;
history of immigration
(Bengali, Jewish and
Hugenot); new museum
information.

Transport: Tube –
Liverpool Street, Aldgate
East; Bus – 10, 25, 225, 253,
67 (closest); Rail – Liverpool
Street

Amenities

B								

Linked visits: For social
history: Museum of London;
Geffrye Museum. For silk
weavers and silk design: Bethnal
Green Museum; V&A; Science
Museum; Museum of London.
For 18th century architecture:
Sir John Soane Museum. For
Jewish History: Jewish
Museum; London Museum of
Jewish Life (Sternberg
Institute). For Hugenot history:
Guildhall Library; Museum of
London. For East End history:
Ragged School Museum Trust.

Reproduced by permission of the Geographers' A-Z Map Co. Ltd.

Comments: This is a recently established museum in a unique
18th century conservation area, in the immediate vicinity of
Christ Church Spitalfields, Hawksmoor's masterpiece. Caution:
the house is small and still requires renovation, but the coordinator
is keen to make contact with schools. Suitable for small groups
of older students studying local history, immigration or 18th
century architecture.

Admission: Free

176

Syon Park and House

Address: Syon Park
Brentford
Middx
TW8 8JF

Telephone [01] 560 0881

Contact:
Education Officer

Exhibits: Syon House is 'noted for its magnificent Adam interiors'; it is a seat of the Duke of Northumberland remodelled by Robert Adam in the 18th century. Gardens by Capability Brown, great conservatory, aviary and aquarium.

Hours: House: Good Friday–28 Sept., Sunday–Thursday, 12 noon–6 pm; closed Friday, Saturday
Gardens: March–Oct., daily, 10am–6 pm
Nov.–Feb., daily, 10 am–dusk

Transport: Tube – Boston Manor, Gunnersbury; Rail – to Syon Lane; Bus – 37, 117, 203, 237, 267, E1, E2

Amenities

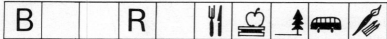

B			R		¶¶	📖	🌲	🚌	✎

Term time courses:

Holiday courses:

Materials provided free:

Materials from shop:
Guidebook; postcard; other.

Research facilities:

Special provision:

Linked visits: For Robert Adam: Osterley Park House; Kenwood; Sir John Soane Museum. For 18th century social history: Museum of London. For 18th century art and furniture: Victoria and Albert Museum.

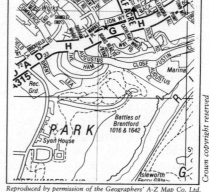

Comments: Guided tour to house can be arranged.

Admission: Charge

Tate Gallery

Address: Millbank
London
SW1 4RG

Telephone [01] 821 1313

Contact:
Education Officer,
 Ext. 204
Secretary, Ext. 202

Exhibits: British collection of paintings 16th–19th century; Modern collection of works by artists born after 1860; prints and sculpture.

Hours: Weekdays,
10 am–5.50 pm
Sunday, 2–5.50 pm

Transport: Tube – Pimlico; Bus – 77, 88 stop outside gallery; 2, 36, 181, 185 stop nearby

Amenities

B	L	P	R	30	⚥	🍴	📚	🌲	🚌

Term time courses: *Teachers*: one day courses; evening courses. *Sixth Form*: study days.

Holiday courses: Occasional holiday courses for children and others.

Materials provided free: Worksheets; trails; monthly Tate calendar of events.

Materials from shop: Catalogue; postcards; books; slides; other.

Special provision: Disabled groups can be helped if pre-booked. Wheelchair access.

Reproduced by permission of the Geographers' A-Z Map Co. Ltd.

Crown copyright reserved

Linked visits: For modern and contemporary art: Hayward Gallery, Serpentine Gallery, Whitechapel Art Gallery. For 18th century art: National Gallery. For related prints and drawings: British Museum, Victoria and Albert Museum. For portraits: National Portrait Gallery; Ranger's House.

Comments: This is a very large collection of great diversity, comprising historic British art on one hand and ultra-contemporary experimental work on the other. For these reasons it is especially important to plan your visit in advance and to limit its theme so as to avoid confusing and exhausting your class.

Admission: Free to main collections. Varying fee to special exhibitions.

Theatre Museum

Address: 1E Tavistock Street
Covent Garden
London
WC2E 7PA

(Public entrance in
Russell Street)

Telephone [01] 836 7891,
Ext. 139

Contact:
Education Officer

Exhibits: The national
collection of material on the
performing arts, from opera to
circus, from the Beatles to
Shakespeare; programmes,
playbills, costumes, props,
puppets; memorabilia of the
famous.

Hours: Tuesday–Sunday,
11 am–7 pm Closed Monday

Transport: Tube – Covent
Garden, Embankment, Leicester
Square; Bus – 2, 8, 22, 24, 55,
68, 77 and others

Amenities

Term time courses: Lectures
(adult education)

Holiday courses:

Materials provided free:
Worksheets; fact cards
(teachers).

Materials from shop:
Postcards; charts; books.

Research facilities: Reference
library; archives.

Special provision: Wheelchair
access.

Reproduced by permission of the Geographers' A-Z Map Co. Ltd.

Linked visits: For Shakespeare: Shakespeare Globe Museum;
Public Record Office. For live performances: Barbican Theatre;
National Theatre, and others; Royal Opera House, Covent
Garden; Coliseum (English National Opera).

Comments: This is a museum for specialists; much of the
material is displayed in low light and labels are not pitched
towards children; an advance visit by the teacher is essential.

Admission: Charge

Tower Bridge

Address: London
SE1 2UP

Telephone [01] 407 0922

Contact:
Bridge Master
Secretary

Exhibits: Bridge designed by Sir
John Wolfe Barry and opened in
1894; massive Victorian steam
pumping engines; amazing
panoramic views over London from
walkways; exhibitions on history
and structure of the bridge.

Hours: April–Oct., daily,
10 am–6.30 pm
Nov.–March, daily, 10 am–4.45 pm
(including Sunday)

Transport: Tube – Tower Hill;
Bus – 15

Amenities

Term time courses:

Holiday courses:

Materials provided free:

Materials from shop:
Brochures; books; other.

Research facilities:

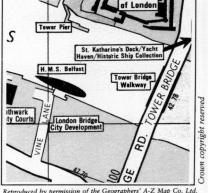

Reproduced by permission of the Geographers' A-Z Map Co. Ltd.

Special provision: Disabled toilets and wheelchair ramp on high
walkway.

Linked visits: For technology and machinery: Science Museum.
For steam machines: Kew Bridge Engines Trust.

Comments: Video show illustrates working on the bridge.

Admission: Charge

180

Tower of London

Address: Tower Hill
London
EC3N 4AB

Telephone [01] 709 0765

Contact: Education Officer,
[01] 480 6358, Ext. 332
Assistant Education Officer,
Ext. 332
Bookings for admission to
Tower, [01] 709 0765,
Ext. 235

Exhibits: Castle building with
interpretive displays; prisoners'
relics. Instruments of torture and
execution. European and Asian
armour and weapons. The Crown
Jewels.

Hours: Weekdays, Nov.–Feb.,
9.30 am–4 pm
March–Oct., 9.30 am–5 pm;
Sunday, 2–5 pm

Transport: Tube – Tower Hill;
Bus – 15, 42, 47, 56, 78

Amenities

B	L	P	R	👪100	🍴		🌲	🚌	✒️

Term time courses: *Teachers*:
one day, usually 3 per year.
Sixth Form: 1st and 2nd year
history A-level students
(separate days); non-academic
by arrangement.

Materials provided free: List
available, Teachers' information.

Materials from shop:
Catalogue; postcards; books
for schools and public; other.

Research facilities: Reference
library; public lectures.

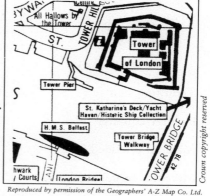

Special provision: All disabled (by arrangement); all Further
Education groups (by arrangement).

Linked visits: For arms and armour: Wallace Collection;
Museum of Artillery. For history of London: Museum of
London. For biographical history: National Portrait Gallery.

Comments: Lessons for pre-booked school groups include video
showings in lecture theatre, handling objects, dressing in armour
and costume, brass rubbing. Occasional projects with Theatre in
Education.

Admission: Charge. (Tower and Crown Jewels): School parties
free September–April; *if pre-booked*, May–August 10%
discount.

181

Uxbridge Library

Address: 22 High Street
Uxbridge
Middx

Telephone 0895 50600

Contact:
Local Studies Librarian

Exhibits: Local history, mainly
Hillingdon, also Buckinghamshire;
books illustrating archives.

Hours: Monday–Friday,
9.30 am–8 pm
Saturday, 9.30 am–5 pm
Closed Sunday

Transport: Tube – Uxbridge;
Bus – 207

Amenities

B	L			👥👥👥 20				

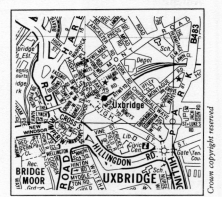

Reproduced by permission of the Geographers' A-Z Map Co. Ltd.

Term time courses:

Holiday courses:

Material provided free:

Materials from shop:
Catalogue.

Research facilities: Reference
Library; archives.

Special provision:

Linked visits:

Comments: Museum objects in store: see by arrangement.

Admission: Free

182

Verulamium, St Albans

Address: St Michael's Street
St Albans
Herts AL3 4SW

Telephone 0727 54659
 59919

Contact:
Education Officer, 0727 59919
Secretary, 0727 54659

Hours: Winter, Monday–
Saturday, 10 am–4 pm;
Sunday, 2–4 pm; Summer,
Monday–Saturday, 10 am–
5.30 pm; Sunday, 2–5.30 pm

Exhibits: Roman museum on
site of the Roman town;
objects from Verulamium:
mosaics, wallplaster, pottery,
glass, metalwork; Roman
hypocaust (underfloor heating
system) nearby.

Transport: Rail – from
St Pancras or Kings Cross to
St Albans; Bus – Green Line

Amenities

Term time courses: *Teachers*:
day courses for Hertfordshire
teachers. *Sixth Form*: days.

Holiday courses: Christmas,
Easter, summer.

Materials provided free:
Worksheets.

Materials from shop:
Catalogue; postcards; books.

Research facilities: Reference
library; archives (City Museum).

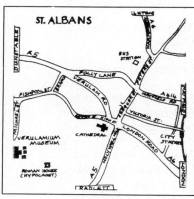

Special provision: Disabled groups – advance booking required.

Linked visits: For Roman Britain: Museum of London; British
Museum; Lullingstone Roman Villa, Kent.

Comments: Introductory talks, handling sessions, replica clothes
and small loan collection for schools. Slide tape programme on
view. This is a very small museum. See also the St Albans City
Museum (folk life, natural history, craft displays).

Admission: Free

183

Vestry House Museum

Address: Vestry Road
Walthamstow
London
E17 9NH

Telephone [01] 527 5544

Contact:
Education Officer, Ext. 4391

Exhibits: Victorian and Edwardian domestic life, housed in 18th century workhouse building; and a Victorian police cell. Also the Bremer car, 1892–4.

Hours: Monday–Friday, 10 am–5.30 pm
Saturday, 10 am–5 pm
Closed Wednesday and Saturday 1–2 pm, also Sunday, Christmas

Transport: Tube – Walthamstow Central; Bus – 34, 69, 97, 97A, 123, 212, 275

Amenities

B		R	30				

Term time courses: Occasional.

Holiday courses:

Materials provided free: Teachers' information; worksheets.

Materials from shop: Catalogue; postcards.

Research facilities:

Special provision: Not suitable for disabled.

Linked visits: For local history studies: William Morris Gallery. For cars: Heritage Motor Museum; Science Museum.

Comments: Introductory talks, slide shows, occasional handling sessions and replica costumes.

Admission: Free

184

Victoria and Albert Museum

Address: Cromwell Road
South Kensington
London
SW7 2RL

Telephone [01] 938 8500

Contact:
Education Officer, Ext. 8638
Secretary, Ext. 8636

Transport: Tube – South
Kensington; Bus – 14, 30, 45,
49, 74, 39A (Saturday only)

Exhibits: Furniture, silver,
ceramics, metalware, armour,
jewellery, dress, textiles and
embroidery, musical instruments,
the arts of Islam, India and the
Far East; paintings and sculpture.

Hours: Weekdays,
10 am–5.50 pm
Sunday, 2.30–5.50 pm
(now open Friday again)

Amenities

B	L	P	R		🍴	📖	🌲	

Term time courses: *Teachers*:
occasional one day courses.
Sixth Form: occasional one day.

Materials provided free:
Teacher information.

Materials from shop:
Postcards; catalogue; posters;
books; other.

Research facilities: Reference
Library; study collection
(textiles).

Special provision: Disabled
groups (where possible) by
arrangement.

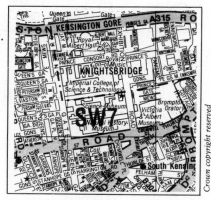

Reproduced by permission of the Geographers' A-Z Map Co. Ltd.

Linked visits: For social history: Museum of London. For Constable:
Tate Gallery. For decorative arts and furniture: Leighton House;
William Morris Gallery; Geffrye Museum. For costume: Kensington
Palace (Court costume); Museum of London. For prints and water-
colours: British Museum. For contemporary design: Crafts Centre;
Design Centre. For Oriental art and design: British Museum.

Comments: The museum's Cast Court contains unique sculpture
casts for art studies. The immensity of this wonderful collection
creates problems for the teacher unless the visit is carefully
planned in advance. Select the aspect of the collection you wish
to see and *firmly* reject the rest – until the next visit.

Admission: Free, but voluntary donations requested.

Wallace Collection, The

Address: Hertford House
Manchester Square
London
W1M 6BM

Telephone [01] 935 0687

Contact:
Education Officer

Exhibits: Outstanding
collection of Old Master
paintings, French 18th century
furniture, Sèvres porcelain,
arms and armour (European
and Oriental), and European
applied and decorative arts.

Hours: Monday–Saturday,
10 am–5 pm
Sunday, 2–5 pm

Transport: Tube – Bond Street,
Baker Street; Bus – 1, 2, 6, 7, 8,
12, 13, 15, 16A, 23, 30, 73, 74,
88, 100, 113, 137, 159, 500

Amenities

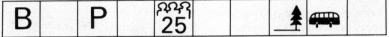

Term time courses:

Holiday courses:

Materials provided free:

Materials from shop:
Catalogue; postcards; other.

Research facilities: Public
lectures (occasional).

Special provision: Not suitable
for disabled children, though a
wheelchair and lift to 1st floor
are available on request.

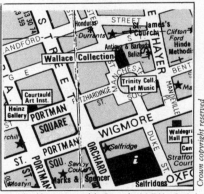

Reproduced by permission of the Geographers' A-Z Map Co. Ltd.

Linked visits: For 18th century painting and decorative arts:
Victoria and Albert Museum; Dulwich Picture Gallery;
Kenwood; National Gallery. For armour: Tower of London.

Comments: No special provision or direct talks offered to school
pupils. Suitable for small groups of older Art History students
with own teacher. The Oriental and Western collection of armour,
including splendid set of horse armour, would greatly interest
primary school classes under guidance of own teachers.

Admission: Free

186

Wandsworth Museum

Address: Putney Library
Disraeli Road
London
SW15 2DR

Telephone [01] 377 6901

Contact:
Curator

Exhibits: Housed in a 19th century building a new local history museum; pre-history to present day life in Wandsworth.

Hours: Monday–Saturday 1–5 pm
Closed Thursday and Sunday

Transport: Tube – East Putney Station; Bus – 37, 264; Train – Putney

Amenities

B		R					

Term time courses: *Teachers*: occasional day or half day courses.

Holiday courses:

Materials provided free:

Materials from shop:

Research facilities:

Special provision:

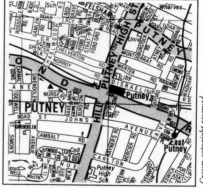

Reproduced by permission of the Geographers' A-Z Map Co. Ltd.

Linked visits: Local history in London: Livesey Museum; Cuming Museum; Greenwich Borough Museum; Greenwich local history centre; Hall Place (Bexley); Church Farm Museum (Hendon); Spitalfields Heritage Centre. Out of London: Bromley Museum, Kent.

Comments: This is a recently established museum still building up its collection and very much at the beginning of its career. The organisers are anxious to make contact with local schools.

Admission: Free

Wellington Museum, Apsley House

Address: Apsley House
Hyde Park Corner
London
W1V 9PA

Telephone [01] 499 5676

Contact:
Education Officer at Victoria
and Albert Museum,
[01] 938 8500

Exhibits: Home of the first
Duke of Wellington: contains
paintings, silver, porcelain,
sculpture, furniture and much
personal memorabilia.

Hours: Tuesday–Sunday,
11 am–5 pm
Closed Monday

Transport: Tube – Hyde Park
Corner; Bus – 2, 2B, 9, 14, 16,
19, 20, 22, 26, 38, 52, 73, 74,
137; Green Line, 704, 705, 714,
716, 716A (to Hyde Park
Corner)

Amenities

B	L	P	R	30			🌲	

Term time courses:

Holiday courses:

Materials provided free:

Materials from shop:
Catalogue; postcards.

Research facilities:

Special provision:

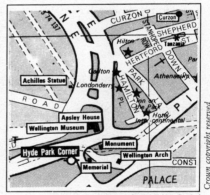

Reproduced by permission of the Geographers' A-Z Map Co. Ltd.

Linked visits: For life and times of Wellington: National Portrait
Gallery. For Military history: National Army Museum.

Comments: Guided tours can be provided. For educational
advice and possible help, contact education officer at the
Victoria and Albert Museum.

Admission: Charge, but pre-booked school parties free.

188

Wesley's House and Chapel

Address: 47 City Road
London
EC1

Telephone [01] 253 2262

Contact:
Enquiries

Exhibits: Personal relics, letters and articles of furniture which belonged to John Wesley who built the chapel and house (in which he died).

Hours: Monday–Saturday,
10 am–1 pm, 2–4 pm
Other times by arrangement

Transport: Tube – Moorgate, Old Street; Bus – 21, 43, 76, 104, 141, 214, 271

Amenities

B			30	♟			

Reproduced by permission of the Geographers' A-Z Map Co. Ltd.

Term time courses:

Holiday courses:

Materials provided free:
Teachers' information.

Materials from shop:

Research facilities:

Special provision:

Linked visits: For religious studies: Salvation Army Museum. For social history in late 18th century: Museum of London; National Portrait Gallery.

Comments: Short introductory talk can be offered if pre-booked.

Admission: Charge (reduction for parties, children, OAPs).

Whitechapel Art Gallery

Address: Whitechapel High
Street
London
E1 7QX

Telephone [01] 377 5015

Contact:
Education Officer
Community Education
Assistant

Exhibits: Changing exhibition programme on 20th century visual arts, each with individual programmes for schools, approximately every two months. (There is no permanent collection.)

Hours: Tuesday–Sunday, 1 am–5 pm; Wednesday, 11 am–8 pm Closed Monday

Transport: Tube – Aldgate East; Bus – 10, 25, 225, 253 pass the gallery; 5, 15, 23, 40, 67, 78 pass nearby

Amenities

B	L	P	R	30	🍴	🍎	🌲	🚌

Term time courses: *Sixth Form*: practical workshops with artists conducting.

Holiday courses: Christmas, Easter, summer.

Materials provided free: Teachers' information; worksheets.

Materials from shop: Catalogue (current exhibitions); postcards.

Research facilities:

Reproduced by permission of the Geographers' A-Z Map Co. Ltd.

Crown copyright reserved

Special provision: Disabled groups can be catered for: make advance arrangements. Practical art and sometimes dancing are included in some special workshops especially for local community. Film and video shows, depending on current exhibition.

Linked visits: For contemporary art: Tate Gallery; Hayward Gallery; Serpentine Gallery.

Comments: New education facilities offer a lecture room, an education room and audio-visuals room.

Admission: Pre-booked groups free.

190

William Morris Gallery

Address: Lloyd Park
Forest Road
Walthamstow
London
E17 4PP

Telephone [01] 527 5544

Contact:
Education Officer

Exhibits: In a park, 18th century house associated with Morris family who once lived there; decorative arts by Morris, Burne-Jones, Rossetti, the Century Guild and others. Paintings by Frank Brangwyn.

Hours: Tuesday–Saturday,
10 am–1 pm, 2–5 pm,
1st Sunday in month
10 am–12 noon, 2–5 pm
Closed Monday, Bank Holidays

Transport: Tube – Walthamstow Central; Bus – from station, 97A, 69, 212, 34 to Bell Corner

Amenities

B								

Term time courses: *Sixth Form*: study sessions for groups of 10 by arrangement.

Holiday courses: Easter, summer.

Materials provided free: Teachers' information and worksheet to copy.

Materials from shop: Postcards; catalogue; posters; other (worksheets 5p for set of 6).

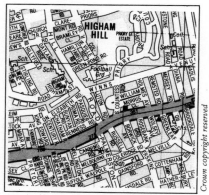

Reproduced by permission of the Geographers' A-Z Map Co. Ltd.

Crown copyright reserved

Research facilities: Reference Library (by arrangement).

Linked visits: For 19th century decorative arts: Victoria and Albert Museum. For historical and biographical background: National Portrait Gallery; Geffrye Museum.

Comments: Slide pack loaned to teachers on deposit of £15. This is a small quiet and beautifully displayed museum showing attractive examples of Morris's Arts and Crafts movement. No direct teaching is offered but the peace, quiet and lack of distraction would repay the journey (possibly) involved.

Admission: Free

Zoo (Chessington)

Address: Chessington Zoo Ltd
Leatherhead Road
Chessington
Surrey
KT9 2NE

Telephone 03727 27227

Contact:
Schools Officer

Exhibits: Large collection of animals; an 'open zoo' where animals are in 'natural settings'.

Hours: Daily, 10 am–5 pm

Transport: Rail – Chessington South

Amenities

B				﹛﹜		♠

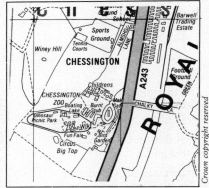

Reproduced by permission of the Geographers' A-Z Map Co. Ltd.

Term time courses:

Holiday courses:

Materials provided free: Worksheets; teachers information.

Materials from shop: Guidebook; postcards.

Research facilities:

Special provision: For blind, 'Touch and feel' tours of children's zoo.

Linked visits: For zoology: Natural History Museum. For live animals: London Zoo (see following entry).

Comments: Teachers may visit prior to party visit – contact Schools Officer.

Admission: Charge

192

Zoo (London)
The Zoological Society of London

Address: Regent's Park
London
NW1 4RY

Telephone [01] 722 3333

Contact:
Education Officer
Secretary

Exhibits: Over 8000 animals, including rare giant pandas, nocturnal animals, birds, reptiles, fish and insects.

Hours: April–Sept., daily, 9 am–6 pm; Oct.–March, daily, 10.30 am–4 pm

Transport: Tube – Camden Town, Baker Street, Regent's Park, St John's Wood; Bus – 3, 74, 53

Amenities

B	L	P	R	30 juniors 100 seniors	🍴	🍎	🌲	🚌

Term time courses: *Teachers:* one or two days. *Sixth Form:* A-level topics by arrangement and Sixth Form symposium.

Holiday courses: Christmas, Easter, summer. (For members of Zoo Club only.)

Materials provided free: Worksheets; teachers' notes and information.

Materials from shop: Catalogue; postcards; books – animal care leaflets; other.

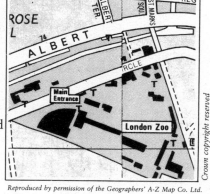

Reproduced by permission of the Geographers' A-Z Map Co. Ltd.

Crown copyright reserved

Research facilities: Reference Library; public lectures.

Special provision: All disabled groups if pre-booked. Further Education: day release for students on Zoo Keeper courses.

Linked visits: For zoology and fossils: Natural History Museum. For live animals in natural settings: Chessington Zoo (see preceding entry). For animals in art: British Museum; Tate Gallery; National Gallery.

Comments: All age groups welcome. Some activities include scientific workshops. Animals are caged, but this enables close study which natural settings may not. Video and audio-visual shows provided.

Admission: Charge

Select Booklist

The history of museums

Hudson, Kenneth (1975) *A Social History of Museums. What the visitor thought*. London: Macmillan.

Impey, O. R. and MacGregor, A. C. (eds) (1985) *The Origins of Museums*. Oxford: Oxford University Press.

MacGregor, Arthur (ed.) (1983) *Tradescant's Rarities: Essays on the Foundation of the Ashmolean Museum*. Oxford: Oxford University press.

Ross, Prudence Leith (1984) *The John Tradescants: Gardeners to the Rose and Lily Queen*. London: Peter Owen.

Witlin, Alma S. (1949) *The Museum, its History, its Tasks in Education*. London: Routledge and Kegan Paul.

Education in museums

Alexander, Eugenie (1974) *Museums and how to use them*. London: Batsford.

Fairley, John (1977) *History Teaching through Museums*. Education Today series. London: Longmans.

Harrison, Molly (1949) *Museum Adventure: The Story of the Geffrye Museum*. London: University of London Press Ltd.

Harrison, Molly (1954) *Learning out of School*. London: Ward Lock Educational.

Harrison, Molly (1967) *Changing Museums*. Education Today series. London: Longmans.

Newson, Barbara and Silver, Adele (eds) (1978) *The Art Museum as Educator*. Cleveland, Ohio: Museum of Art.

Schools Council (1972) *Pterodactyls and Old Lace. Museums in education*. London: Evans/Methuen.

General information

Alcock, Sheila (ed.) (annually) *Historic Houses, Castles and Gardens*. East Grinstead: British Leisure Publications.

Alcock, Sheila (ed.) (annually) *Museums and Art Galleries in*

194

Great Britain and Ireland. East Grinstead: British Leisure
Publications.
Rogers, Malcolm (1986) *Blue Guide: Museums and Galleries of
London.* (2nd rev. edn) London: A and C Black.
Guide to English Heritage Properties (annually). London: English
Heritage.

For teachers and parents
Dyer, Martin (ed.) (1986) *Heritage Education Handbook.*
Twickenham: Heritage Education Trust (HET).
Gorman, Pauline (1986) *Days Out, in and around London.*
Harlow: Longman.
Jerman, Betty (1986) *Kid's Britain.* London: Pan.

For teachers: GCSE
Museums and the New Exam. (Foreword by Hazel Moffatt, HMI)
(1987) London: Area Museums Service for South East
England (AMSEE).

For children
Brown, Marc and Laurene Krasny (1986) *Visiting an Exhibition.*
London: Collins.
Lucas, John (1979) *The Magic of London's Museums.* Watford:
Exley Publications.
Peppin, Anthea (1983) *The National Gallery Children's Book.*
(Illustrator Pauline Baynes) London: Eyre and Spottiswoode.
Richardson, Joy (1984) *Inside the British Museum.* (Designer
Roger Davies) London: British Museum.

For GCSE pupils
Cheetham, Linda (1988) *The Innocent Researcher and the
Museum.* Occasional Paper No. 3, Museum Ethnographers
Group. Leeds: Leeds City Museum.
(Obtainable from Distribution Manager, Leeds City Museum,
Calverley Street, Leeds, LS1 3AA).

Official reports
Department of Education and Science Education Survey (1971)
Museums in Education. London: HMSO.

Her Majesty's Inspectors of Education (1985–7) Five Surveys:
(Obtainable from Department of Education and Science,
Publications Despatch Centre, Honeypot Lane, Stanmore,
Middx, HA7 1AZ. Phone [01] 952 2366)
*Survey of the use of museums made by some schools in the
North West.* S341/7/015/20/87 NS25/85

Survey of the use some schools in six LEAs make of Museum Services. S330/7/019 53/87 NS1/86
Survey of how some schools in five LEAs made use of Museum Loan Services. INS 56/12/0192 290/87 NS/87
Survey of the use some Oxfordshire schools and colleges make of Museum Services. S9 31/7/010 312/87 DS 16/86
A survey of the use some pupils and students with Special Educational Needs make of Museums and Historic Buildings. INS 56/12/0196 4/88 NS2/87
[A further Survey on Further Education usage is to come]

Local Education Authority, Hertfordshire (1987) *Museum Education in Hertfordshire. A development plan.* The Report of the Working Party appointed by the Standing Committee for Museum Services in Hertfordshire.

Journals
Museum Association Journal, published by the Museums Association.
Journal of Education in Museums (JEM), published by GEM (Group for Education in Museums).

Articles
'GCSE maritime studies and motor vehicle studies and museums.' 2 articles *Museums Journal*, Vol. 87, No. 1, June 1987.
'Hands up for hands-on science (museums)' *New Scientist*, Vol. 110, No. 1505, 24 April 1986.
'The Geological Museum – 150th anniversary' *Head Teachers Review*, Winter 1985/86.
'Museums and Industry Year 1986' *Museums Bulletin*, Vol. 25 No. 12, March 1986, Supplement i–iv.
Anderson, A. 'Science with a touch of magic (at Bristol's new science museum)' *Nature*, Vol. 323, No. 6083, 4 September 1986.
Leicestershire museums initiatives: the response to GCSE *Museums Journal*, Vol. 87, No. 1 June 1987.
Budge, A. '(GCSE) Media studies (and museums)' *Museums Journal*, Vol. 87, No. 1, June 1987.
Cassin, M. '(GCSE) Art (and museums)' *Museums Journal*, Vol. 87, No. 1, June 1987.
Cruickshank, M. 'A whole constellation (science centres)' *TES*, No. 3693, 10 April 1987.
Cruickshank, M. 'Dealing with new demands (museums and the challenge of GCSE)' *TES*, No. 3687, 27 February 1987.
Cruickshank, M. 'Fundays, fantasies, facts and faces (a summer

guide to museum activities for children)' *TES*, No. 3657, 1 August 1986.

Divall, P. 'Group for education in museums (an outline of their work)' *Safety Education*, Autumn 1987.

Fassnidge, J. '(GCSE) History (and museums)' 2 articles *Museums Journal*, Vol. 87, No. 1, June 1987.

Freeborn, J. 'Interpretation and display (in museums) – an integrated approach' *Environmental Education*, Winter 1985.

Fry, H. 'Worksheets as museum learning devices' *Museums Journal*, Vol. 86, No. 4, March 1987.

Gold, K. 'New light cast on temples of gloom (a recent conference on museum studies) *THES*' No. 752, 3 April 1987.

Goodhew, E. '(GCSE) Ethnography (and museums)' *Museums Journal*, Vol. 87, No. 1, June 1987.

Goodhew, E. D. '(GCSE) Natural history (and museums)' *Museums Journal*, Vol. 87, No. 1, June 1987.

Gregory, R. 'The exploratory (Hands-on Science Centre, Bristol)' *TES*, No. 3692, 3 April 1987.

Hewison, R. 'Museums are one of our few growth industries' *Listener*, Vol. 115, No. 2966, 26 June 1986.

Jobbins, D. 'Secrets in the backroom of evolution's storehouse (the British Museum (Natural History))' *THES*, No. 699, 28 March 1986.

Lawson, I. 'Museums and GCSE: Standard Grade and Scottish museums' *Museums Journal*, Vol. 87, No. 2, September 1987.

Lucas, A. M. and others 'Investigating learning from informal sources: listening to conversations and observing play in science museums (in Britain and France)' *European Journal of Science Education*, Vol. 8, No. 4, October-December 1986.

MacLeod, K. 'Gallery and school: art study programmes' *Journal of Art and Design Education*, Vol. 4, No. 3, 1985.

Makins, V. 'Around the world (Dutch educational museum)' *TES* No. 3658, 8 August 1986.

Marshner, J. '(GCSE) Costume and textiles (and museums)' *Museums Journal*. Vol. 87, No. 1, June 1987.

Mathieson, A. '(GCSE) Geology (and museums)' *Museums Journal*, Vol. 87, No. 1, June 1987.

McConnell, A. 'Quis custodet custodes?: Museums are about more than glossy videos and flashing lights' *THES* No. 722, 21 August 1987.

Millar, S. 'What is heritage education?' *TES*, No. 3687, 27 February 1987.

Morgan, B. 'Science is child's play. Techniquest: an exhibition of interactive science and technology, Cardiff' *New Scientist*, Vol. 112, No. 1536, 27 November 1986.

O'Grady C. 'Woods of natural phenomena (the "daddy" of

interactive museums, the San Francisco Exploratorium)' *TES*, No. 3641, 11 April 1986

Pollock, S. 'Making a museum visit (for primary schoolchildren) work for you' *Primary Science Review*, No. 2, Autumn 1986.

Reeve, J. '(GCSE) Classics and classical studies (and museums)' *Museums Journal*, Vol. 87, No. 1, June 1987.

Rivron, P. 'Dead hand of questionnaires weighs down living brains (museum visits)' *Teacher*, Vol. 42, No. 23, 17 February 1986.

Rogers, R. 'Off the walls, out of the cases (a look at how museums and galleries meet current educational needs)' *Arts Express*, No. 39, June 1987.

Sorrell D. 'Group for education in museums presentation (at the Museums Association 1985 conference)' *Museums Journal*, December 1985.

Sorrell, D. S. '(GCSE) Craft, design and technology (and museums)' *Museums Journal*, Vol. 87, No. 1, June 1987.

Stewart, I. 'In the Past: A Museum Visit' *Child Education*, February 1986.

Tanner, K. 'Museums and GCSE: Cookworthy Museum and GCSE: A Case Study' *Museums Journal*, Vol. 87, No. 2, September 1987.

Whincop, A. 'GCSE for curators (of museums. How museums should prepare for the new exam)' *Museums Journal*, Vol. 87, No. 1, June 1987.

White, D. 'Pay as you go (arguments for and against museum admission charges)' *New Society*, Vol. 76, No. 1221, 23 May 1986.

This list has been taken from the DES Library bibliography and reading list for museums, January 1988.

Useful Addresses

Museums groups

The Museums Association
34 Bloomsbury Way
London
WC1A 2SS
01 404 4767

Area Museums Service for
South East England
(AMSEE)
Ferroners House
Barbican
London
EC2Y 8AA
01 600 0219

London Museums Officer for
London Curators
Consultative Committee
Ferroners House
Barbican
London
EC2Y 8AA
01 600 0219

Group for Education in
Museums (GEM)
Kent County Museum Service
West Malling Air Station
West Malling
ME19 5QE
0732 845845, Ext. 2147

GEM Membership
389 Great Western Road
Aberdeen
AB1 6NY
0224 215355

Heritage organisations

English Heritage
Education Officer
15–17 Great Marlborough
Street
London
W1V 1AF
01 734 6010, Ext. 843

Heritage Education Trust
(HET)
Hon. Secretary
St Mary's College
Strawberry Hill
Twickenham
TW1 4SX
01 892 0051

Her Majesty's Inspectorate

HMI with national responsibility for the development of Museum Education:

Miss Hazel Moffatt, HMI
Department of Education and
 Science
Turret House
Epsom
Guildford GU1 3PH
0483 38662

Tourist organisations

Clerkenwell Heritage Centre
Unit G 1
33 St John's Square
Clerkenwell
London
EC1
01 250 1039

London Visitor Convention
 Information Service
26 Grosvenor Gardens
London
SW1
01 730 3488

British Tourist Authority
Tourist Information Centre
64 St James's Street
London
SW1
01 499 9325

The National Trust

The National Trust
Headquarters
36 Queen Anne's Gate
London
SW1H 9AS
01 222 9251

Education Adviser
8 Church Street
Laycock
Wilts
SN15 2LB
024973 430

Independent museums

Association of Independent
 Museums
c/o National Motor Museum
Beaulieu
Hants

National Association of Decorative and Fine Arts Societies

Young NADFAS
NADFAS Office
38 Ebury Street
London
SW1W 0LU
01 730 3041

Loan collections, London

Islington Schools Loan
 Collection
Ambler School
Blackstock Road
London
N4 2DR
01 226 4708

Hackney Schools Study
 Collection
Orchard School
Holcroft Road
London
E9 7BB
01 986 7244

Passmore Edwards Museum
Romford Road
Stratford
London
E15 4LZ
01 534 0276

'Get Stuffed'
105 Essex Road
Islington
London
N1
01 226 1364

Loan collections, South-East England

The Booth Museum of Natural
 History
Dyke Road
Brighton
East Sussex
0273 552586

East Sussex Museum Loan
 Service
Corsica Hall
Cricketsfield Road
Seaford
East Sussex
BN25 1BI

Education Loans Service
Oxfordshire County Museum
Fletcher House
Park Street
Woodstock
Oxon
OX7 1SP
0993 811456

Commercial hire establishments

Gerrard Hire Ltd
85 Royal College Street
London
NW1
01 387 2765

Travel

British Rail
Group Travel Section
Waterloo Travel Centre
Waterloo Station
London
SE1 8SE
01 928 5151, Ext. 23315

London Regional Transport
Party Travel
Commercial Officer
55 Broadway
London
SW1H 0BD
01 222 5600, Ext. 2295

Thames Boats
Westminster Pier
01 930 4097

Thames Boats
Charing Cross Pier
01 839 5393

TRIPPS
Travel-related Ideas for Pupil
 Participation Studies
30 Whinneys Road
Loudwater
High Wycombe
Bucks
HP10 9RJ
0494 445584

Index of museums and galleries

Air Projects, 71
Apsley House, *see* Wellington Museum

Banqueting House, 72
Bear Gardens Museum, *see* Shakespeare Globe Museum
HMS *Belfast*, 73
Bethnal Green Museum of Childhood, 74
Bexley Museum, *see* Hall Place
British Museum, 75–6
British Museum (Ethnography), *see* Museum of Mankind
British Museum (Natural History), *see* Natural History Museum
British Piano and Musical Museum, *see* Musical Museum
Bromley Museum, 78
Bruce Castle Museum, 79

Cabinet War Rooms, 80
Care of Buildings, Exhibition, 81
Carlyle's House, 82
Chartered Insurance Institute Museum, 83

Chatham Historic Dockyard, 84
Chessington Zoo, *see* Zoo (Chessington)
Chiswick House, 85
Church Farm House Museum, 86
Cockpit Gallery, 87
Commonwealth Institute, 88
Courtauld Institute Galleries, 89
Cricket Memorial Gallery, 90
Cutty Sark Clipper Ship, 91
Cuming Museum, 92

Dr Johnson's House, 93
The Design Museum, 94
Dickens' House, 95
Dulwich Picture Gallery, 96

Epping Forest Museum, 97
Erith Museum, 98

Fenton House, 99
Forty Hall, 100
Foundling Hospital, Art Gallery and Museum, 101

Geffrye Museum, 102
Geological Museum, 103
Greenwich Borough Museum, 104

203

Index of reference libraries in museums and galleries